A Wish Your Heart Makes

FROM THE GRIMM BROTHERS' ASCHENPUTTEL
TO DISNEY'S *CINDERELLA*

Charles Solomon

INTRODUCTION BY

Kenneth Branagh

A WELCOME ENTERPRISES BOOK

Disney
EDITIONS

NEW YORK • LOS ANGELES

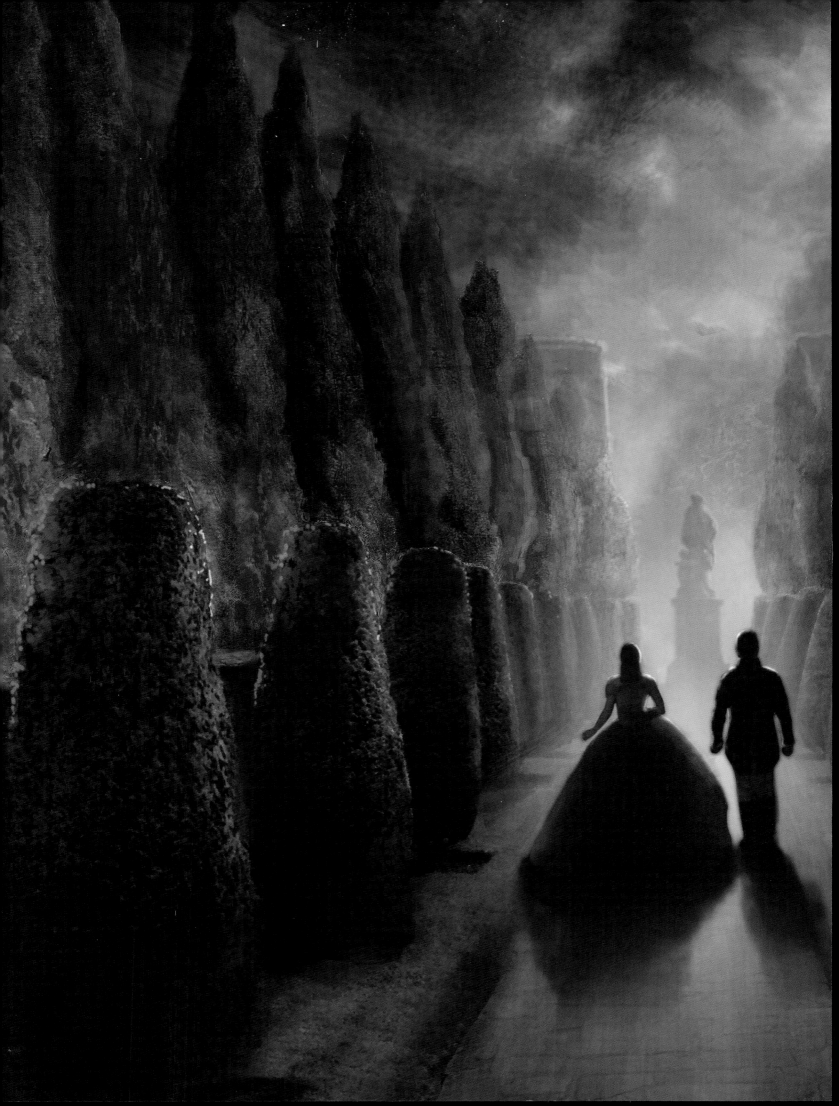

Contents

Conceptual study of Cinderella in her room by Mary Blair. Medium: watercolor, gouache.

Introduction

Everyone knows "Cinderella". All ages, all cultures, all moviegoers. Charles Solomon's fascinating book makes this beautifully clear.

Therefore, when it comes to making a new film version of this timeless classic, and especially when the picture comes from The Walt Disney Studios, the expectations are high.

How do you go about presenting "Cinderella" in the twenty-first century?

Well, if even the youngest viewer is familiar with the story, then perhaps what really counts is exactly *how* you present the many famous elements—the pumpkin transformation, the wonderful coach, the king's palace, our heroine's beautiful gown, the grand ball itself—together with the unforgettable characters of the stepmother, the stepsisters, the fairy godmother, and most importantly, Cinderella herself.

When I joined the project, the Disney studios team was already at work on planning for the new film. Dante Ferretti had begun early sketches for his production design, and Sandy Powell was developing her approach to the costumes. Both were working in a "classical" fairy-tale style that was bold and sumptuous. It was just the right moment for me to begin the process of guiding these and many other elements—cinematography, visual effects, music, and acting—into what I hoped would be a cohesive style for the complete film.

My dream was to not only find a way of combining the best inspirations from [Charles] Perrault and from the Disney animated film, but also

to make our own new and original contributions to the "Cinderella" myth.

I find the story very magical, very funny, and very emotional. We wanted the film to be, first and foremost, entertaining, so all of these qualities required a lightness of touch. The performances of our actors were crucial.

An emphasis on the "human" element of this great tale was a defining part of our approach: whether it was the hint of a tragic past in Cate Blanchett's magnificent stepmother, the contemplative depth of Richard Madden's gentlemanly prince, the compassionate eccentricity of Helena Bonham Carter's marvelous fairy godmother, or even the potential loneliness behind the delicious comedy of Sophie McShera and Holliday Grainger's stepsisters.

But most importantly, Lily James's character of Cinderella needed to meet and exceed a modern audience's expectations for this dearly loved character.

Well, here is no sap. No pushover. No doormat.

This Cinderella's strength comes from a highly developed sense of humor, from a natural joie de vivre, and from an ability to positively turn the other cheek, even when facing the greatest provocations. Her key characteristics (perhaps inherited, but certainly encouraged, by her parents) are courage, kindness, and an ability to see the world not always as it is, but perhaps as it could be if we believe that happiness is everyone's birthright.

I'm pleased to say that in Lily's glorious performance and in the work of the rest of our remarkable cast, the actors rose to the challenge of living in a world with just a hint of magic—and a great deal of human feeling.

In a story that shows what might be the first experience of loss for many of our young viewers,

the desire to be faithful and true to that heartache, while keeping a restorative lightness of spirit, and fun throughout the whole movie experience, was one of the greatest challenges and greatest joys of bringing *Cinderella* to the screen.

Solomon places our contribution to the *Cinderella* story in the lively and entertaining context of what has gone before. It's a rich and inspiring heritage to be a part of. We certainly hope to live up to the honor and responsibility of bringing one of literature's most enduring characters to a new life in the cinema.

My thanks to The Walt Disney Studios for inviting our magnificent team of artists to the ball!

—Kenneth Branagh

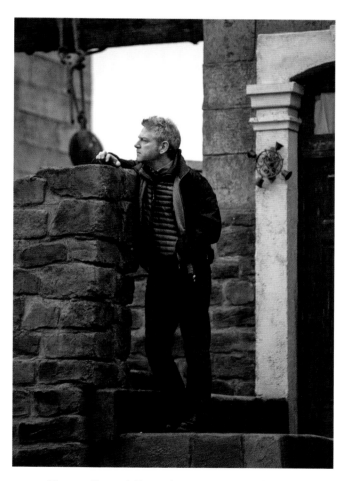

Director Kenneth Branagh pauses contemplatively on the set of the live-action *Cinderella*.

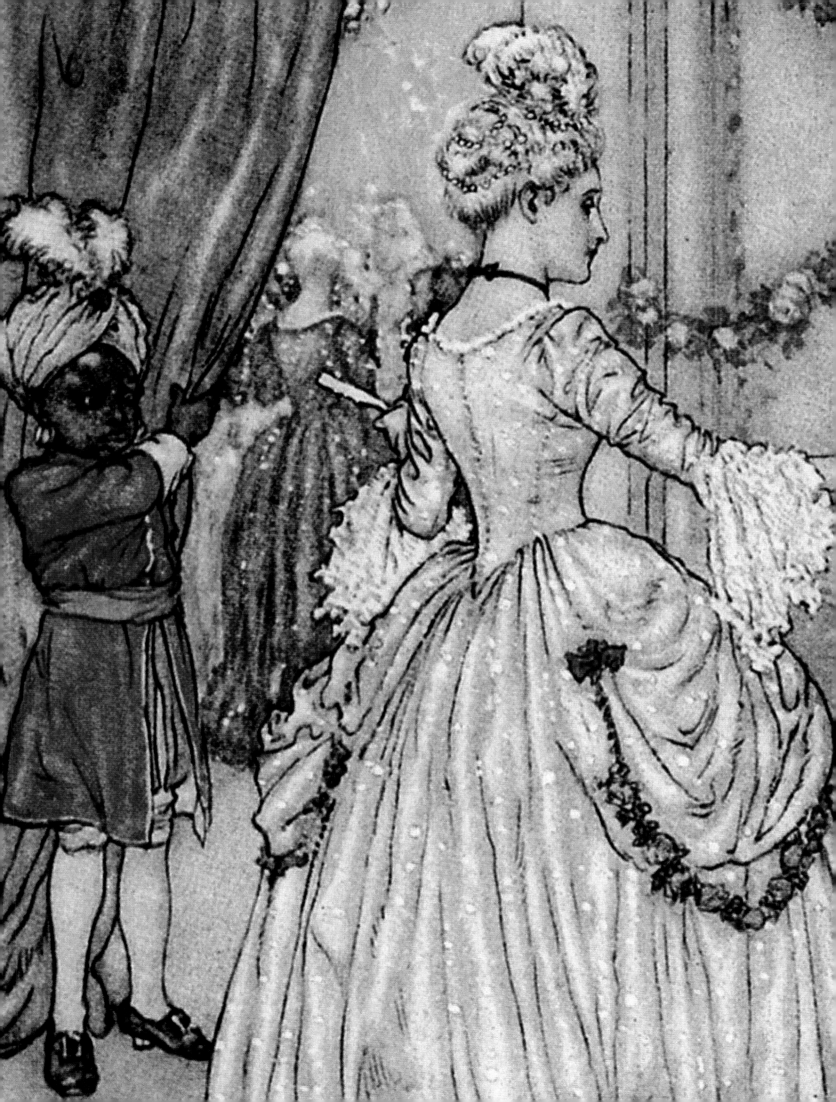

Part I
Once Upon A Time

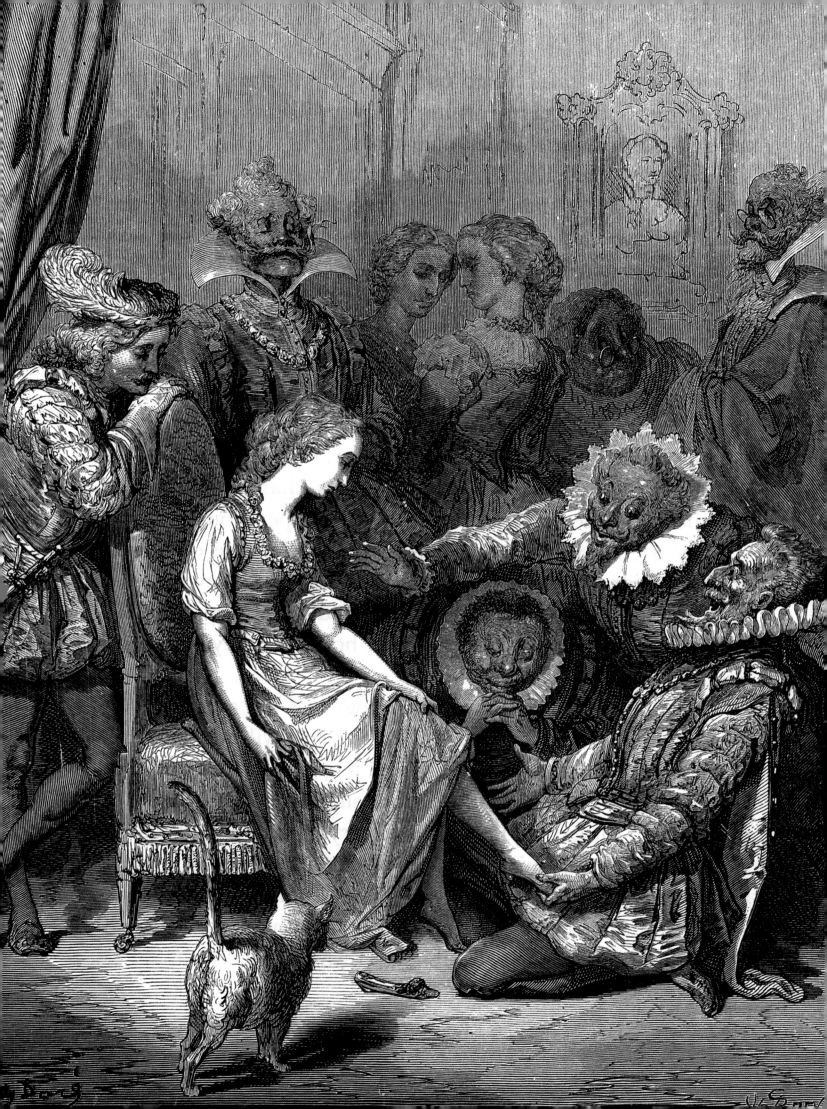

When a story corresponds to how the child feels deep down—as no realistic narrative is likely to do—it attains an emotional quality of "truth" for the child. The events of "Cinderella" offer him vivid images that give body to his overwhelming but nevertheless often vague and nondescript emotions; so these episodes seem more convincing to him than his life experiences.

— Bruno Bettelheim

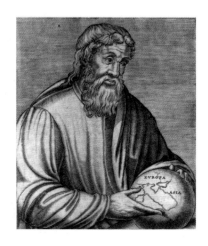

"Cinderella" is one of the oldest, most widely known and best-loved of all fairy tales. In 1893, British researcher Marian Roalfe Cox compiled 345 variations of the story. Since then, scholars have discovered even more versions, including dozens from China and Southeast Asia. In some stories, the heroine's wishes are granted by a black cow, a fish, a doll, a red calf, or a tree. Sometimes she attends two or even three balls, looking lovelier each night. A few center on mistreated boys. But in all of them, the degraded central character triumphs over the abusers.

The oldest known version of the story appears to be the tale of the slave Rhodopis, "The Egyptian Cinderella," which the Greek writer Strabo recorded during the first century B.C.E. It centers on a lovely Thracian slave who is treated harshly by the other servants in the house of her Egyptian master. When he sees her dancing, the master gives Rhodopis a pair of gilded slippers. The other serving-women prevent Rhodopis from attending a festival held in Memphis by Pharaoh Ahmose II. But a falcon, the symbol of the god Horus, takes one of her slippers and drops it in the pharaoh's lap. Recognizing it as an omen, Ahmose declares he will marry the girl whose foot fits the slipper. When he finds Rhodopis, she tries it on—and shows him the object's mate.

Strabo's heroine may be based on an earlier figure. Almost five centuries prior, the Greek historian Herodotus had written about a beautiful Thracian hetaera named Rhodopis, who was taken to Egypt during the reign of Pharaoh Amasis (570–536 B.C.E.).

11

More of the familiar elements of the "Cinderella" story appear in the Chinese tale of Ye Xian, which appears in the *Yu Yang Tsa Tus* (*Miscellany of Forgotten Lore*), written by the scholar Duan Chengshi in the mid-ninth century. The title character is abused by her cruel stepmother, who makes her draw water, cut wood, and perform various other chores.

One day, Ye Xian finds a tiny fish with golden eyes; she feeds it food scraps and keeps it in a succession of bowls as it grows larger and larger. Finally, she moves it to the pond behind the house. When her stepmother discovers the beautiful fish, she kills and eats it out of malice, then hides its bones. But a stranger tells Ye Xian where to find the bones and to hide them in her room. If she prays to them, her wishes will be granted.

Despite her stepmother's and stepsister's objections, Ye Xian appears at a festival in splendid clothes (including a cloak of blue kingfisher-feathers and tiny golden shoes) that the fish magically provides when the girl prays to it. When Ye Xian later flees to escape her family's notice at the festival, she loses one of the shoes, which is as light as down and makes no noise, even when she walks over gravel in them. The king sees it and undertakes a search for the maiden who can wear it. When he finds Ye Xian, he marries her, and buries the bones of the fish with great ceremony. (Some scholars have seen a link between the tiny golden slipper and the practice of foot binding, although the tale seems to predate the widespread practice of deforming women's feet.)

The story apparently arrived in western Europe centuries later: there are references to a sermon delivered in Strasbourg in 1501 that mentioned it. The sixteenth-century French nobleman and author Bonaventure des Périers published a story containing elements of both "Cinderella" and the related fable "Donkey Skin" ("*Peau d'ane*") in *Nouvelles récréations et joyeux devis* (*New Amusements and Cheerful Conversations*) in 1558. The Neapolitan poet and courtier Giambattista Basile included "The Cat Cinderella" in *Il Pentamerone*, an early collection of folktales derived from oral sources, which was published posthumously in two volumes in 1634 and 1636.

In Basile's tale, Zerzolla, the daughter of a widowed prince, persuades her father to marry her governess, who has been very kind to her. But once she becomes her stepmother, the woman and her six daughters mistreat Zerzolla, changing her name to La Cenerentolla—the Italian equivalent of Cinderella. When her father returns from a trip, he brings her gifts from the fairies: a date tree, a hoe, a golden bucket, and a silk napkin. Zerzolla cares for the tree, and a fairy emerges from it, telling her when she recites a special incantation before the tree, she will be dressed in finery.

Above:
A contemporary engraving of the sixteenth-century writer and folklorist Giambattista Basile, who published one of the first European versions of "Cinderella."

Wearing increasingly lavish garments, Zerzolla attends three royal feasts. At the third, she loses one of her dainty slippers and the young king searches for its owner. At the next supper, the slipper darts on its own to Zerzolla's foot "like iron flies to the magnet." The king marries her while the stepsisters return home, unhappily recognizing their destiny.

Basile's story was published in the little-known Neapolitan dialect, which made it inaccessible to most readers. It wasn't translated into standard Italian for more than a century. When a German translation appeared in 1846, Jacob and Wilhelm Grimm, who had been collecting what they believed to be German stories from native sources, were surprised to find that "Cinderella" and other tales had been printed in Italy two centuries earlier.

The Brothers Grimm recorded one of the two versions best known to Western readers. In their retelling, the stepsisters, who dub the heroine *Aschenputtel* ("Ash Girl"), are "fair of face, but ugly and black in their hearts." When the father goes to a fair, they demand fine clothes and jewels, but Cinderella asks for "the first twig that brushes against your hat on the way home." She plants the twig on her mother's grave and waters it with her tears. It grows into a handsome hazel tree, where a white bird perches that grants Cinderella whatever she asks for from it.

When she wants to go to the royal festival, being held by the king who wants his son to choose a bride, the stepmother mocks Cinderella and empties a dish of lentils into the ashes, telling her she may go if she picks the lentils back out of the ashes in two hours. Cinderella calls to the birds in the garden, and they

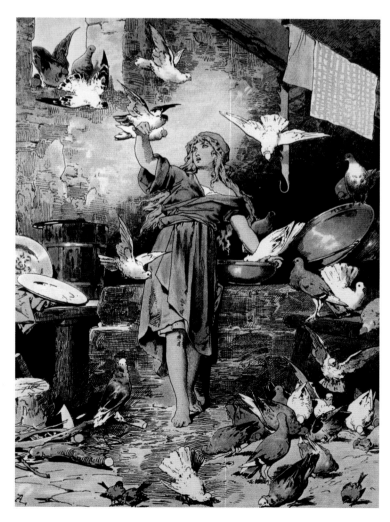

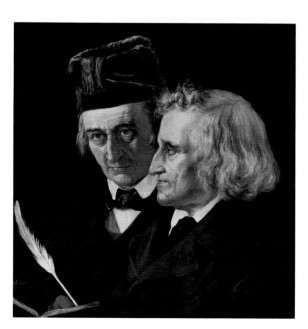

help her complete the task in half the allotted time. But the stepmother merely doubles the task, emptying two dishes of lentils into the ashes and challenging her to sort them in one hour. Again, the birds come to her aid and she accomplishes the chore in just half an hour. But when she displays the lentils to her stepmother, the woman simply goes back on her word and hurries off to the festival with her two daughters. Left alone, Cinderella goes to her mother's grave and pleads to the hazel tree, " . . . scatter gold and silver on me." The white bird presents her with a beautiful dress. She dazzles everyone at three balls, but loses a dainty slipper of solid gold at the last one.

When the prince comes looking for the mysterious girl, one stepsister cuts off her toe to fit into the shoe; the other, part of her heel. (The stepmother tells them, "When you become queen, you won't need to walk.") The prince is initially fooled, but the birds warn him that he has the wrong bride. In a grisly conclusion, the sisters come to Cinderella's wedding, where the birds peck out their eyes as punishment for their malice and treachery.

As is true of many fairy tales, the most familiar version of "Cinderella" appeared in Charles Perrault's *Histoires ou contes du temps passé* (*Stories or Fables of Times Past*), published in 1697. An aristocratic writer of exceptional taste and imagination, Perrault infused the story with delightful magical touches. He introduced the fairy godmother and the magic that turns a pumpkin into a gilded coach and mice into horses. There's no suggestion of these fantastic elements in earlier versions of "Cinderella," but once Perrault introduced them, they became essential features of the tale.

Perrault also added what generations of readers and filmgoers regard as the signature motif of the story: the glass slipper. Some folklorists believe that "glass" is a mistranslation. They argue that the author wrote *vair*, a blue-gray and white fur taken from the winter coat of a European red squirrel that was used to trim and line rich garments. The word was mistakenly rendered as the homophone *verre*, or glass. Most scholars agree that Perrault intended glass, and the impossible beauty of a glass shoe fits into the magical world he describes. Even if Perrault envisioned Cinderella dancing in fur shoes, the glass slippers have become so strongly identified with his heroine, she will continue to wear them as long as the tale is read, filmed, or recited.

Significantly, his Cinderella does not ask for a gown or to go to the ball but is granted these gifts because she deserves them. At the end of Perrault's story, the stepsisters throw themselves at Cinderella's feet and beg her forgiveness—which she graciously grants. She gives them lodgings at the palace and marries them to "Great Lords of the Court."

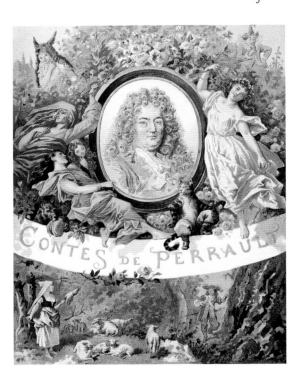

Above:
Frédéric Théodore Lix's frontispiece for a volume of Charles Perrault's fairy tales (circa 1890) features an image of the author based on a seventeenth-century portrait.

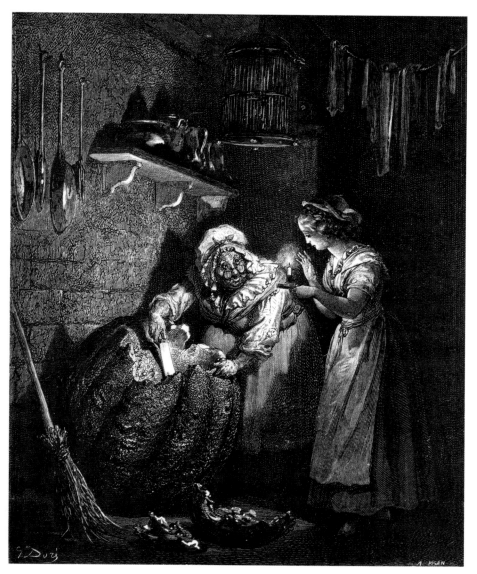

Psychologist Bruno Bettelheim criticized Perrault for this ending: "It does not seem fitting to the child that Cinderella's evil sisters should go scot-free, or even be elevated by Cinderella. Such magnanimity does not impress the child favorably, nor will he learn it from a parent who bowdlerizes the story so the just and the wicked are both rewarded. The child knows better what he needs to be told."

But Bettelheim argued that "Cinderella" was popular because it addressed deep, unhappy feelings: "No other fairy tale renders so well as the 'Cinderella' stories the inner experiences of the young child in the throes of sibling rivalry, when he feels hopelessly outclassed by his brothers and sisters. . . . Exaggerated though Cinderella's tribulations and degradations may seem to the adult, the child carried away by sibling rivalry feels, 'That's me; that's how they mistreat me, or would want to; that's how little they think of me,' . . . When a story corresponds to how the child feels deep down—as no

15

realistic narrative is likely to do—it attains an emotional quality of 'truth' for the child."

In recent years, feminist critics have complained about the absence of mothers in the Disney animated features and the fairy tales that they were based on. And yet a child without a mother (or both parents) is a character who must define himself. No one leaves a comfortable home to embark on a voyage of self-discovery. If Cinderella's mother and/or father had lived, her happy upbringing and marriage to a good man chosen by her loving parents would have been a crashing bore that no one would care to read about. There's no conspiracy against mothers, but a proven literary formula that spans myths, fairy tales, and novels dictates that a motherless child has to make his own way in the world.

The repellant figure of the stepmother allows a child to resent his mother when he's punished and adore her as the fairy godmother when he's given what he wants. As Bettelheim explained, "So the typical fairy-tale splitting of the mother into a good (usually dead) mother and evil stepmother serves the child well. It is not only a means of preserving an internal all-good mother when the real mother is not all-good, but it also permits anger at the bad 'step-mother' without endangering the goodwill of the true mother who is viewed as a different person."

But the character of the stepmother also reflects a social reality: when Perrault and the Brothers Grimm published their versions of "Cinderella"—and during the previous centuries when it circulated as a folktale—women often died young, largely due to complications tied to childbirth. It was common for widowers to remarry. Evidence suggests that 80 percent of the widowed men remarried within a year of their wives' deaths in seventeenth- and eighteenth-century France. Many children grew up with stepmothers and stepsiblings.

As British author and historian Marina Warner notes, "When a second wife entered the house, she often found herself and her children in competition—often for scarce resources—with the surviving offspring of the earlier marriage, who may well have appeared to threaten her own children's place in their father's affection too."

Cinderella's mistreatment may represent an extreme case, but her basic situation was familiar to many children who heard the tale by the fire. And to listeners in any situation, the tale of an unjustly mistreated girl who finds love, happiness, and riches without sacrificing her innate kindness, modesty, and integrity proved irresistible. Instead of stooping, Cinderella rises to conquer.

16

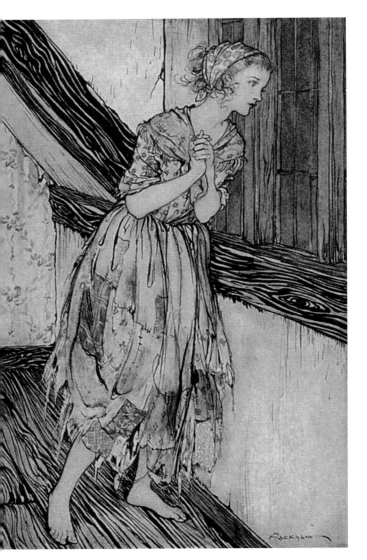

Above:
Arthur Rackham's delicate 1919 illustration suggests the pathos of Cinderella's plight without sliding into sentimentality.

A Multimedia Princess

Ce que l'on voit dans cet écrit, (What one sees in this story,)
Est moins un conte en l'air que la verité même. (Is less a tale than the truth itself.)
— Charles Perrault

Given the popularity and widespread distribution of "Cinderella," it's not surprising that the story has been illustrated, staged, set to music, and filmed countless times. These retellings reflect where and when they were created, sometimes with unintended comic results. In a Romanian Marxist revision from 1950, the king rejects the prince for wanting to marry the commoner Cinderella, and then reveals that when he needed an heir, he adopted a working-class boy and raised him in luxury. The prince replies he never liked the king and marries Cinderella in a burst of class solidarity.

The oldest extant illustration of "Cinderella" is an engraving by an unknown artist in sixteenth-century Nuremberg. The heroine kneels by the hearth, weeping as she tries to sort out the lentils her stepmother dumped into the ashes. Since then, every major fairy-tale illustrator and many fine artists have turned their imaginations to Cinderella, placing her in different centuries and settings.

For an edition of *Les contes de Perrault* (*Perrault's Tales*) published in 1867, Gustave Doré portrayed Cinderella, the

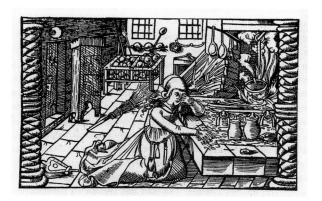

Above:
This engraving by an unknown artist from sixteenth-century Nuremberg (now a part of Germany) is the earliest documented illustration of "Cinderella."

Right:
Cinderella dazzles the courtiers at the ball. Although many illustrators set the story in eighteenth-century France, Gustave Doré's engraving suggests sixteenth-century Spain.

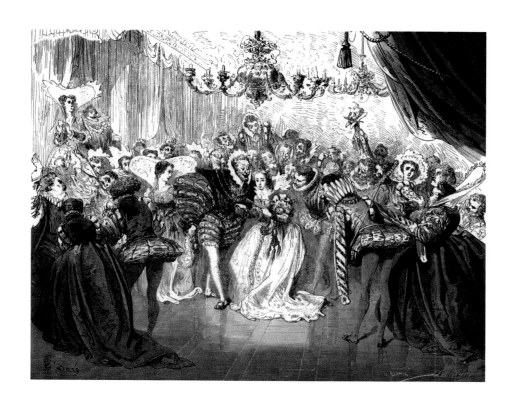

Near right:
Sir Edward Burne-Jones's painting of Cinderella (from 1863) shows her standing before a cabinet filled with Chinese porcelain.

Far right:
Four years later (1867), Walter Crane placed Cinderella in a similar setting, but the playing card motifs on the prince's jacket give the picture a more playful tone.

Opposite:
Edmund Dulac's watercolor (done in 1910) suggests the magic of the moonlit night as Cinderella speeds to the ball.

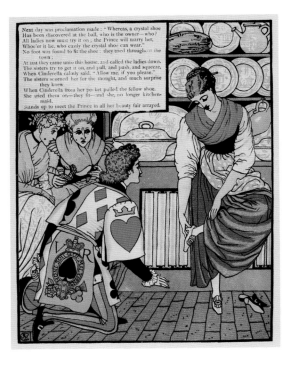

Below:
The elaborate costumes in this illustration by Frédéric Théodore Lix (circa 1890) show the influence of Peter Paul Reubens.

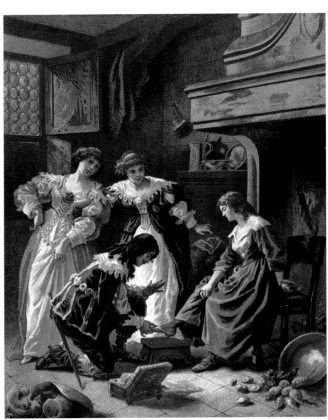

prince, and his court in elaborate sixteenth-century Spanish ruffs and collars. The illustrations by nineteenth-century French artist Frédéric Theodore Lix (1830–1897) evoked the rich satins, ribbons, and laces of Flemish Baroque painter Peter Paul Rubens's canvases of the seventeenth-century French court.

Pre-Raphaelite painter and designer Sir Edward Burne-Jones (1833–1898) painted Cinderella standing by a cabinet of fashionable blue-and-white Chinese porcelain in 1863. The watercolor is now on display in the Boston Museum of Fine Arts. Illustrator Walter Crane (1845–1915) used a similar cabinet (and similar china) as a backdrop in an illustration of the tale published in London in 1875. The prince who watches this Cinderella put on her lost slipper wears a jacket decorated with playing card motifs, as if he were the Jack of Hearts.

The celebrated illustrator Edmund Dulac (1882–1953) suggested the character's consummate grace in his delicate 1910 watercolors for *The Sleeping Beauty and Other Tales from the Old French*; British cartoonist and illustrator Charles Folkard (1878–1963) focused on the stepsisters' elaborate Edwardian frocks for a book of Grimm's fairy tales published a year later. Irish arts and crafts artist Harry Clarke (1889–1931) drew Cinderella in an elaborately stippled dress and high eighteenth-century coiffure that reflected the influence of Aubrey

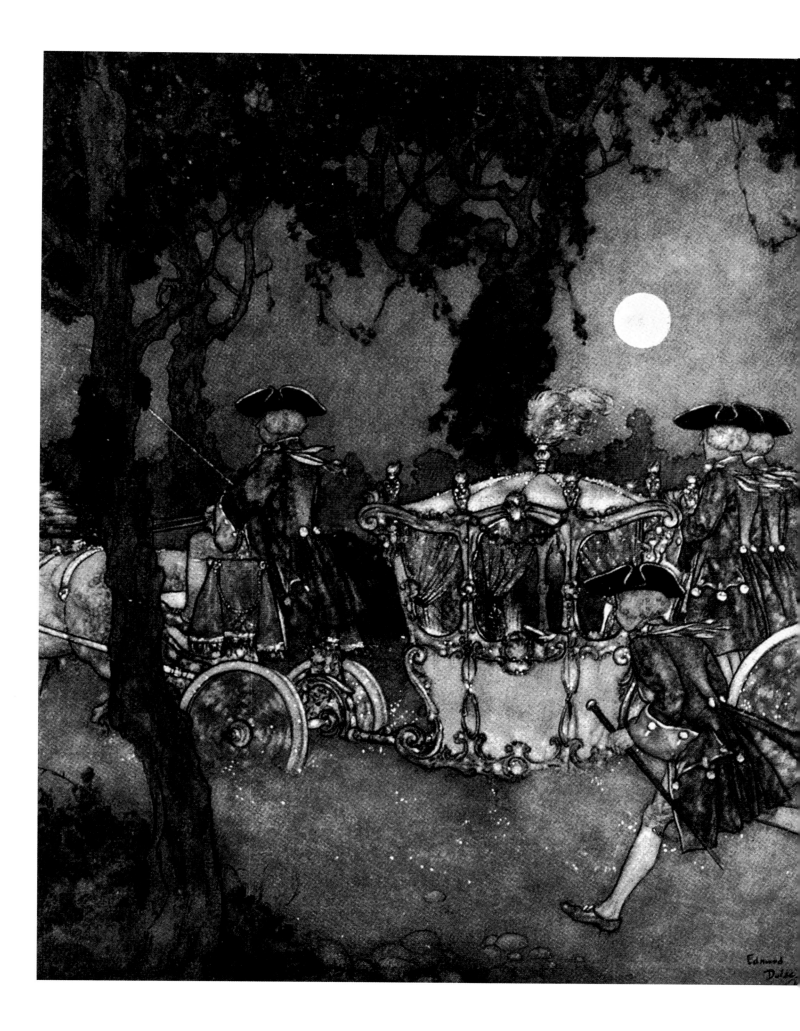

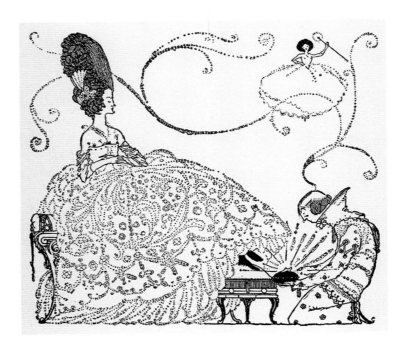

Right:
The stippled costumes and rigid poses in Harry Clarke's 1922 illustration reflect the influence of Aubrey Beardsley.

Below left:
Charles Folkard gave Cinderella's stepsisters fussy, Edwardian dresses.

Below right:
The fabric of Cinderella's gown floats with an art nouveau grace in Arthur Rackham's delicate 1913 illustration .

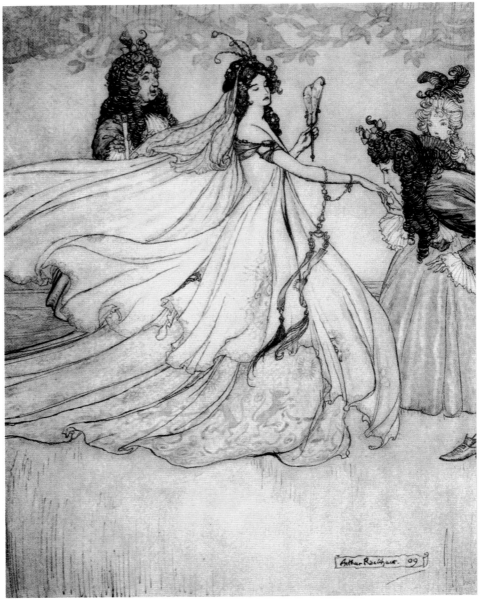

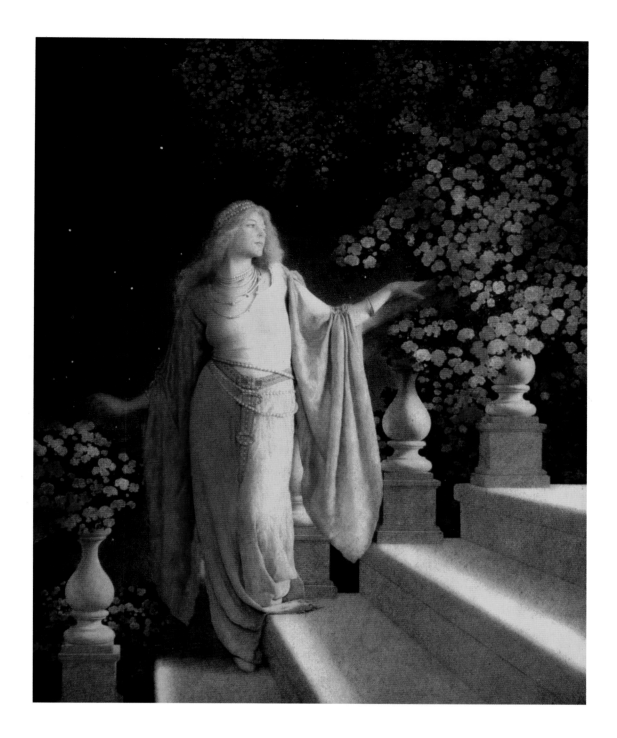

Beardsley's illustrations to Alexander Pope's poem "The Rape of the Lock." British illustrator Arthur Rackham (1867–1939) painted fragile watercolors that suggest a more graceful eighteenth-century setting for a book published in 1919.

American painter and illustrator Maxfield Parrish (1870–1966) bathed Cinderella in opulent, golden light as she paused on a classical staircase in a 1913 oil painting. American author-illustrator Johnny B. Gruelle (1880–1938), who wrote the Raggedy Ann stories, drew black-and-white figures for children to cut out and enact a play of "Cinderella" that Carolyn Sherwin Bailey wrote for *McCall's* magazine in 1911.

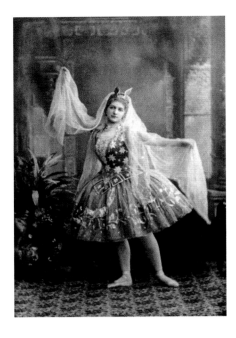

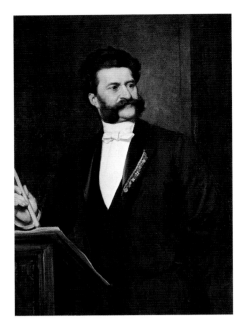

Near right:
Maria Anderson as the fairy godmother in the ballet *Cinderella*, composed by Boris Fitinhoff-Schell in 1893. Photographer unknown.

Far right:
Portrait of Johann Strauss, the Younger by August Eisenmenger, oil on canvas, 1888.

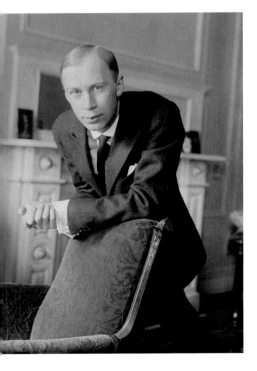

Above:
The Russian composer Sergey Prokofiev, circa 1918. Photographer unknown.

Other artists took Cinderella off the printed page and into the realm of the performing arts. There are records of "Cinderella" ballets dating back to 1813 in Vienna, although none of them have attained the status of the great Pyotr Ilyich Tchaikovsky fairy-tale ballets. Composer Boris Fitinhoff-Schell's lavish "Cinderella" debuted at the Imperial Mariinsky Theatre in St. Petersburg, Russia, in 1893.

The subject for the ballet *Aschenbrödel* (*Cinderella*) by Johann Strauss II was chosen in a contest organized by the editor and the music critic of the magazine *Die Waage* (*The Weighing Scales*). Composer Josef Bayer completed it after Strauss died in 1899; it premiered in 1901 at the Berlin Royal Opera—as composer-conductor Gustav Mahler rejected it for the Vienna Court Opera.

Sergey Prokofiev's *Cinderella* (1945) ranks among the most popular ballet scores of the twentieth century, and has been choreographed in Russia, England, and America. He worked on it for five years, setting it aside while he composed the opera *War and Peace*. The music juxtaposes lush romanticism with comedy and satire.

Since the 1810 premiere of Maltese composer Nicolas Isouard's *Cendrillon*, an opera comique with spoken dialogue, there have been four more "Cinderella" operas, all of them based on Charles Perrault's story and interpretation. To provide inspiration while he was composing *Cendrillon* (1899), Jules Massenet reportedly withdrew to a seventeenth-century house in France's Normandy region. His melodic opera features an elaborate tableau in act 3 where Lucette/Cinderella and the prince sing to each other in an enchanted arbor attended by fairies.

A bumbling stepfather replaces the evil stepmother in chamber comic *Cendrillon* (1904) by the French mezzo-soprano, teacher, and composer Pauline Viardot. At the time of its premiere, there was speculation that she had written it with her friend (and possibly lover) Ivan Turgenev. *La Cenicienta* (1966), by Chilean composer Jorge Peña Hen, is one of the few operas designed to be performed entirely by a cast of children.

However, the most celebrated operatic interpretation of "Cinderella" is Gioacchino Rossini's *La Cenerentola ossia La bontà in trionfo* (*Cinderella, or Virtue Triumphant*). Rossini reportedly wrote the opera, first performed in 1817, in three weeks, shortly after *The Barber of Seville*. The wicked stepfather, Don Magnifico, takes the place of the stepmother, and Cinderella is recognized not by her slipper but by a bracelet. (Historians speculate that a bracelet would have mollified the Roman censors who might have objected to displaying a woman's bare foot onstage.)

When it was harshly criticized at its premiere, Rossini reportedly told his grieving librettist Jacopo Ferretti, "Fool! Before carnival ends everyone will be in love with it; and within a year it'll be sung from one end of the country to the other." His predictions proved true.

Cinderella debuted as a pantomime at the Drury Lane Theatre in London in 1904, the same year as the premiere of the first musical comedy in America: stage and film composer Louis F. Gottschalk's *Cinderella and the Prince, or The Castle of Heart's Desire*. Richard Rodgers and Oscar Hammerstein II composed their version for a CBS-TV production in 1957 starring Julie Andrews: an estimated audience of more than one hundred million watched the broadcast. Their "Cinderella" was remade for television in 1965 with Lesley Ann Warren and again in 1997 with Brandy Norwood. A revised version of the show debuted on Broadway in 2013.

Cinderella is one of the many fairy-tale characters Stephen Sondheim and James Lapine brought together for the Broadway show *Into the Woods* (1987). Originally played by Kim Crosby, she sings the musical's most famous song, "No One Is Alone," to Little Red Ridinghood, joined by the baker and his wife.

There have been scores of live-action "Cinderella" films. One of the earliest was made in

Below:
Poster for the opera *Cendrillon*, composed by Jules Massenet in 1899. Lithograph by Émile Bertrand for the Théâtre National de l'Opéra-Comique, Paris.

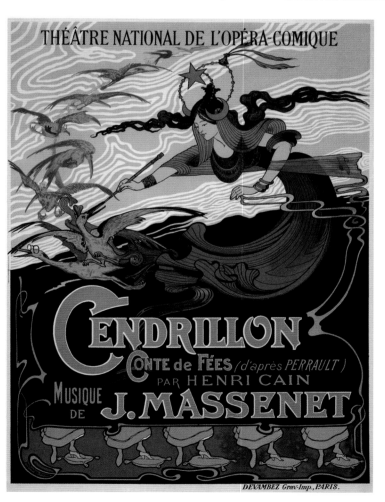

THÉÂTRE NATIONAL DE L'OPÉRA-COMIQUE

CENDRILLON
CONTE de FÉES *(d'après PERRAULT)*
PAR HENRI CAIN
MUSIQUE DE J. MASSENET

DEVAMBEZ Grav-Imp.,PARIS.

1898 by British special effects pioneer George Albert Smith. George Méliès filmed the story twice: *Cinderella Up-to-Date* (1909) and 1912's *Cendrillon ou la pantoufle merveilleuse* (*Cinderella or The Magical Slipper*).

"America's Sweetheart," Mary Pickford, took the title role in a silent 1914 *Cinderella*, opposite Owen Moore. *A Kiss for Cinderella* (1925), based on the play by J. M. Barrie, starred Betty Bronson—whom Barrie had chosen to play his most famous character, Peter Pan, in a film made the previous year.

In addition to the more straightforward retellings, there have been numerous musical adaptations, usually tailored to the heroine's talents: Deanna Durbin sang as the Cinderella-esque heroine of *First Love* (1939); Leslie Caron danced through Paris as Ella, a modern Cinderella, in *The Glass Slipper* (1955).

In 1976, Robert and Richard Sherman, who had written the songs for *Mary Poppins*, collaborated on *The Slipper and the Rose: The Story of Cinderella*, with Gemma Craven as the heroine and Richard Chamberlain as Prince Edward.

Some adaptations have strayed further from the original. A magic pair of shoes enabled Kelly Carter (Jennifer Grey) to appear as supermodel Prudence—and win the affection of fashion designer Francesco Salvitore (Rob Lowe) in *If the Shoe Fits* (1990). In the short *Cinderella's Love Lesson* (1953), burlesque star Lili St. Cyr stayed too long at the ball and her lavish costume disappeared. Any rags-to-riches tales, from the original *Rocky* (1976) to *Pretty Woman* (1990) is invariably referred to as a "Cinderella story" (although a film about an über-rich businessman falling for a high-priced call girl seems very far from Perrault's account of virtue rewarded).

There have also been a number of animated Cinderellas over the decades. Tex Avery lampooned the tale in *Cinderella Meets Fella* (Warner Bros., 1938), though he made a faster, funnier send-up at MGM seven years later: *Swing Shift Cinderella* (1945), with Red, the sexy nightclub chanteuse who appeared in many of his wartime shorts, in the title role. When she calls her fairy godmother for help, the old girl's in a bar, slapping back an outsized drink. A lecherous wolf pursues Red around a Hollywood nightspot while the libidinous godmother soon arrives and chases after the wolf. But Red has to flee the scene completely at midnight—to change into coveralls and a welding mask for her shift at the aircraft factory.

Canadian author-animator Janet Perlman earned an Oscar nomination for her hilarious spoof, *The Tender Tale of Cinderella Penguin* (1981), which featured such absurd touches as a medieval *licorne* tapestry with a penguin and

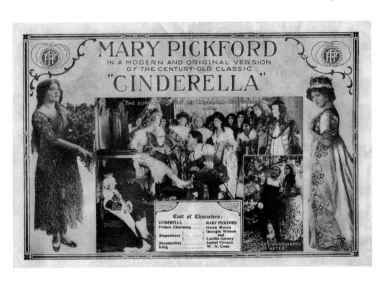

Above:
Poster for the film *Cinderella* (Famous Players Film Company silent, 1914), featuring Mary Pickford in the lead.

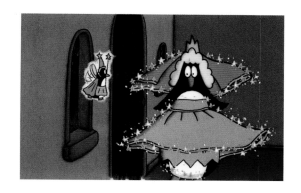

a glass slipper shaped like a swim flipper—to fit a webbed foot. The American TV animation studio Rankin/Bass Productions included "Cinderella" in their Festival of Family Classics animation series (1972) on ABC.

The story has been animated several times in Japan. *Cinderella Monogatari* (*The Tale of Cinderella*, 1996) stretches the story into a twenty-six-episode TV series that suggests a combination of the traditional fairy tale and Mark Twain's *The Prince and the Pauper*. Additional Japanese retellings appeared in the series *Grimm's Fairy Tales*, *Famous World Fairy Tales*, and *Hello Kitty*.

Poor Cinderella, from the New York-based Fleischer Studios, with Betty Boop in the title role, ranks as the oddest cartoon. Under pressure from Paramount to duplicate the success of Disney's Silly Symphonies, the Fleischer brothers began their "Color Classics" with *Poor Cinderella* in 1934. Betty dances with the prince at the palace while a caricature of Rudy Vallee sings through a megaphone. The two-strip cine-color process produced a weird spectrum of acid greens and harsh reds, and Betty's normally black curls have the color of pumpkin-pie filling. But the rubbery animation and the singing lizards, mice, horses, and pumpkin give *Poor Cinderella* an outré charm the other "Color Classics" lack.

And in 1922, an ambitious young cartoonist and his friends animated an updated version of the story in which the stepsisters read *Beauty Secrets* and *Eat and Grow Thin*, and the fairy godmother presents Cinderella with a jazzy modern car instead of the traditional pumpkin-coach. *Cinderella* was the last of the six Laugh-O-gram fairy tales Walt Disney produced in Kansas City, Missouri. More than a quarter of a century later, he would return to the story.

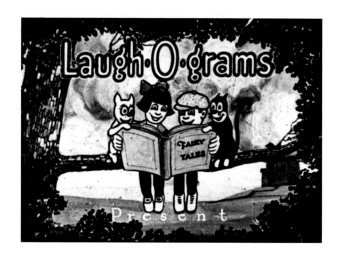

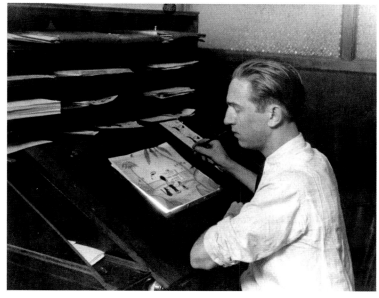

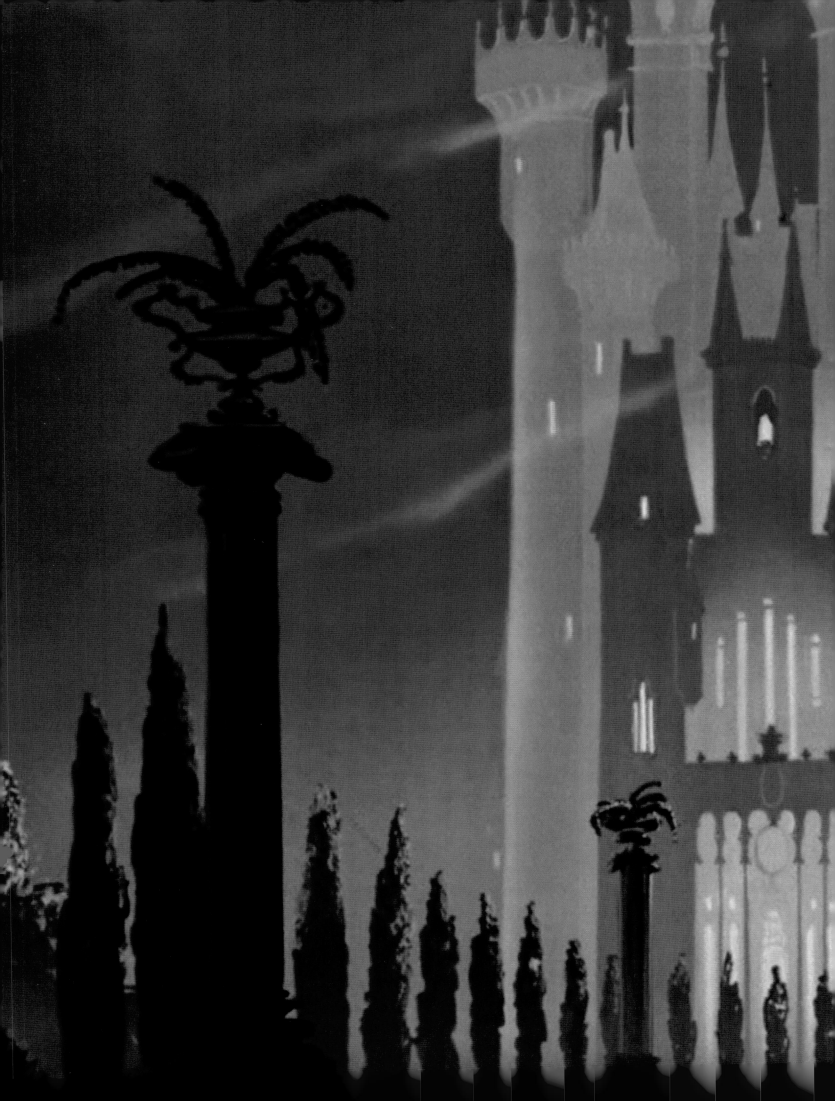

Part II
Walt Disney's Cinderella Story

I had too many interpretations of what Alice ought to be. Being a literary thing, it has an appeal to the intellect without anything to appeal to the emotions. Those things are a keg of dynamite. I don't want any more of 'em because I don't feel 'em myself either. I'm just corny enough I want to be hit right here in the heart. You pull for Cinderella. You feel for Cinderella.

— Walt Disney

Snow *White and the Seven Dwarfs* (1937), **Walt Disney's** first feature-length animated film, was both a critical and financial triumph. The film received rave reviews and earned over $8 million at the box office. (The Studio estimates that more people saw *Snow White* on its initial release than those who went to see *Star Wars* upon its theatrical opening in 1977.) However, although *Pinocchio* (1940), *Fantasia* (1940), and *Bambi* (1942) featured even more beautiful animation and more polished filmmaking than *Snow White*, they failed to duplicate its success. *Dumbo* (1941) made a small profit, but audiences didn't warm to the character of Pinocchio the way they had to the more vulnerable Snow White.

And the outbreak of World War II in 1939 was a further setback cutting off outright the European markets, which had been supplying almost 45 percent of the Studio's revenue at that point.

During the war, the Disney Studio became a de facto war plant, turning out thousands of training films for the U. S. Navy, as well as various government agencies. Walt also made a goodwill tour of Latin America (even before America's involvement in the war) and produced *Saludos Amigos* (1942) and *The Three Caballeros* (1944) at the behest of Nelson Rockefeller, Coordinator of Inter-American Affairs (CIAA).

The government policy of budgeting all training films at a modest profit, coupled with the revenue from the wartime entertainment features, erased the debts *Pinocchio*, *Fantasia*, and *Bambi* had incurred on their initial releases. In 1945, the Studio reported a net profit of over $50,000.

Pages 26–27:
A frame of the castle from the animated Disney feature.

Opposite:
A preliminary study of Cinderella and the Prince waltzing. Artist: Mary Blair; medium: watercolor and gouache.

29

After the war ended, the Studio underwent profound changes. Production of the cartoon shorts the Studio had been founded on was gradually phased out. Walt's attention shifted from animation to live action, nature documentaries, television, and Disneyland. "I wanted to diversify," he later said. "I wanted to set it up so that all my eggs were not in the cartoon basket. So I could fall on my nose with one picture but have another one right behind it that would be a hit."

But phasing out war production, rebuilding his staff as artists returned from military service, and returning to pure entertainment caused Disney to run up a debt of more than $4 million with the Bank of America. To keep the Studio going, he tried making films for various corporations in 1945, including Westinghouse, Texaco, Firestone, and General Motors. But Walt disliked taking orders from executives and quit making industrial films the next year. Budgeting measures had to be instituted at the Studio.

Disney needed a hit, but creating a new animated feature would require an effort of three to four years and a substantial budget. His solution was the so-called "package features," which could be made more quickly and cheaply than a regular feature: *Make Mine Music* (1946), *Fun and Fancy Free* (1947), and *Melody Time* (1948). Like *Fantasia*, they were collections of short, illustrated musical selections, although they lacked the innovative visuals. Perhaps in response to the criticism Walt had received for using classical music in *Fantasia*, the animation was set to songs by Benny Goodman, Dinah Shore, the Andrews Sisters, and other popular performers.

Audiences failed to embrace them. The package features performed indifferently at the box office and received lukewarm reviews, as did *The Adventures of Ichabod and Mr. Toad* (1949). The live-action/animation combination *Song of the South* (1946) earned a modest profit, but not enough to have much impact on the Studio's debt.

Disney's situation was growing desperate. He seemed to have lost both the big, general audiences that supported the Studio during the 1930s and the intellectuals and critics who had praised everything he touched as a work of genius. The Academy Award for Animated Short Film had largely been created to recognize his achievements, and Disney films had won nine of the first ten Oscars in that category. But now MGM and Warner Bros.—their cartoon studios founded by his former employees—were winning the awards. Walt needed a hit on the scale of *Snow White*.

Frank Thomas, one of the "Nine Old Men" and the animator of Cinderella's stepmother, recalled, "All the things that Walt had tried for seven years hadn't really gone over for one reason or another. He had to go back to something that was as surefire as he could make it: something like *Snow*

Above:
Animator Frank Thomas at work on *The Adventures of Ichabod and Mr. Toad*, circa 1948.

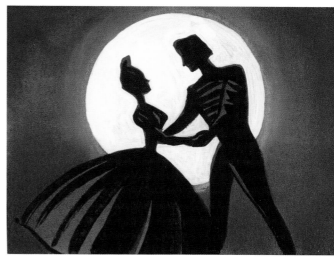

White—a pretty young girl in trouble, a fairy tale—and a popular one."

Disney decided to gamble everything he had on a single film, as he had on *Steamboat Willie* and *Snow White and the Seven Dwarfs*. The question was which film? His artists had already done extensive preproduction work on *Cinderella*, *Peter Pan*, *Alice in Wonderland*, and *Lady and the Tramp*. The discussions over which film to produce provoked unusually strong arguments between Walt and his brother Roy, who managed the Studio's finances.

"*Alice in Wonderland* never appealed to me as a property that would make a motion picture," Roy later said. "*Peter Pan* I was against for the same reasons. But Walt wouldn't shelve them."

After one intense, protracted discussion, Roy recalled, "I finally said, 'Look, you're letting this place drive you nuts, and that's one place I'm not going with you.' I walked out on him.

"I didn't sleep that night, and he didn't either," Roy added. "The next morning I'm at my desk, wondering what the hell to do. We were in a hell of a fix, tight payroll on our hands and everything. You don't worry about yourself; you worry about your commitments, your involvements.

"I felt awfully low. I heard his cough and his footsteps coming down the hall," Roy further recounted. "He came in, and he was [so] filled up, he could hardly talk. He says, 'Isn't it amazing what a horse's ass a fella can be sometimes?' And he walked out. That's how we settled our differences."

Walt put *Cinderella* into production, which proved an inspired choice. Like *Snow White*, it was a well-known, well-loved fairy tale with a sympathetic heroine—and a concise plot that offered the artists a chance to develop appealing, comic side characters.

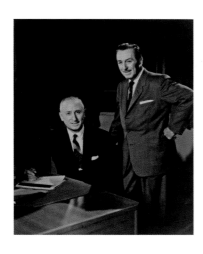

31

Transforming a Classic

Without the intrigue of the mice and the cat, you could tell the story in seven minutes.
It's also a well-known story: you couldn't add a hell of a lot to it, or your audience would
be ahead of you. Of course the girl's going to fit the glass slipper, but it has to look like
he's not going to get there. It's a well-worn fairy tale, just like 'The Three Bears,' but it
could build into an epic.

— *Cinderella* story artist Bill Peet

This page:
Conceptual studies of
Cinderella (above), the King
(below left), and the stepsisters
(below right), from 1940. Artist:
unknown; medium: pencil,
watercolor, gouache.

Although a few preliminary sketches exist for an unmade Silly Symphony of "Cinderella," the earliest feature treatment was prepared by January 30, 1940, by Studio inspirational artists Dana Coty and Bianca Majolie. In this version, set at the *Château de la Poche* (Castle of the Pocket), Cinderella has a cat (Bon Bon), a mouse (Dusty), and a turtle (Clarissa).

Dancing with Cinderella, Prince Charles makes fun of other women at the ball, saying the Marquise Bellondet "looks for all the world like an old mare prancing beside a raw-boned huckster's horse." They both laugh uproariously at these sallies. When Spink, the prince's agent, visits the château, the stepmother and stepsisters mockingly insist that the "dirty little servant girl" try on the slipper. When it fits, the fairy godmother returns to declare, "She is indeed a princess: crowned with kindness, humility, and truth. There can be no greater distinction in all the world than these three virtues."

Coty and Majolie kept Charles Perrault's ending, with Cinderella forgiving her nasty relatives. The treatment is most notable for the lovely watercolor sketches Majolie painted to accompany it.

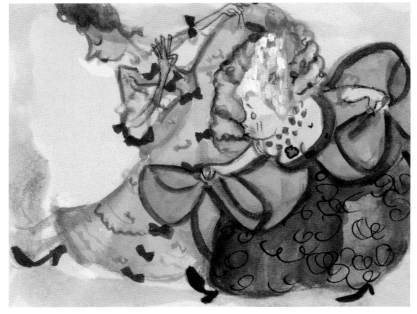

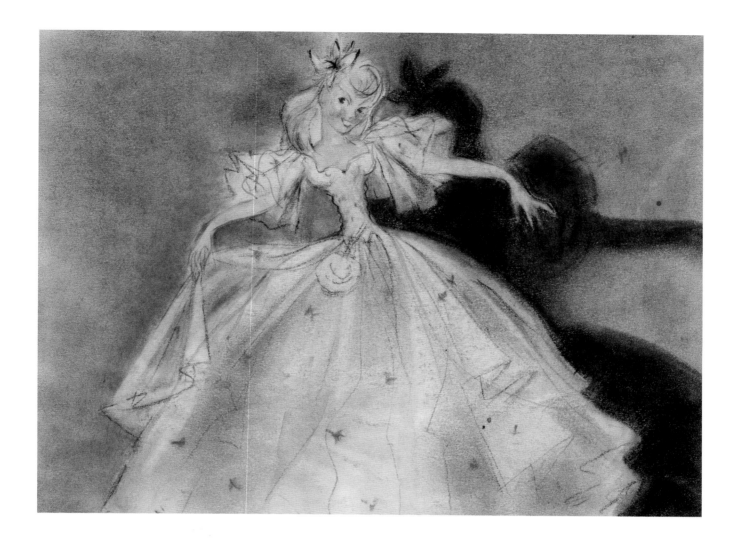

Above:
A preliminary painting of
Cinderella in her ball gown,
done in 1940. Artist: Bianca
Majolie; medium: pencil,
watercolor.

An uncredited draft dated September 1, 1944, features many more
side characters: a pompous "Actor Mouse" who anticipates Mr. Pricklepants
in *Toy Story 3*, Court Mouse, Troubadour Mouse, and Modiste Mouse (the
only female). The stepmother sends Cinderella to a gypsy camp to sell her
late mother's jewelry to help pay for the stepsisters' upkeep. At the camp, she
meets the prince in disguise—the sort of meet-cute that occurs in numerous
operettas. This version also features "Mystery Mouse": his magic locket sum-
mons the fairy godmother—who transforms Cinderella's rags without her
realizing it.

A slightly later draft (dated September 30, 1944) features a differ-
ent meet-cute when the prince arrives incognito at Cinderella's home in the
guise of an undistinguished traveler.

Story work continued over the next several years, with different artists
trying to find the right approach to the familiar story. Bill Peet, who did some
of the key story work on *Cinderella*—and many other Disney features—later
commented, "The personalities developed for an animated film should be
larger than life. In some cases, you can't do that because you're dealing with

33

a prince or princess or something else that has to be done with restraint. But the best characters are always larger than life—the Dwarfs, the mice, the ones that are *animatable*."

A treatment dated August 7, 1947, credited to story men Ted Sears, Homer Brightman, and Harry Reeves, takes place "in a small European kingdom in the early 1800s." It features twelve songs—twice as many as the final film would—including "I Saw You from Afar," "I Lost My Heart at the Ball," and "Philosophy Song" for a band of crows. This very talky treatment suffers from a plethora of barnyard side characters, including the crows and some hens. Cinderella communes with the spirit of her late father, and is preparing to run away when a fairy godmother appears.

Writer-producer Bill Walsh offered an odd, undated proposal. He planned to announce to the public that "Walt Disney would commission certain well-known composers to provide one song each for the 'Cinderella' score." He added, "A preliminary campaign, emphasizing the fact that only the finest living writers will be presented in the score, will make it easier to deal with the writers themselves."

Walsh's list of suggested composers included Jerome Kern (love theme), Cole Porter (comedy song), Igor Stravinsky (ballet), Irving Berlin (march), and Ira Gershwin (patter song)—hardly a group of unknowns who'd vie for the chance to contribute to a cartoon. Walsh apparently didn't realize that hiring these artists would probably have cost more than the film's total budget.

Walsh's treatment continues, "Almost every woman associates herself with the heroine . . . the little poor girl who somehow finds riches and a handsome husband." He proposed opening the film with a series of "light, satirical sketches" of five women from different walks of life preparing for bed: a "hard faced show girl" with a diamond necklace and a fat husband, a queen with a heavy crown, a charlady finishing a pint of beer, a psychology professor in horn-rimmed glasses and a frilly nightgown, and a wholesome working girl. The sandman puts them all to sleep, and "Cinderella" becomes their shared dream. At the end, the five woman wake up to mundane reality, repeating softly to themselves "happily ever after!" as the image dissolves to Cinderella and the prince riding off into the sunset to the love theme.

Brenda Chapman, the Oscar-winning director of *Brave*, recalls, "At the [Disney] Animation Research Library, I saw some old storyboards for *Cinderella*. It was very interesting, because she was whiny and complain-y in some of them. She was annoying! It was really a great exercise to see that even they went through bad versions before they got to the good ones. But boy, when they got to the good ones, they really got to them!"

Above:
Two early storyboard panels for Cinderella. Artist: unknown; medium: pencil.

Story, Story, Story

They made films that were more beautiful, and they made films that had better character animation or more memorable songs. But in terms of story, Cinderella *is at the very pinnacle of Disney adaptations.*

— The Incredibles *director Brad Bird*

Above:
Two storyboard drawings of the storybook in the opening of *Cinderella*. Artist: unknown; medium: pencil.

Below:
A final frame of Lady Tremaine walking up the tower stairs toward Cinderella's garret.

Most animation artists agree that *Cinderella* remains one of the finest examples of storytelling and story adaptation in the history of The Walt Disney Studios. As Bill Peet noted, everyone in the audience knows how the story will end before the film even begins. But it's presented with such skill and imagination that the viewer remains uncertain and excited.

"I knew the story even when I was little, but I was still on the edge of my seat because they upped the suspense," says Brenda Chapman. "When the stepmother walks up those stairs, locks her [Cinderella] in, then walks down, you think, 'Oh, my God, that's not supposed to happen!' That was a new twist to the story. The inventiveness they showed putting extra things in the story to add suspense was brilliant."

"It had an impact on me, most significantly in the area of storytelling," agrees Brad Bird, who won Oscars for *The Incredibles* and *Ratatouille*. "It grabbed the audience with authority, then kind of had its way with them."

Bird is effusive when he talks about the movie. "They did an extraordinary job taking a very familiar fairy tale and ramping up the suspense and the feelings of the audience in the way that they told the story. For me, it's the best of the Princess movies. Not because it was the most ambitious, which would be a toss-up between *Snow White* and *Sleeping Beauty*. Not because it was at a technical level that was extraordinary like *Sleeping Beauty*. But the story was the best adaptation. The last fifteen minutes is probably the best finale they ever did in any of their movies, because of the way they toy with what the audience knows, and gets invested in the slipper."

Up director Pete Docter adds, "The way they balance storytelling and great character moments in ways that further the plot is really inspiring. A lot of modern films go relentlessly from one plot point to the next. These artists knew they needed a simple story they could build

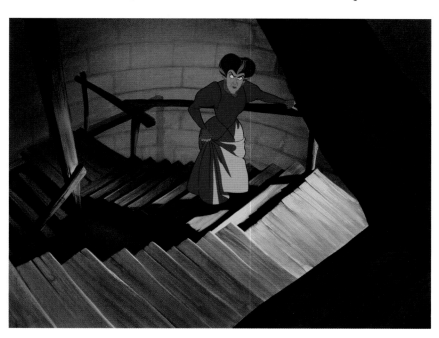

35

36

Right:
Mary Blair's inspirational sketch of Cinderella on the staircase. Medium: watercolor, gouache.

Below left:
A preliminary study of the staircase leading to Cinderella's garret room; the complex, distorted perspective reflects trends in contemporary art and stage design. Artist: unknown; medium: pencil, colored pencil.

Below right and opposite:
A layout drawing feels more solid (below right) and matches the final frame of Cinderella descending the stairs (opposite).

Pages 38–39:
Cinderella locked in her garret.

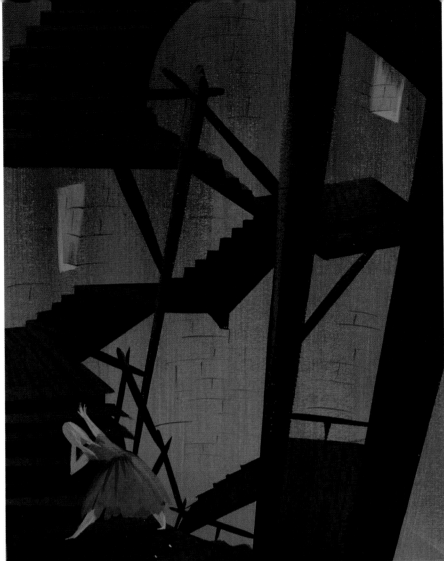

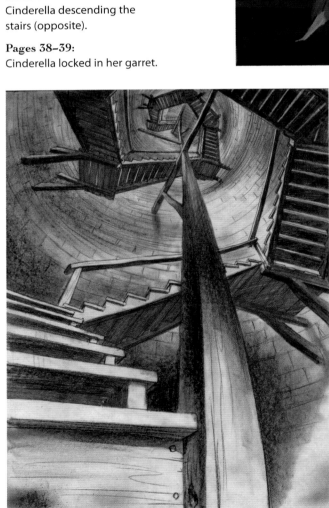

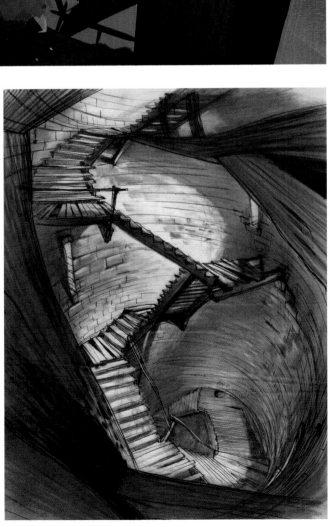

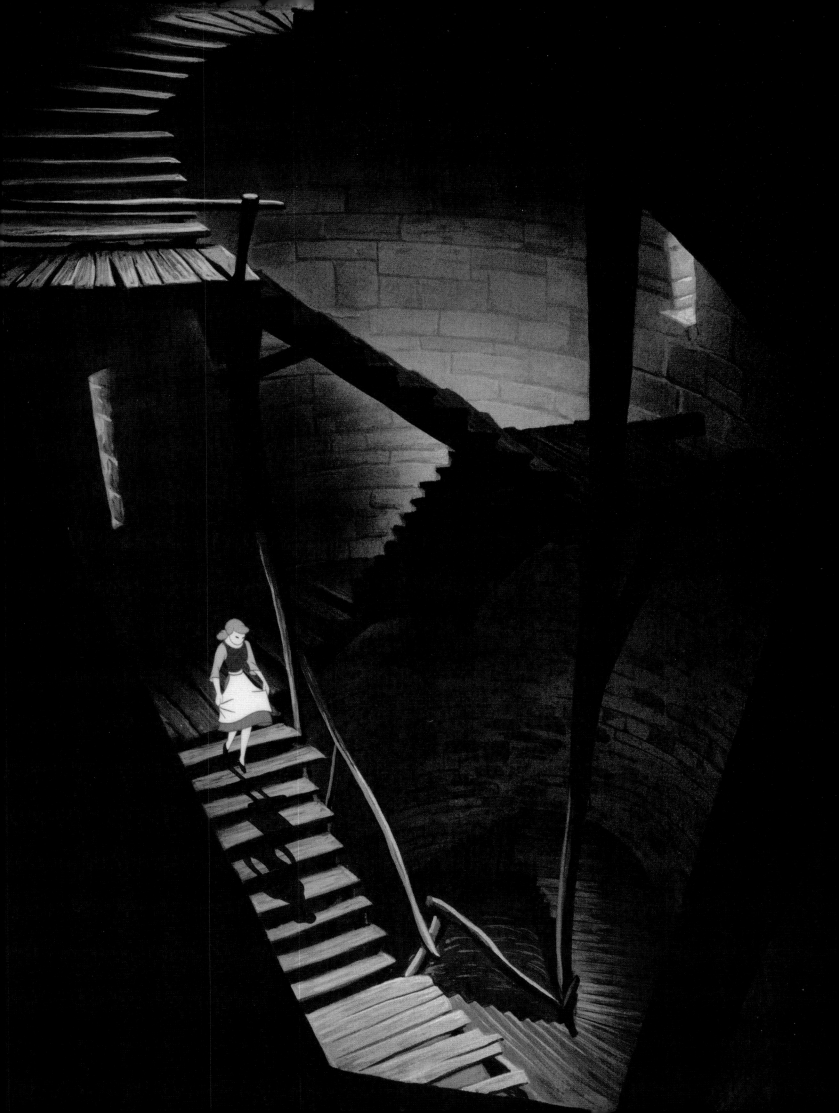

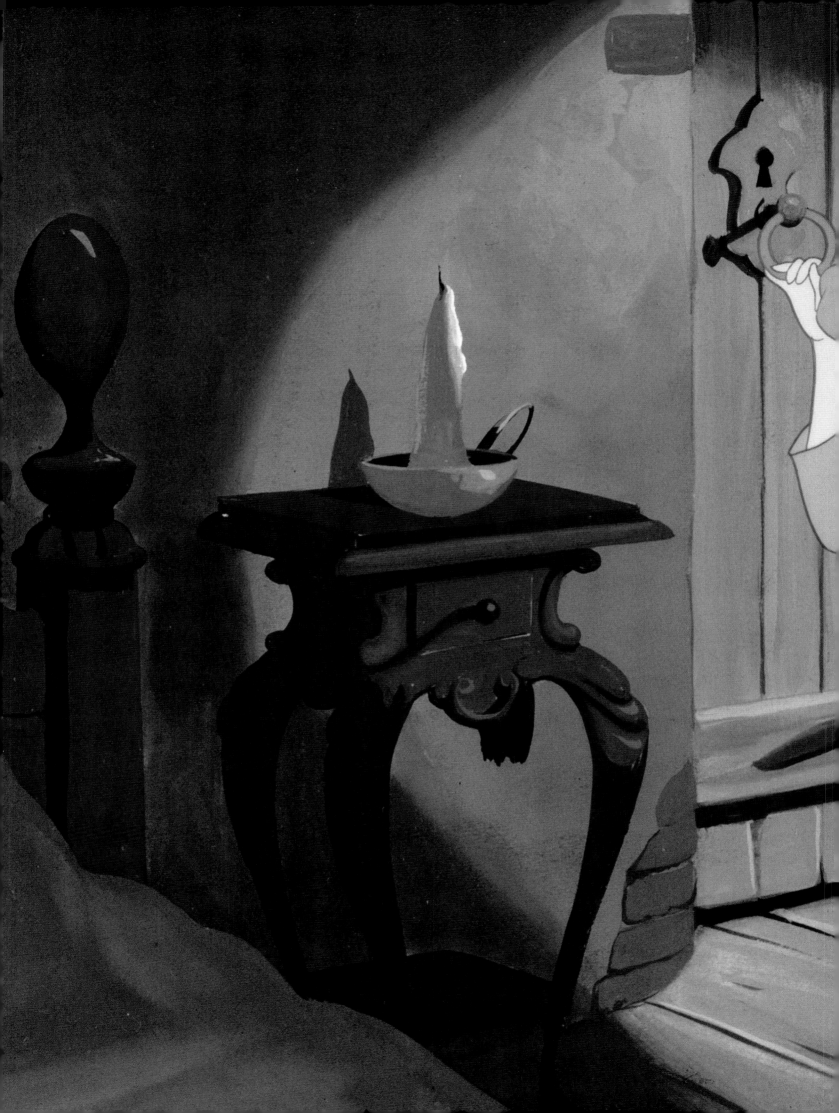

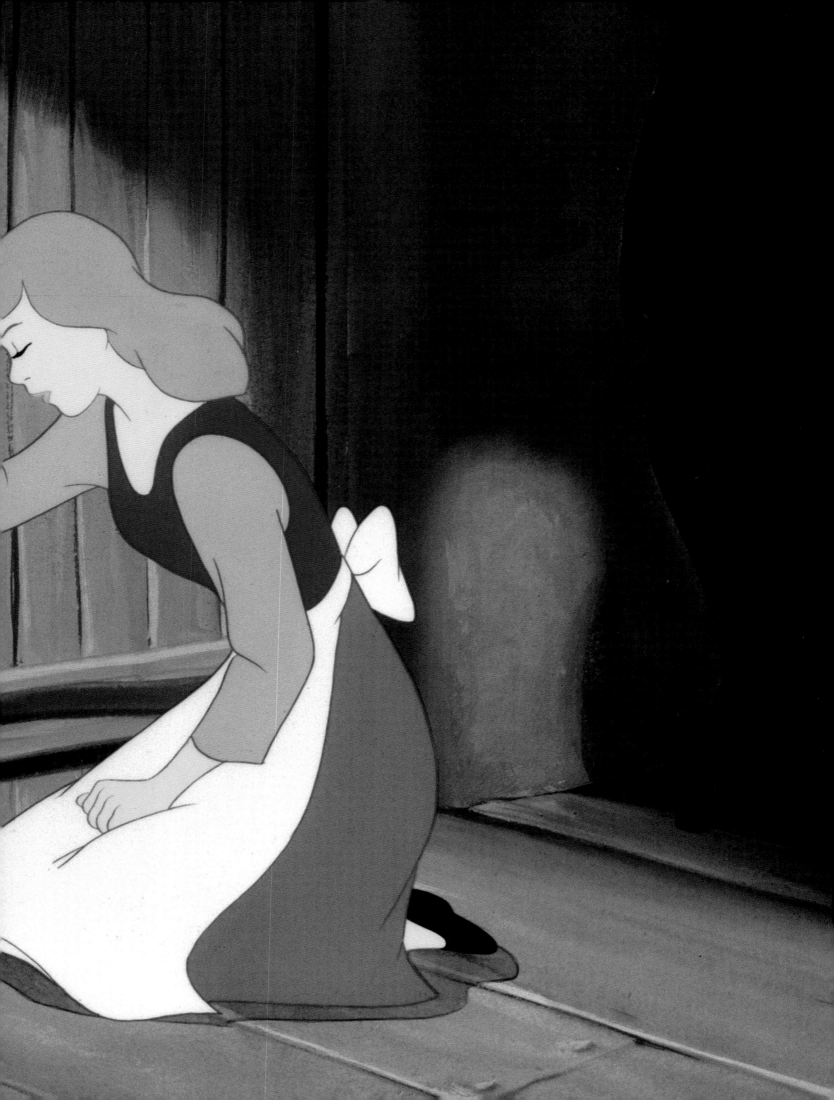

Above:
Walt Disney examines artwork for *Cinderella* in his office, circa 1949.

Below left:
Eleanor Audley, in costume as Lady Tremaine, confers with Rhoda Williams as Drizella (she also provided the character's voice) and Helene Stanley as Anastasia. Stanley was such a gifted performer, the artists had her enact two characters.

Below right:
Drizella, Lady Tremaine, and Anastasia prepare to leave for the ball in this final frame.

on with these great entertaining bits. It has this wonderful sense of rhythm and forward momentum, and it just accelerates so wonderfully."

"It's the master storyteller who takes a story that everybody knows, but keeps you on the edge of your seat," says John Lasseter, the director of *Toy Story* and *Toy Story 2*. "The little mice have to get the key out of her pocket—that's tough enough. Then they look up those stairs! That climax keeps you on the edge of your seat, but you're laughing because it's also funny."

As the story work on the film neared completion, Walt Disney decided to shoot as much of the film in live action as possible, and then use the resulting footage as a guide for the animators. The Disney artists had shot reference footage for earlier films, beginning with *Snow White*. Teenage dancer Marge Belcher (the future Broadway star Marge Champion) enacted many of the title character's movements. This process, known as rotoscoping, enabled artists to gain a better understanding of complex human movements by studying the film frame by frame.

In fact, much of *Cinderella* was filmed shot for shot, with costumed actors performing all the actions and gestures. Disney had never approached a film this way, which was an attempt to pre-edit the story, eliminating scenes that didn't work before the animators wasted precious time and money on footage that wouldn't make it to the final movie.

Ollie Johnston, another of the "Nine Old Men," recalled, "Walt decided we've got to do something we can do for a price, and we've got to know what we're doing all the way through it, so that we don't have to make a lot of changes.

"At the time," Johnston adds, "I was working with him on the train [for his yard in Holmby Hills]. He was talking about all the expenses, waiting for *Ichabod* to come out, and God, the Studio's always hanging on one picture. He turned to this: he just had no choice. He had to find some sure way."

Actors wearing wigs and costumes were filmed on minimal stages and platforms that represented locations in the film. Helene

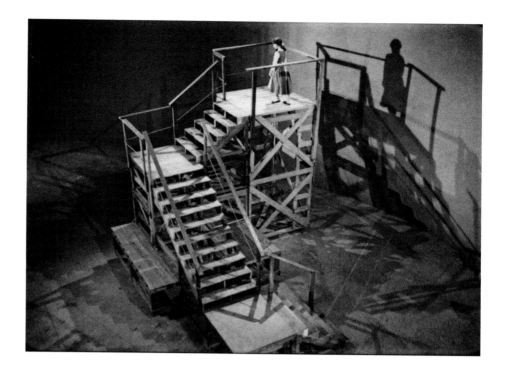

Stanley portrayed Cinderella. Eleanor Audley, who provided the voice for the stepmother and enacted the character, recalled with grim humor, "I'll never forget those stairs in *Cinderella*, when I had the key. I'm not kidding about being up in the rafters. I think there were two platforms, and they had steps up to God himself. I'm sure if I had said 'God' up there, He would have answered me."

The extensive live-action footage proved helpful—and educational. As the artists studied the printed photostats of the individual frames, they discovered that human movements were much more complicated and subtle than they had realized. The reference footage enabled them to discern tiny changes in the position of an eyebrow or the corner of a mouth, or how a person may unconsciously shift her weight from one foot to another.

But the animators also chafed at the restrictions on the staging and camera placement the live-action footage imposed. Frank Thomas said, "The reason for shooting it in live action was to be sure that everything worked, and it did. But as an animator, you felt that your feet were nailed to the floor. Anytime you'd think of another way of staging a scene, they'd say, 'We can't get the camera up there.' Well, you could get that shot with an animation camera!

"You had to go with what worked well, but it was a great choice to prove it with live action," Thomas concluded. "When the chips are down and you're out of money, you're going to put everything in a film that you know how to do. It proved a wise, wise choice."

Live Action and Animation

When people dismiss rotoscoping, I point to Cinderella *and say that's where it's done right. They used it for the movements and the expressions, but they didn't just trace it. They pushed things. I look at it and I know it's rotoscoped, but it doesn't feel rotoscoped.*

— Brave *director Brenda Chapman*

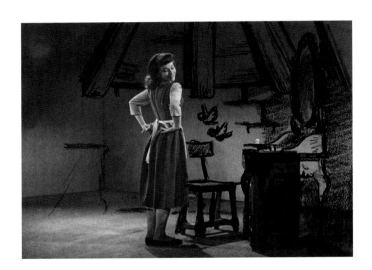 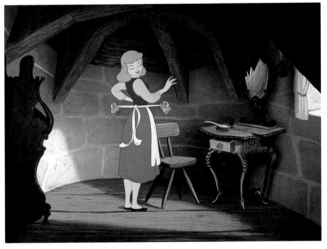

Above left:
Helene Stanley knots her apron string; the birds have been drawn in to suggest their place in the frame.

Above right:
In the finished film, the birds perform the task for Cinderella.

The Disney artists used the rotoscope for many of the later films, including *Alice in Wonderland, Peter Pan, Sleeping Beauty,* and *One Hundred and One Dalmatians.* In recent years, a new generation of artists has employed the tool on several films, including *Pocahontas* and *Mulan.*

Ruben Aquino, whose animation includes the realistic Shang in *Mulan* and David in *Lilo & Stitch,* explains, "It's harder to animate realistic humans without reference. Often, if we didn't have video reference, we would do our own. I remember doing scenes in *Oliver & Company* of Fagin; I would wear a trench coat and just act out stuff."

Right:
It fits . . . sort of. Helene
Stanley poses as the stepsister
Anastasia. Don Barclay, who
later appeared as Mr. Binnacle
in *Mary Poppins*, is the lackey.
A frame from the film shows
how the animators pushed the
poses and expressions.

"Disney used live action better than anybody else," says Dave Pruiksma, who animated Mrs. Potts and Chip in *Beauty and the Beast*. "When you look at Gulliver in the Fleischer Studios's *Gulliver's Travels*, it's very, very rotoscope-y. They didn't take much liberty with it at all. Maybe they did stick to the live action in *Cinderella*, but the personalities are there. They changed the proportions: if you didn't know it was derived from live action, you probably wouldn't suspect it."

The practice of using live-action reference has continued into the computer graphics (CG) era. For his comic animation of Spanish Buzz in *Toy Story 3*, Carlos Baena studied footage of flamenco dancers and bullfighters—and of himself. He recalls, "I had [fellow Pixar artist] Jaime Landes stand in the middle of the room, while I shot footage of myself playing with personal space and unexpected moves. A lot of the reactions I got from him are basically what Jessie ended up doing in those scenes."

Reflecting on the influence of *Cinderella*, *Pocahontas* codirector Eric Goldberg comments, "It appears the animators had a sliding scale as to how

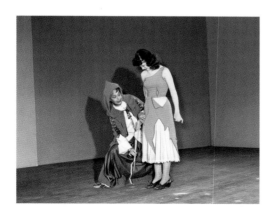

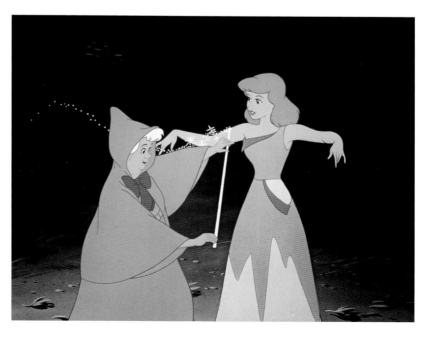

Above and right:
Claire Du Brey measures Helene
Stanley for her ball gown in this
reference footage (above). A
frame from the finished scene
(right).

43

44

much or how little to use the live-action material. For the more realistic characters like Cinderella and the stepmother, they used quite a bit of it; on the more caricatured characters like the stepsisters, they used it more loosely; and on the Grand Duke, Lucifer, and the mice, they used very little, if any. On *Pocahontas*, we knew we could apply a similar sliding scale to our characters."

Marc Davis, who was the lead animator on the character of Cinderella, believed that the live action offered important suggestions for the acting and helped to unify the animation. It's rare for a single artist to draw all of a character's scenes, so the live action can help ensure the consistency of the performance.

"I think *Cinderella* would have been a different film if they animated it from scratch," says Andreas Deja, who animated Gaston in *Beauty and the Beast*. "You change and adjust and retime, but the live actors give you the basic acting pattern. If you agree with that piece of acting, you're going to have a good time interpreting it in drawings. If you disagree, you might have to throw out the reference and start over.

"For characters with the degree of realism in the drawing and animation in *Cinderella*, it's a good thing," Deja continues. "The actors bring something to the table that you can look at and use your judgment. You don't start with a blank sheet of paper. The use of the rotoscope sped up the production of *Cinderella*. The old animators said they completed the rough animation in six months, which is incredible."

The opening sequence of Cinderella waking up, greeting the mice and birds, and preparing for another day of dreary chores immediately establishes her as an endearing and sympathetic figure. Eric Larson animated the sequence, although the drawings had to be adjusted when Davis made the character a little older and more graceful—what Larson later called "more the exotic dame."

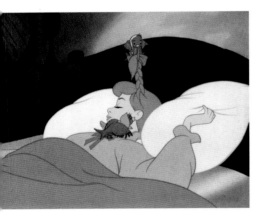

Above:
A frame of Cinderella waking up in her garret.

Below:
A storyboard drawing from the sequence suggests a somewhat younger heroine talking with a bluebird. Artist: unknown; medium: charcoal, pastel.

"Marc Davis had a big influence on Cinderella's appearance, and all the people who worked on her drew a lot better than fifteen years earlier on *Snow White*," commented Frank Thomas. "Marc insisted that everything be related mechanically, so for her head to be okay, the chin, the cheeks, all had to be in place."

Veteran Disney story man Burney Mattison, who worked with both Larson and Davis, comments, "Eric wasn't the draftsman Marc was, but the scenes of Cinderella when she wakes up and the birds sing with her were all Eric's. It's some of the loveliest animation of the girl in the picture. Eric had great feeling in his drawings."

In those opening minutes, Cinderella shows a sense of mischief and an emotional complexity many animated heroines lack.

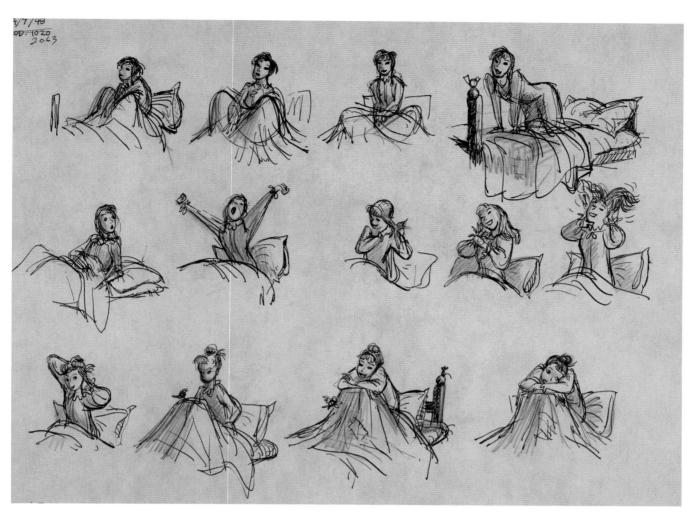

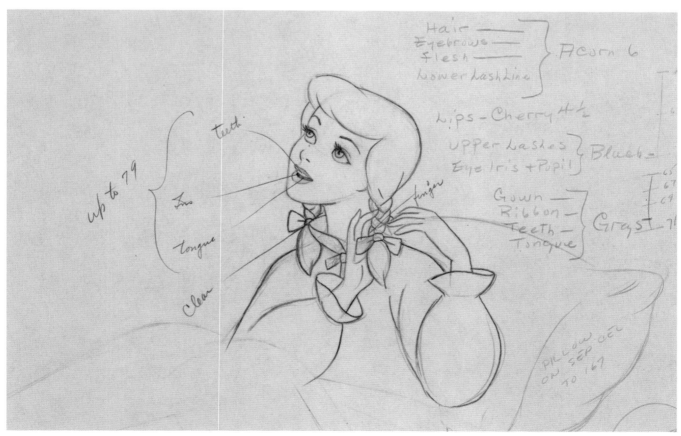

45

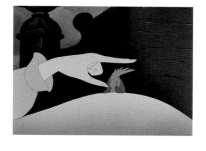

She walks her fingers along the edge of the bed and gives one of the birds a little boot in the rear for waking her. And when the clock strikes, sounding the time for her to begin her chores, she gestures impatiently, saying, "Even he orders me around." Throughout the film, she displays an emotional depth neither Snow White nor Princess Aurora can match.

"I always felt that Snow White was a bit on the cloying side. I appreciate the film very much, but she always struck me as a little too cutesy," says Brad Bird. "Aurora, even though she was gorgeous, was a bit of a cipher and could have used some of the relatability that Cinderella had in spades. For me, she's the most successful of all the Disney Princesses."

Reflecting on his own work, which includes the animation of Jasmine in *Aladdin* and Tiana in *The Princess and the Frog*, Mark Henn notes, "People ask me what made our generation's Princesses different from the earlier generation's. Our stories got a lot more complicated, and our girls were more integral to propelling the stories along. Snow White is largely reactive; things just kept happening to her. When things happen to Cinderella, you see a little more what's going on inside of her."

Every animator has a favorite moment in which Cinderella displays that depth of personality, and Henn continues, "There's the really great scene where she receives the invitation to the ball, and upstairs the sisters singing and playing the flute. She asks Gus and Jaq, "Should I interrupt the 'music lesson'?" There's a level of sarcasm you wouldn't have seen in Snow White or some of the other characters."

"Cinderella's not nasty or mean. She always has a positive outlook, but she's got a little piss and vinegar in her," Pruiksma agrees. "I can appreciate Snow White as the first, and I can see why the film was a blockbuster when it was released. But it feels like it's of another era, when women were treated with kid gloves. Snow White is very sweet, but she's not very bright. Cinderella knows she's in a bad place, but in 'A Dream Is a Wish Your Heart Makes,' she declares she'll never give up the hope that someday things will be better. It's at that point where she loses hope after her dress is destroyed that the Fairy Godmother comes to buoy that hope."

Magic Moments

I would argue that Cinderella *is Walt Disney's masterpiece. It was made at a time when he was still focusing on animation. It was his comeback to the one-story feature film. The advances in skill and artistry he and his artists had gained since* Snow White—*are staggering: Mary Blair was at her peak; so were the Nine Old Men. It's emotional. It's dramatic. It's funny. It's stunning. It's romantic. The music is spectacular.*

— Cars director John Lasseter

One of most magical moments in *Cinderella*—and the entire canon of Disney animation—occurs when the Fairy Godmother appears to change the humble pumpkin into an elegant coach (that still retains the curving lines of the pumpkin) and the tattered remains of Cinderella's dress into a shimmering silver ball gown. That sequence has appeared in every montage of great moments from Disney films. Viewers who didn't watch the feature in its entirety until they were adults saw the clip on the *Disneyland* TV show and later *The Wonderful World of Color*.

"I especially like the 'Bibbidi-Bobbidi-Boo' sequence because it's the definitive Disney magical moment. When you think of Disney magic, it's the transformation of the maid into a princess," states Ruben Aquino. "Transformation is what animation does best. I still haven't seen CG animation top the 'Bibbidi-Bobbidi-Boo' sequence in terms of magical transformation."

"Like all of Walt Disney's films, *Cinderella* has a moment where you want to jump up and down in your seat with excitement," adds John Lasseter enthusiastically. "After all she's been through, wanting to go to this ball, her stepsisters ripping apart the gown that her animal friends made, she's left all by herself. The Fairy Godmother shows up and sings 'Bibbidi-Bobbidi-Boo.' She's off to the ball and you're thinking, 'Yayyyyyyy, Cinderella!!' You're just so happy for her."

The Disney artists portrayed the Fairy Godmother not as the elegant spirit depicted by many illustrators, but as an endearing, if slightly addled,

Below:
Three lively story sketches by Joe Rinaldi suggest the Fairy Godmother's poses and attitude. Medium: pastel.

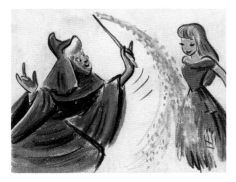
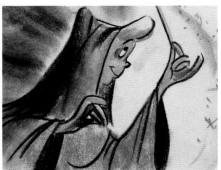
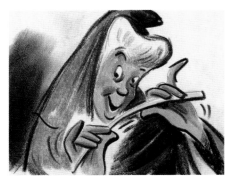

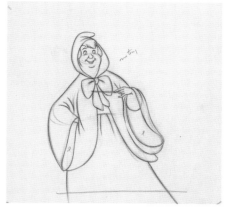
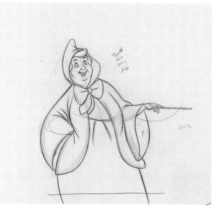
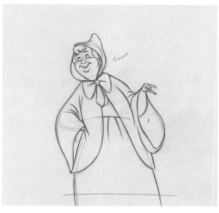
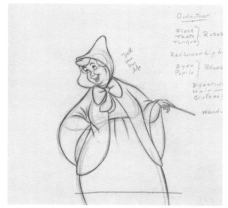
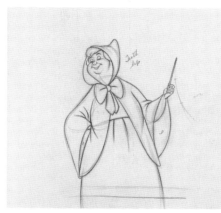

Above:
This series of drawings shows how Milt Kahl brought to life the attitude suggested in the storyboard panels. Animation cleanup drawing; medium: pencil, colored pencil.

Below:
The Fairy Godmother explains the importance of the magic words in the finished film.

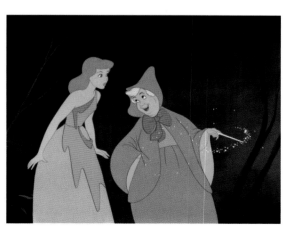

matron. This interpretation gave them the chance to introduce great character interaction and comedy: Cinderella eagerly awaits the transformation of her rags into a lovely dress, while the Fairy Godmother ignores her to take care of the coach, driver, and horses.

But when she realizes Cinderella can't go "looking like that," the results are spectacular. *Wreck-It Ralph* art director Mike Gabriel comments, "How beautiful Cinderella looks when she's in that silver-gray dress and black choker! The animation of her at that point is stunningly executed—it's Marc Davis in his prime. She almost takes your breath away with how stunning she looks."

The Fairy Godmother was animated by Milt Kahl, who was usually given the princes and other straight human figures because of his exceptional draftsmanship. He gave the character little sideways glances and small hand gestures that emphasize both her warmth and confusion.

"It's a question of how befuddled do you play the Fairy Godmother before she ceases to be likable. It's a fine line," Andreas Deja observes. "She forgets things, and then oh, yes, she finds her wand. You could have gone a lot further with it to get more comedy, but her role is too important to be zany. She gives the title character a chance to find happiness.

49

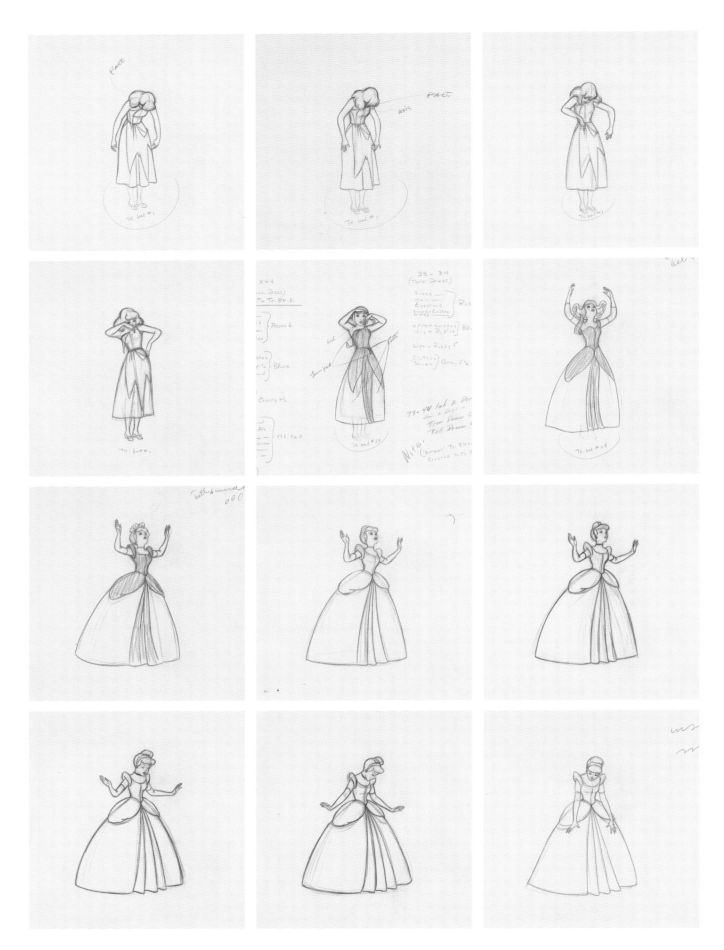

Above: A magical moment: Marc Davis's animation stresses graceful poses as Cinderella's gown is transformed.
Animation cleanup drawing; medium: pencil, colored pencil.

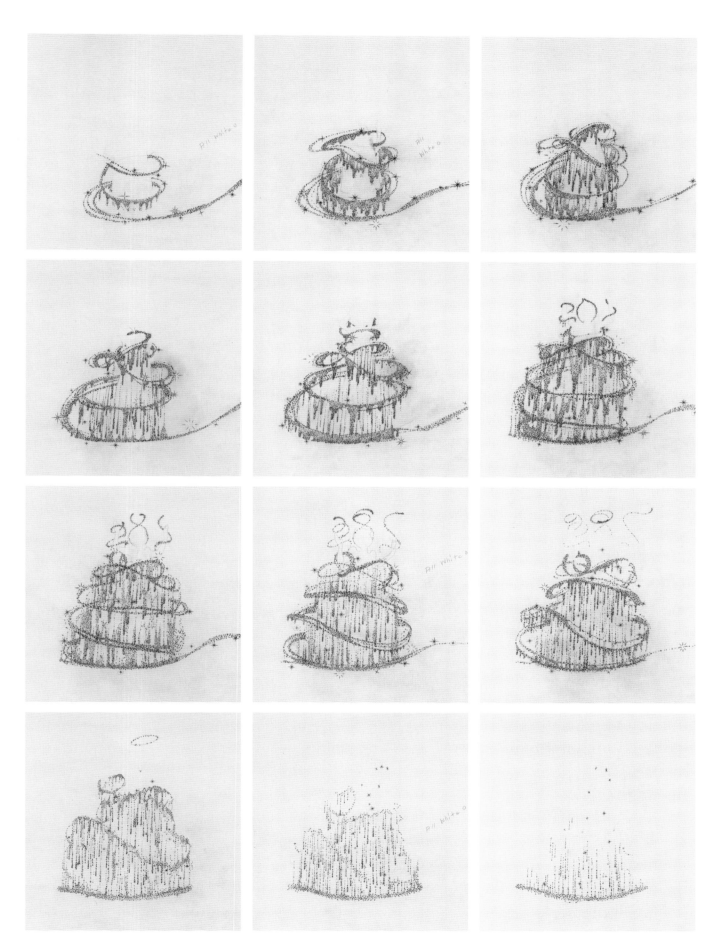

51

Above: Sequential drawings of the magic sparkles or "Disney dust" that accompany the character animation.
Artist: George Rowley. Medium: pencil, colored pencil.

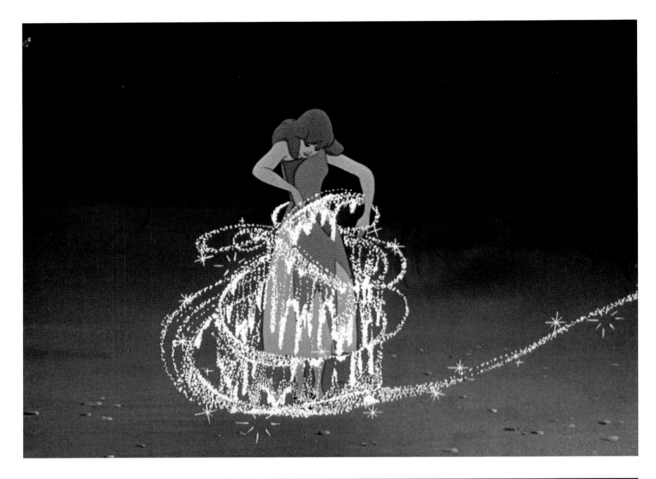

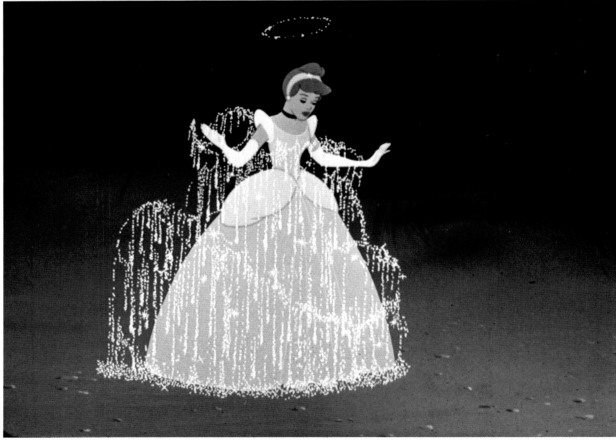

Above: Two frames from the film of the classic transformation.

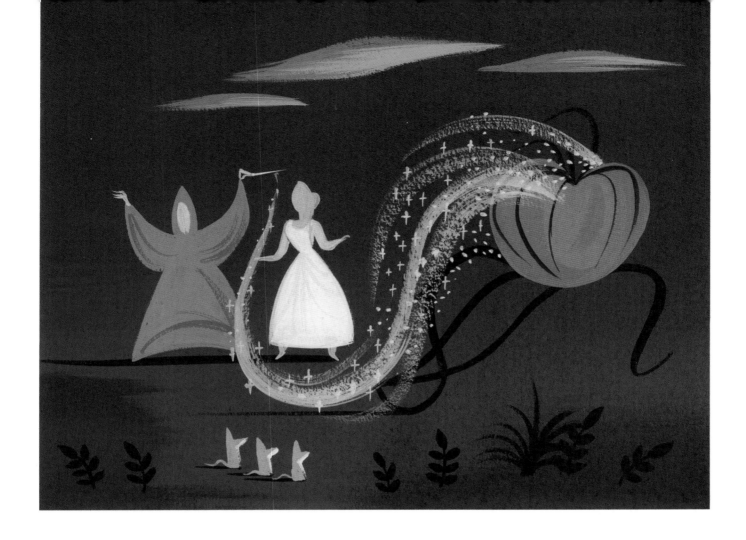

Above:
The clear, simple shapes
in Mary Blair's preliminary
painting emphasize the magic
of the moment. Medium:
watercolor, gouache.

Below and pages 54–55:
The Fairy Godmother begins
to look for her wand and then
with a wave transforms a
pumpkin into a beautiful coach.

She can't guarantee it, but she gives her a chance. That's very important."

Brad Bird found the treatment of the Fairy Godmother's magic intriguing. "There was an effortlessness to the way they depicted magic that made it feel both exotic and very familiar at the same time. It was a big influence on me," he adds. "The Fairy Godmother starts to work with the wand. No pixie dust is flowing from it, so she has to slap it against her palm in order to get the magic flowing. The mundane aspect of it being clogged intersecting with something as fanciful as a magic wand is wonderful to me.

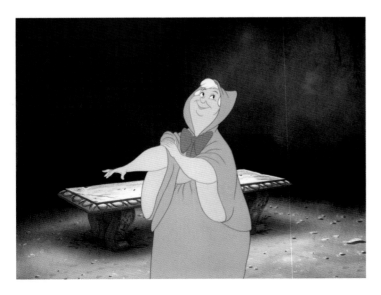

"You can really see how it influenced me in *The Incredibles*, where I was constantly having mundane things intersecting with the superheroes," Bird continues. "The wand is one of the earliest examples I can remember in a movie where they took something very exotic and made it very everyday—which only made it more impressive and believable. One of the conceits that I brought to *Mission: Impossible—Ghost Protocol* was, 'What if they had all this cool stuff and it didn't work?' I enjoy that, and the first example that comes to mind is the Fairy Godmother dealing with the wand."

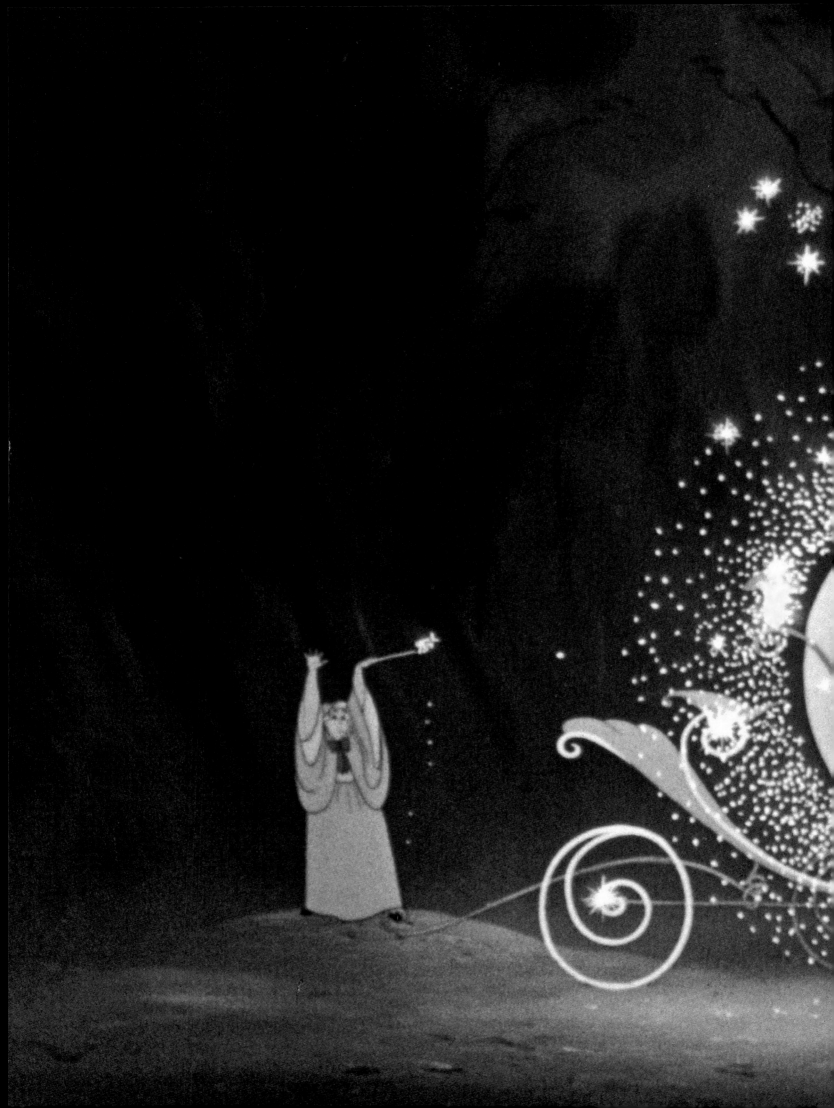

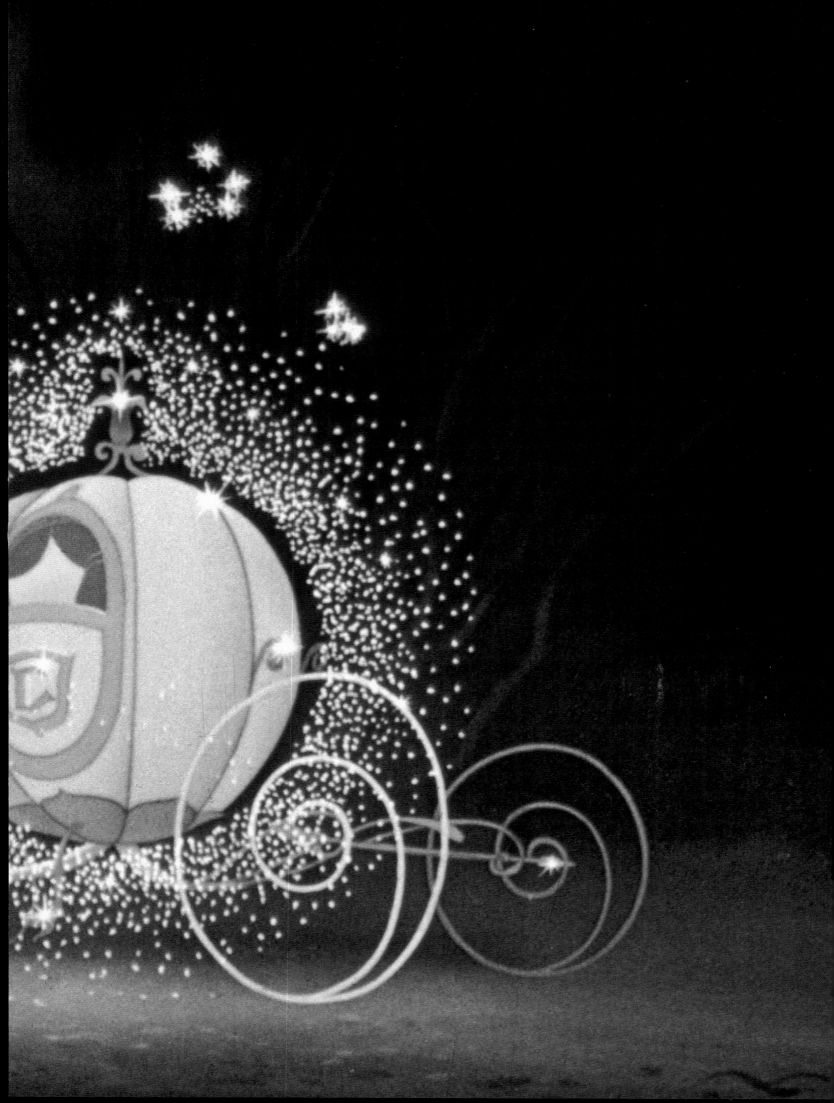

The Power of Understatement

Cinderella has a breadth of style. You have these kind of extremes of very believable, realistic, naturalistic animation and some pretty cartoony stuff. Yet the film navigates its way between the two really wonderfully.

— *Up* director Pete Docter

The slightly befuddled benevolence of the Fairy Godmother offers a striking contrast with the icy, calculating stepmother. The new generation of animators praises the character as one of Disney's most frightening villains. They point to the way Frank Thomas underplayed the animation to heighten the drama of her first encounter with Cinderella. Although Thomas described the assignment as "a terrifying chore" that was "very difficult to do and not much fun," he felt the character was "the thing that made the whole picture work."

"A sequence that I try to analyze to learn why it's so powerful is when the stepmother is in bed, stroking her cat, and Cinderella comes in," says Deja. "There really isn't much happening. She's just sitting there. Her body is a held drawing and just the hand is animated, so you can really take in her stare. The tilt of her head. The expressions. What the eyes do.

"I asked Frank [Thomas] how he came up with that, and he very modestly said he probably got it out of the live action," Deja continues. "He probably did, but you still have to know how to make that read: a subtle action, like a flare of the eye; how you bring everything down so that it reads."

Below, left and right:
Two dramatic storyboard drawings of Cinderella appearing before her stepmother after the mouse has turned up in the morning tea. Artists: unknown; medium: charcoal.

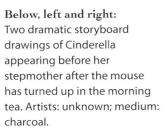

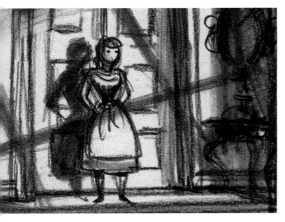

Opposite:
Three images of the sequence from the finished film echo the staging in the storyboard drawing. The grid of shadows suggests Cinderella's imprisonment by her stepfamily.

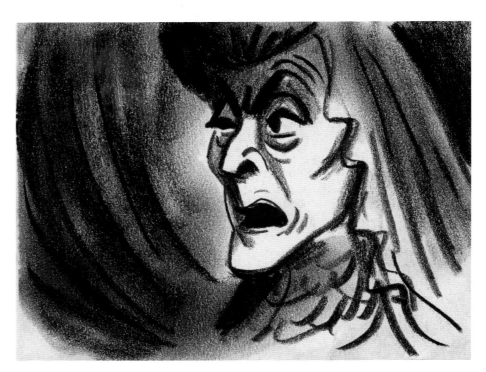

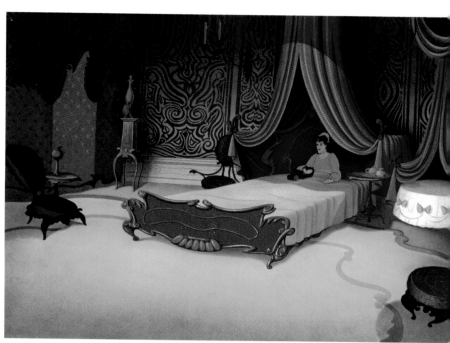

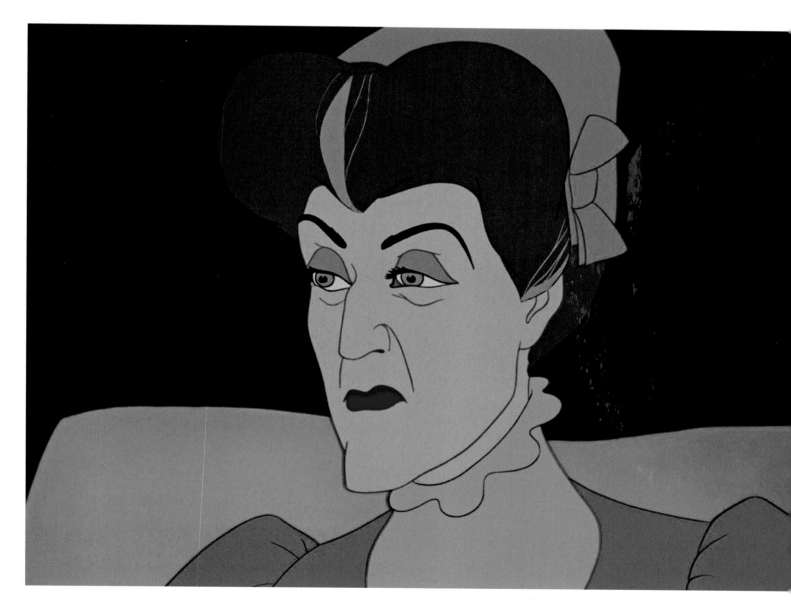

Opposite:
Mary Blair's preliminary study of Lady Tremaine set the look for the character. Medium: watercolor, gouache.

Right:
A powerful image of Lady Tremaine. Animation cleanup drawing. Animator: Frank Thomas; medium: pencil, colored pencil.

Below:
A frame of the character from the film. Treating her hair as a single, helmetlike form emphasized the cold angularity of her face.

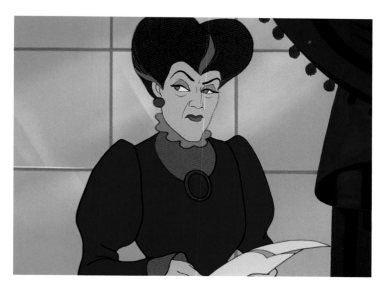

"The stepmother is so fantastic in her subtlety: the most natural villain we've had," agrees Mike Gabriel. "Nothing supernatural, no magical powers, nothing but the ability to take away what the heroine wants. That's what gives her all her power, and she uses it so well.

"She conjures up powerful emotions in everyone watching because we all felt at times that our moms were mean to us," Gabriel notes. "But the little subtle things she does feel like a mean mother or someone you would know in real life. She just sends a chill up my spine."

Animator Randy Haycock, who worked on the title character in *Pocahontas*, notes that the subtle animation of the characters plays off Eleanor Audley's understated vocal performance. "The stepmother doesn't yell because she's powerful. She doesn't have to move a lot because she's powerful. I don't know how much fun that would've been to animate, but Frank Thomas showed a huge amount of restraint by having her move so little.

"Even when everything is chaos around her, she's always in complete control," Haycock adds. "A character who's really powerful and knows it

59

isn't going to show off that power. She doesn't have to."

Audley said, "My radio training helped more than the theater. Having been in the theater for twenty-five years, I learned things about projecting that I had to unlearn for radio—or animation. Acting is acting; with animation you are more aware of your voice and you tend to look for contrasts wherever you can find them. I think *Cinderella* is the best thing I ever did outside of the theater. The stepmother had more chances to be sarcastic and sweet and venomous. There was more chance to get different ranges and play with it more; I didn't play with Maleficent."

Pixar designer Ralph Eggleston notes that the lighting and setup of her initial encounter with the heroine heightens the intensity. "You see that slice of light cross over the room; Cinderella comes in, shuts the door, and it's dark" he explains. "She moves forward, and you see the glow of her eyes. She's sitting, calmly petting the cat. That's one of the scariest things ever!"

Eggleston adds that the stepmother reminds him of Bette Davis's Oscar-nominated performance as the devious matriarch Regina in William Wyler's *The Little Foxes* (1941). "She kind of looks like Bette Davis," he says

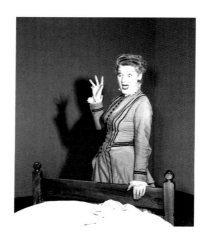

thoughtfully. "Her eyes are certainly the same. The way she sits, the way she poses herself."

Both characters wear their hair in an elaborate pompadour. But the stepmother's becomes almost a helmet, like the Evil Queen's cowl in *Snow White* and Maleficent's horned headdress in *Sleeping Beauty*. The stepmother's hair never moves in a way that would soften her features or make her appear more delicate. Veteran Disney artist Joe Grant, who designed the Queen, commented, "It gives a masklike look to the face, even if the beauty is there. If you have that type of costume, the focus is on the face, on the expression."

In contrast to the icy majesty of the stepmother, the stepsisters Anastasia and Drizella (a play off "Drusilla,"

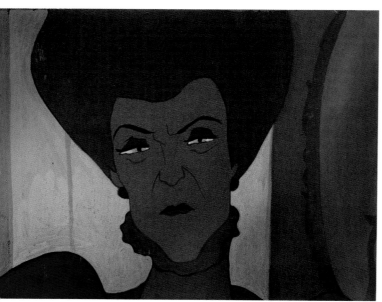

Above:
Eleanor Audley poses as Lady Tremaine, and an image of the character. A veteran stage and film actress, Audley took great pride in her performance.

Caligula's sister) are broadly comic figures. They are selfish, conceited, imperious, and, at times, vicious. But most of their scenes are played for laughs: they mangle "Oh Sing Sweet Nightingale" (making even Lucifer cover his ears), prance like performing ponies at the ball, and have faces that could stop a sundial. Yet they don't feel out of place next to the more realistic stepmother or Cinderella.

"How did those girls come from the stepmother? They look like different species," laughs Ruben Aquino. "As long as the rules of the universe in the film are consistent, you buy the differences in design. It's not like you

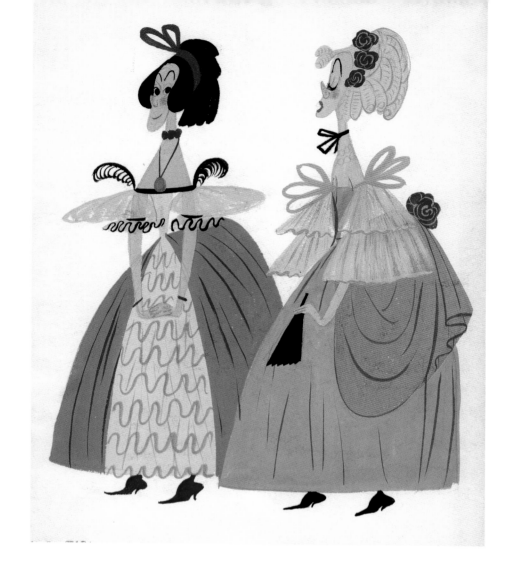

Right:
Mary Blair's preliminary study captures the absurd airs the stepsisters assume, and suggests the palette for their costumes in the film (below). Medium: watercolor, gouache.

Below:
Anastasia and Drizella, in a final frame, can't believe their mother would even think about allowing Cinderella to attend the ball.

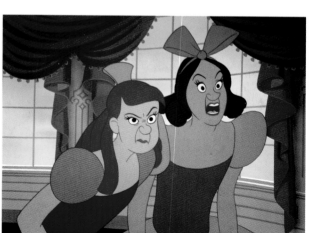

suddenly have one character that defies gravity and does all these cartoony things and another is rotoscoped. They all are caricatures to different degrees, partly depending on the design. The stepsisters were caricatured more broadly, but the animators still followed the same rules, so you buy them as part of the same animated world."

The stepsisters were animated by Ollie Johnston, an artist usually associated with warmer, gentler characters: Flora and Fauna in *Sleeping Beauty* and Rufus in *The Rescuers*.

"The stepsisters are pretty cartoony because they're supposed to be the *ugly* stepsisters: they couldn't be drawn as beautiful girls," says Deja. "When the Grand Duke arrives, the sisters curtsy and one of them says, 'Your Highness!' She has this grotesque face as it is now, but Ollie drew her a lot uglier because he thought she should come across as really ugly. Walt called Ollie and said, 'Suppose you change that a little bit and make her not that ugly.' I think Walt was against repulsive-looking images. He was fine with something looking scary and

61

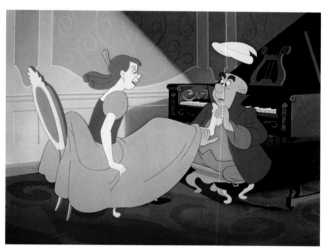

comedic, but if something was truly ugly, he had a word to say about that. Ollie went back in and brought the expression down a bit."

"The stepmother's purpose in the film requires her to be more realistic in design because she has to be a believable character that you relate to on the level of a real human being. The same with Cinderella and the Prince," explains Haycock. "The stepsisters, the King, and the Grand Duke are largely comic characters. You allow the character to look like what their role is in the film. If their role is to be more comedic and broad, you should have a little leeway. They still live in the same world. They're proportioned somewhat realistically, even if they're more caricatured in their features and movements.

"But that's perfectly appropriate," Haycock continues. "If the stepsisters were more realistic, it would be more disturbing and less entertaining to see how grotesque they were. It wouldn't be near as enjoyable to watch them on-screen."

Oddly, no one seems to notice—or care—that the stepsisters and stepmother essentially vanish once Cinderella puts on the glass slipper. They receive neither the cruel punishments the Brothers Grimm describe nor the

63

forgiveness Charles Perrault envisioned. "Once that shoe fits and the Prince is there, the story is over," Brenda Chapman concludes. "How many endings should we have? The stepmother's anger and disappointment at being shown up in front of the Prince and the lackey are the humiliation she deserved. She's insignificant now. We're moving on with Cinderella."

64

Animal Friends and Royal Family

Our family had a cat with six or seven toes who looked like Lucifer. When Walt came out one day to show our railroad to a fellow who was the president of the [Romney, Hythe, and Dymchurch narrow-gauge railway] that runs on the southern coast of England, he saw our cat and he said, "There's your cat! Make him like that!"

— Animator Ward Kimball

Like Snow White and Briar Rose, Cinderella has befriended small animals and birds, which demonstrates her gentle nature. But Cinderella shares a closer bond with them than the other Disney Princesses. She not only feeds them, she makes little clothes for them and gives them names. In return they work harder to help her, altering her mother's old dress for her to wear to the Prince's ball. At the climax of the film, Gus and Jaq steal the key from the stepmother's pocket and carry it up the towering Hitchcockesque staircase to free her from her garret.

Veteran animator Ward Kimball, who helped to design the mice, said, "That was a lot of fun because that was the first time we based a character on

Above:
Two early storyboard panels of a mouse gathering the corn Cinderella scatters. Artist: Unknown; medium: pencil, colored pencil.

Right:
Gus and Jaq maneuver the heavy key to Cinderella's door up the house's many steps.

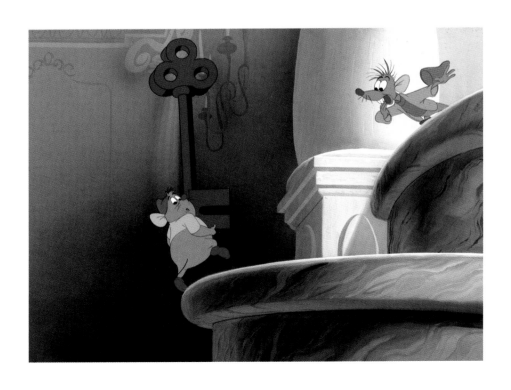

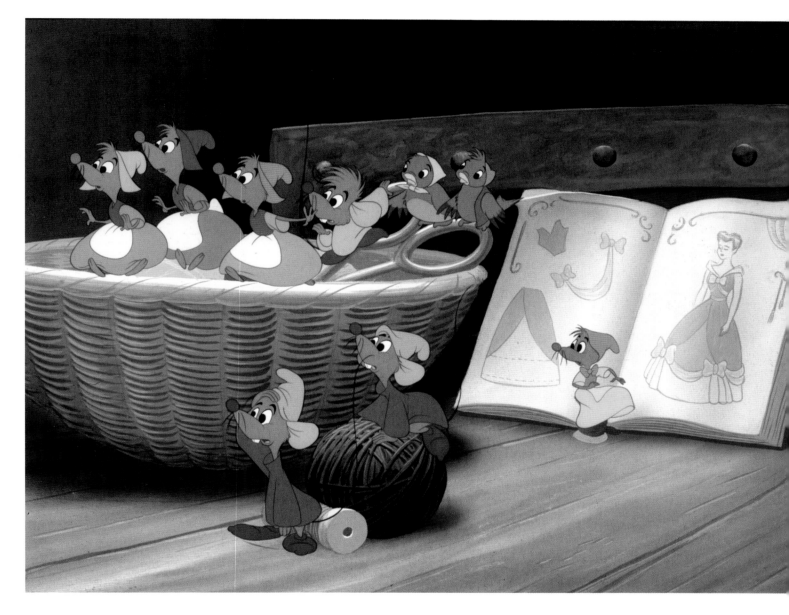

Top:
Three storyboard drawings of the mice reworking the dress for Cinderella to wear to the ball. Artist: unknown; medium: pencil.

Above and left:
Frames from the finished sequence.

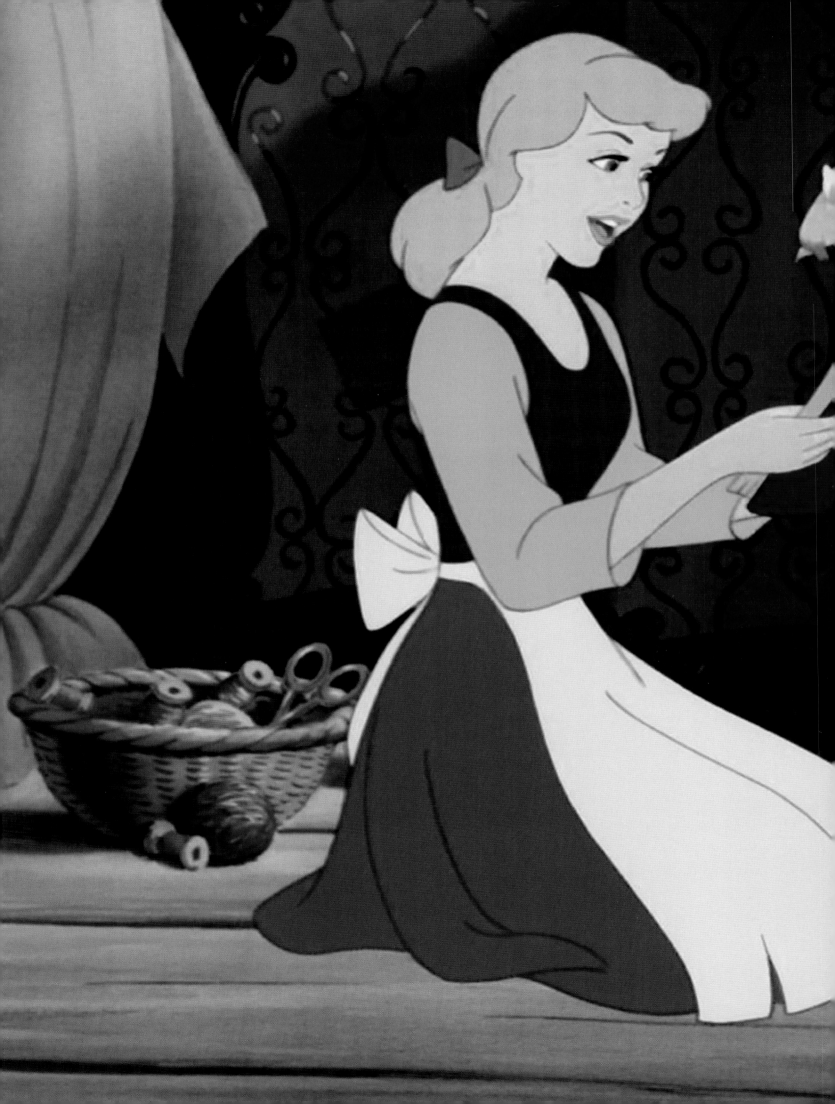

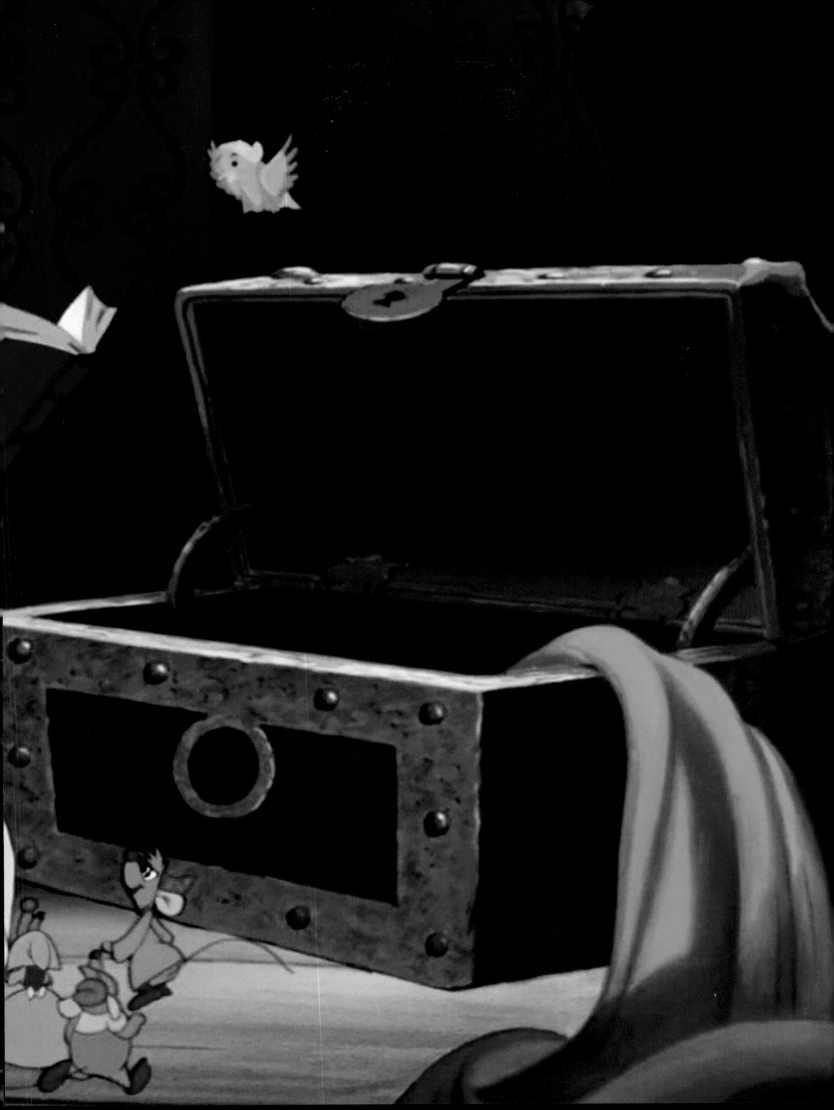

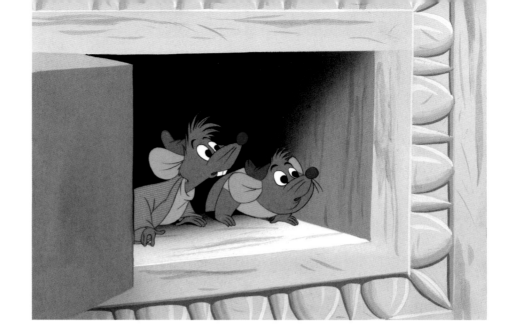

Pages 66–67:
Cinderella consults a book on dressmaking, hoping she'll be able to make a gown for the ball.

Right:
Jaq and Gus check to see if the coast is clear to gather the scattered beads.

Above:
Two vivid storyboard drawings of the mice. Artist: Bill Peet; medium: pencil, colored pencil.

Below:
Walt Disney and an unidentified visitor watch animator Ward Kimball at his animation desk.

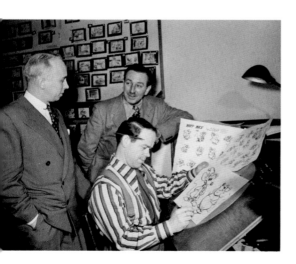

Right:
Lucifer tries to capture Gus-Gus.

a caricature of the real thing. We tried to give the mice little, pointed noses and whiskers and mouse ears, and that was quite a breakthrough, especially after years of drawing a mouse like Mickey. It pointed up the value of caricaturing the real thing."

But for all their charm and hard work, the mice are largely eclipsed by Lucifer, the stepmother's spoiled, conniving cat, who wants to make a meal out of the plump Gus. Kimball animated the cat in a broad, cartoony style that Eric Goldberg compares to "a 1940s cat-and-mouse cartoon."

"He's a greedy, lazy cat who is the embodiment of the stepsisters' indulgences," says Brad Bird. "It's a bigger, blowsier caricature of a fat cat. Everybody knows a cat like that, one that just sits around and gets fatter by the day. You get away with the cartoony-ness because it's done in a very knowing way. It was the perfect assignment for Kimball, because he could cut loose."

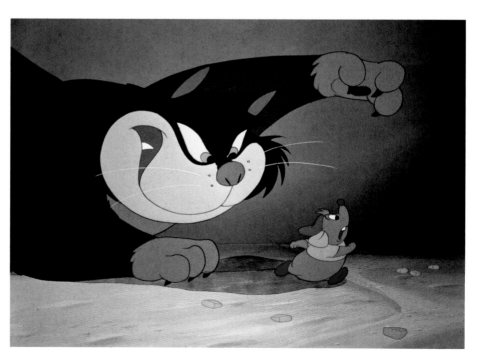

"Even though the movements of the humans are treated more realistically, their designs and those of the mice and Lucifer are all from the same world," adds Mark Henn. "That's always the key. If everything feels like it's from the same world, it should work. *Cinderella* is a really well-designed movie."

The biggest laugh in the film occurs when Lucifer tries to find the mouse hiding under a teacup on the stepsisters' breakfast trays. Andreas Deja comments, "Kimball's game with the cups and Lucifer is just a masterpiece of comedic timing. The audience knows where the mouse is at any given time, but the cat doesn't, so you laugh doubly hard. It's as good as anything [Charlie] Chaplin ever did. Lucifer grabs things with his paws, which a cat can't do, but you don't care because it's just so funny."

"I'm a big fan of the Lucifer stuff," agrees Pete Docter. "You look at the scenes of Kimball's, like the cat looking under the third cup, then putting it down without realizing that he's seen the mouse. Then he goes back and does this wacky

Below left:
Ward Kimball's lively poses and expression captures Lucifer's frustration. Animation cleanup drawings; medium: pencil, colored pencil.

Below right:
Lucifer looks for Gus in vain, as seen in these final frames.

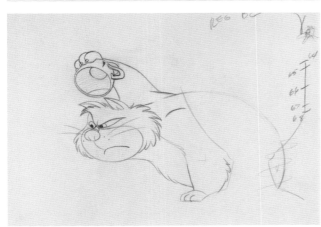

arm-waving and tongue-wagging thing before he grabs the cup. In different hands, it would not have fit in the film. But it's really funny and works great."

However, not everyone in the audience shared the artists' enthusiasm for the portrayal of Lucifer. On February 17, 1950, Walt sent a personal letter to a Mrs. Ruth Van Voast of Brooklyn, New York. She had apparently let Disney know she was displeased with the way Lucifer was presented in the movie. Disney seemed sympathetic, but stuck by his artists:

Dear Mrs. Van Voast -

We are sorry to know that you feel our characterization of Lucifer is somewhat of an injustice to all Catdom. Honestly, all of us love him and think he's wonderful!

Although CINDERELLA was only released to the public this week in Boston, we screened the picture a number of times to private, though large, audiences in our studio theatre and those who saw it acclaimed Lucifer as a guy with quite a personality. Beyond this, and I am sure you will agree, what is a more natural heavy for Mice than a Cat? On the other hand, not all Cats want to eat mice—many prefer their rations out of a can!

I don't dislike cats at all—in fact, I love them as I do all other animals—they have always fascinated me. However, I do prefer dogs and have a brown French Poodle, but I have owned two cats.

I once had a beautiful Manx Cat sent to me from the Isle of Man. Unfortunately, it died, and later we acquired a Siamese Cat. This cat and the poodle were the best of friends—they ate together, slept in the same bed and were inseparable. Then one day the Cat disappeared and never returned. We were unable to learn what happened to him and for two or three months after this, the Poodle was completely unhappy and lost without her pal. I definitely believe that Cats, too, have their virtues as well as other animals.

I want you to know that I appreciate your letter and your love for Cats, and I hope now you will no longer consider me one of Kitty's worst enemies.

Curiously, the least interesting character in the film is the object of so much attention from the others: Prince Charming. The origin of his name is uncertain. Charles Perrault refers to the character simply as *le fils du roi* (the king's son). The hero of *"L'oiseau blue"* ("The Blue Bird") by the eighteenth-century writer Madame de d'Aulnoy is *le roi charmant* (the charming king), which was turned into King Charming in Andrew Lang's *The Blue Fairy Book* (1889). The first mention of Prince Charming seems to occur in Oscar Wilde's *The Picture of Dorian Gray* (1890). In Disney's *Snow White*, the title character says, "Anyone could see the prince was charming, the only one for me."

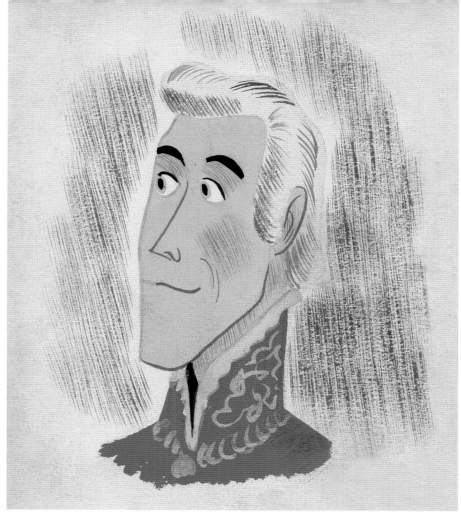

Right:
An early study for the Prince: handsome, blond, and bland. Artist: unknown; medium: pencil, colored pencil.

Below:
For the film, the Prince was given dark hair, to contrast with Cinderella's blond tresses.

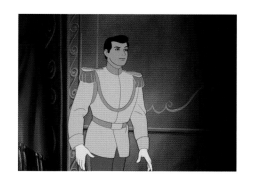

Below:
Drawings of the princes from *Snow White and the Seven Dwarfs*, *Cinderella*, and *Sleeping Beauty*. Over the years, the animators learned how to animate a character who felt believably masculine without seeming effete or wooden. Animation cleanup drawings; medium: pencil, colored pencil.

Regardless of the etymology, the character has only a few scenes. "The Studio doesn't seem to have been interested in the princes then," comments Deja. Realistic male characters proved even more difficult to animate than females. If the character moved too gracefully, he looked effete; too stiffly, he appeared wooden. Eric Larson later complained that his animation of Prince Charming was too stiff. It wasn't until *Sleeping Beauty* in 1959 that Milt Kahl managed to make a male heroic character, Prince Phillip, masculine, flexible, and alive.

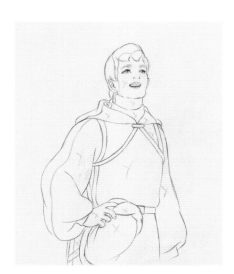
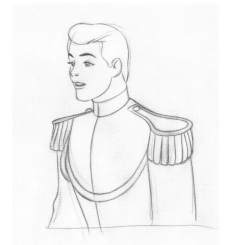
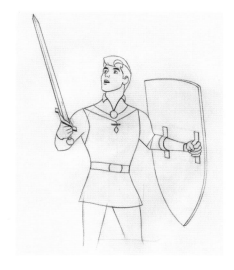

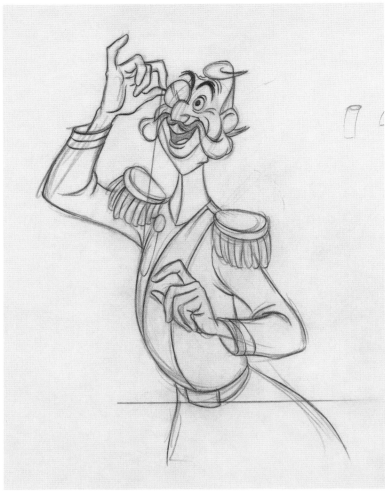

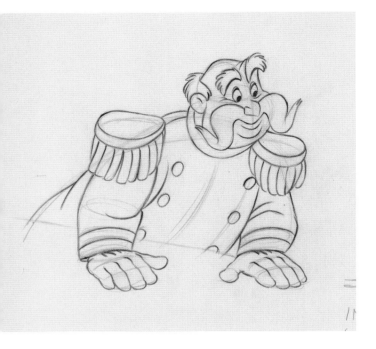

This page:
Walt Disney insisted that even supporting characters in the film had to be lively individuals: The King (above) and the Grand Duke (above right) were from animator Milt Kahl, while the lackey (right) was by animator Ollie Johnston. Animation cleanup drawings; medium: pencil, colored pencil.

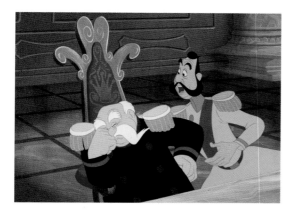

Top, left and right:
Two lively storyboard drawings capture the attitudes of the woebegone king and the haughty grand duke. Artist: unknown; medium: pastel.

Above and below right:
The King wants his son to get married so he'll finally get the grandchildren he's been waiting for—a feeling that Walt Disney shared at the time.

Pages 74–75:
With his usual calm, the King reacts to the Grand Duke's announcement that the girl who stole the Prince's heart has escaped.

Among the minor characters, the king sets much of the plot in motion by holding a ball and inviting every eligible woman in the kingdom to attend. He's hoping one of the girls will attract his son so he'll propose, marry, and start providing the grandchildren he desires. Walt's daughter, Diane Disney Miller, recalled, "Dad said, 'I identify with him because I want some grandchildren . . .'" The year after *Cinderella* opened, Diane began attending University of Southern California, where she met football player Ron Miller. The Millers married in 1954, and Walt soon had the grandchildren he had longed for.

"I really love the Duke and the King and, most of all, the lackey," says Pruiksma. "The lackey is a wonderful character Ollie Johnston animated; in the hands of a lesser artist, he could have been a throwaway. But he's absolutely wonderful in the way he runs around. He's very officious and is always getting into position and getting kicked in the face. It's remarkable animation for a character that would probably have gotten short shrift today."

"The use of the cartoony side-kicks was something they developed on *Snow White*," concludes Bird. "I don't feel they ever topped setting up the expectations of the King, with the sequence where he's imagining having grandchildren—and the Grand Duke has to say that Cinderella got away. It's a fantastic scene, and it's completely the invention of the Disney story artists. It's a genius scene."

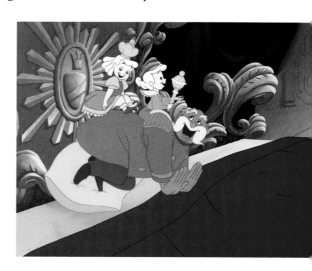

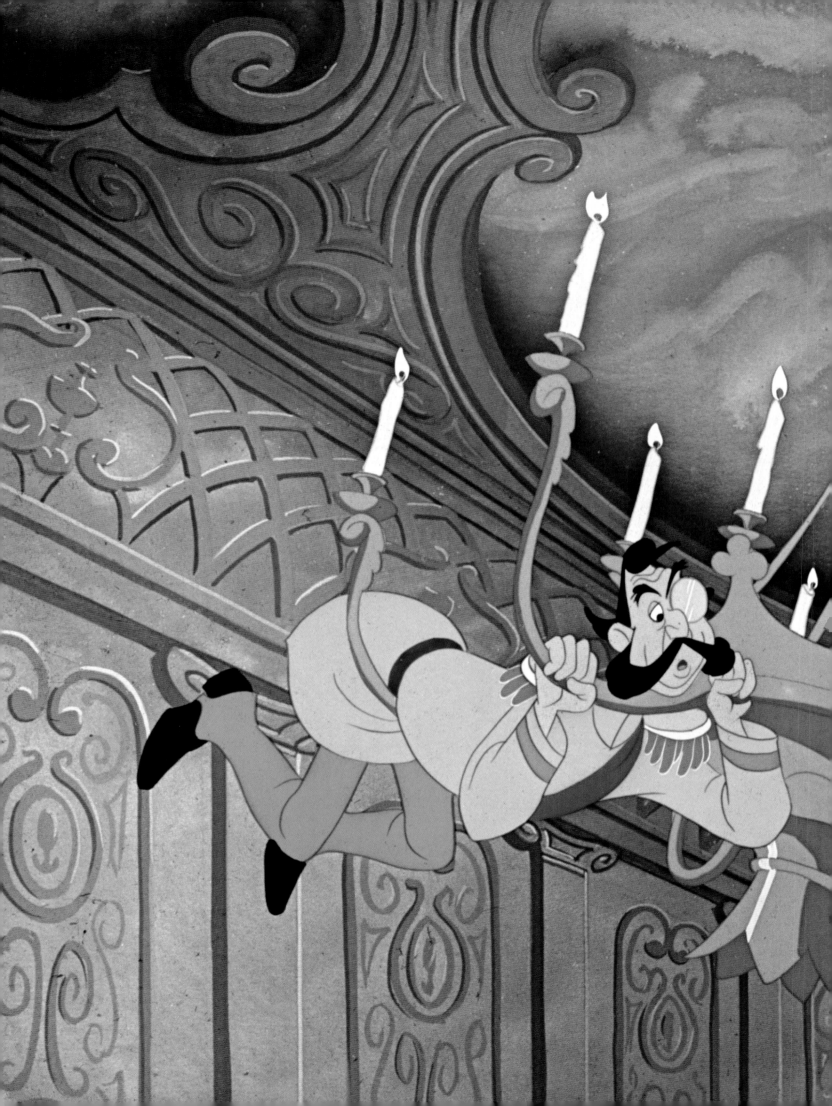

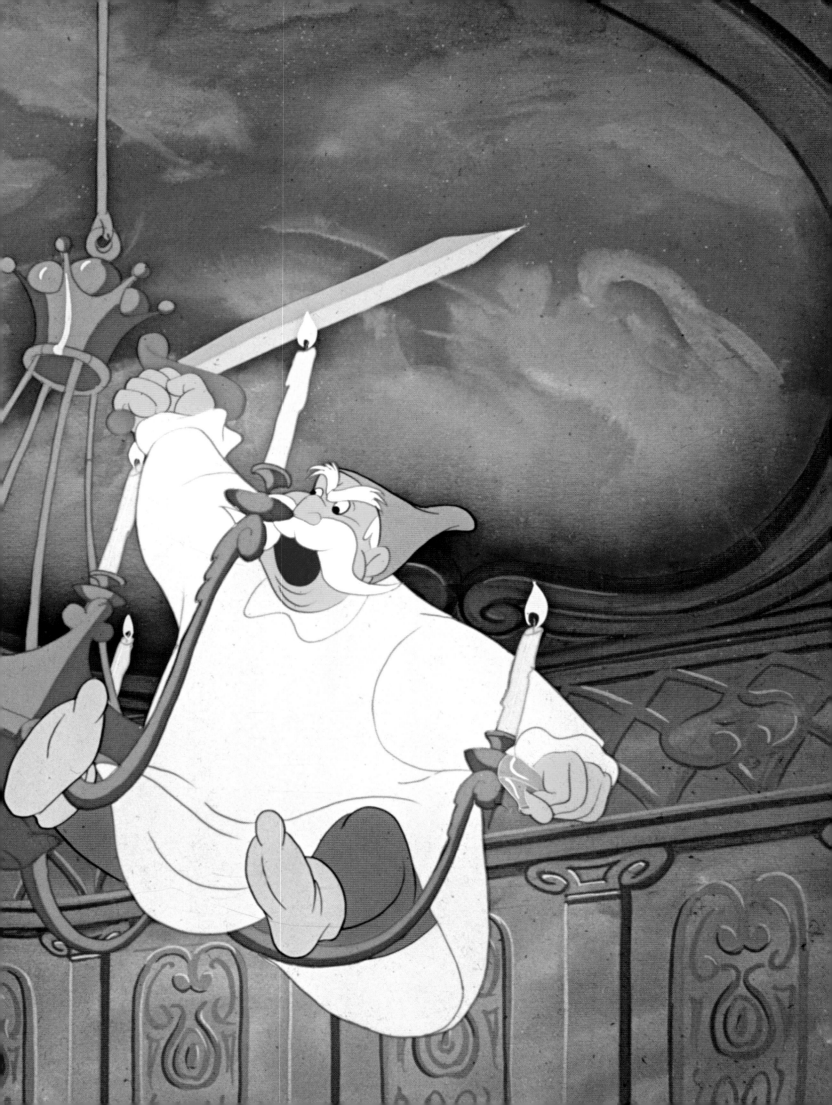

Visual Styling

Mary Blair's work on this film is, as always, nothing short of spectacular. In this film, which relies heavily on a "live-action" approach, it helps immensely to have her sense of unusual color and design. A more representational approach is used for the family home, to establish the wealth and lifestyle of the stepmother, while a more design-y approach on the coach and the Prince's ball serves the magic and the romance of that part of the story.

— *Pocahontas* director Eric Goldberg

The basic look and palette of *Cinderella* were created by Mary Blair, one of the few women to play a major creative role in American animation at the time. Walt Disney loved her bold colors and stylized imagery that seemed to distill not only the physical elements but the emotional content of every scene. During production, however, the designs lost some of her modern simplicity.

Years later, Walt explained in a meeting on *Sleeping Beauty* why the artists were not to change Eyvind Earle's stylized designs: "For years and years I have been hiring artists like Mary Blair to design the styling of a feature,

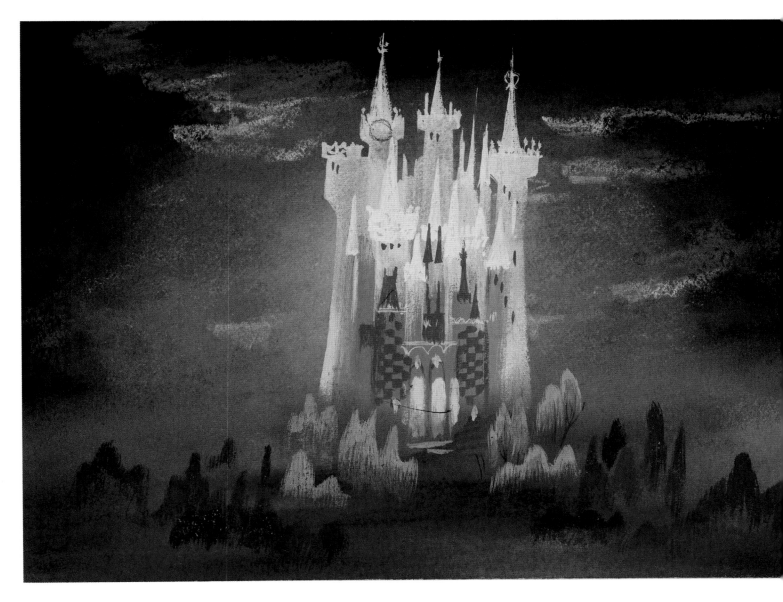

Opposite, top:
Mary Blair with fellow Disney
designer John Hench at the
Studio during the production
of *Cinderella*. Walt Disney loved
the imaginative use of color
and shape in Blair's paintings.

Opposite, bottom:
Blair's preliminary study for
the Tremaine estate suggests
a modern reinterpretation
of a French country house.
With typical imagination, she's
made the sky pink. Medium:
watercolor, gouache.

Above:
Blair's painting of the Prince's
castle stresses elegance and
fantasy, rather than a buildable
structure. Medium: watercolor,
gouache.

and by the time the picture is finished, there is hardly a trace of the original
styling left."

But Blair's distinct stamp can still be seen throughout the film. The
castle Cinderella gazes at from her bedroom window is a lacy fantasy that
lacks the solidity of King Stefan's castle, where the viewer feels he can touch
the individual stones.

"One of the things Blair contributed is a sense of lyrical whimsicality,"
says *Frozen* art director Mike Giaimo. "There's a cursive style in *Cinderella*
that's perfectly appropriate for the French countryside, channeling sort of
French Provincialesque effects. Mary Blair's artwork perfectly suited and
channeled that aesthetic.

"The look of *Cinderella* is a combination of high stylization and very
fully realized space," Giaimo continues. "When they do those long shots
of the castle, they're stylized; we've definitely taken off from Mary Blair's
inspirational work."

Right:
Mary Blair's painting of Cinderella in the kitchen inspired Retta Scott Worcester's illustrations for the Golden Book of the animated film. Medium: watercolor, gouache.

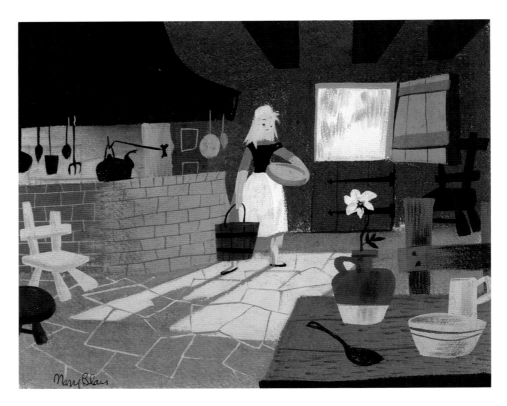

Below:
In a discarded fantasy-sequence, Cinderella dreamed of having multiple versions of herself perform the household chores. In this Blair painting, the Cinderellas wash the face of the clock. The idea was later reworked into Cinderella singing with herself amid clouds of bubbles. Medium: watercolor, gouache.

This page:
Mary Blair's early designs for Cinderella's coach. Her use of pinks and blues (above) emphasize the magic of the transformation. The delicate shading on the trees suggests speeding through a forest on a windy night (right). Medium: watercolor, gouache.

Opposite and this page: Preliminary character designs by Mary Blair. This version of Cinderella feels younger and more childlike (opposite). The cartoony rabbit recalls Blair's designs for the bunnies in the "Once Upon a Wintertime" segment of *Melody Time* (1948). A slimmer Fairy Godmother radiates a no-nonsense sensibility (above). A plump, fussy-looking Victorian Lady Tremaine (far left). Early drafts of the story included a long-suffering music teacher who would instruct the dismally untalented Anastasia and Drizella (near left). Medium: watercolor, gouache.

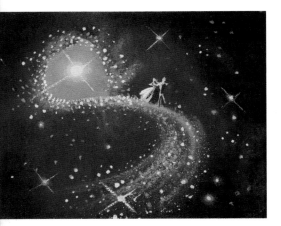

Above:
In a discarded fantasy sequence, Cinderella and the Prince would waltz among the stars. The blue and pink gowns seem to anticipate the changing color of Aurora's dress in *Sleeping Beauty*. Artist: Mary Blair; medium: watercolor, gouache.

Right:
Blair's painting of the coach arriving at the castle deftly blends immediacy and fantasy under a green-tinted sky. Medium: watercolor, gouache.

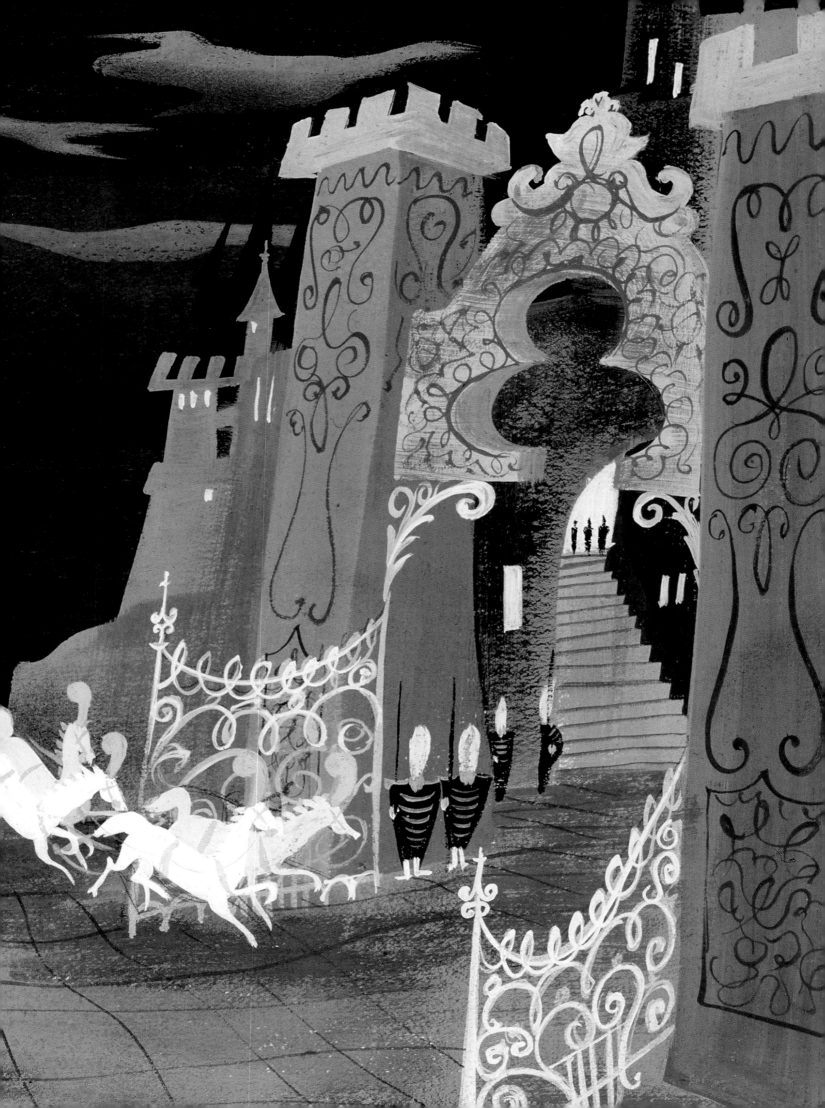

Below:
Two frames from the film showcase the exaggerated scale and moody lighting inspired by Mary Blair's designs.

Giaimo's excitement about the movie extends beyond just those scenes. "Inside the château and the palace, the spatial relationships between characters and environments are astounding," he says. "When you enter the ballroom, when she opens the curtains up in the hallway in the château, you feel that screen is as wide as any wide-screen movie. That's really a tribute to the brilliance of the layout artists, particularly Ken O'Connor."

Much of the story unfolds in Cinderella's house, a country château where she lived happily with her father—and much less happily after his death, when the house became the domain of her stepmother. The condition of the house reveals that the family's status has declined over the years. Fraser MacLean, the author of *Setting the Scene*, notes, "The mice she's befriended appear through cracks in the stonework where the plaster has been allowed to crumble away. These are all physical indications of the underlying themes of pretense and the surface appearance of things: internal as opposed to surface beauty."

In contrast to the sweeping vistas of *Pinocchio* and *Sleeping Beauty*, where key events take place outdoors, the more confined settings of *Cinderella* would feel claustrophobic in less talented hands. *Up* codirector Peter Sohn

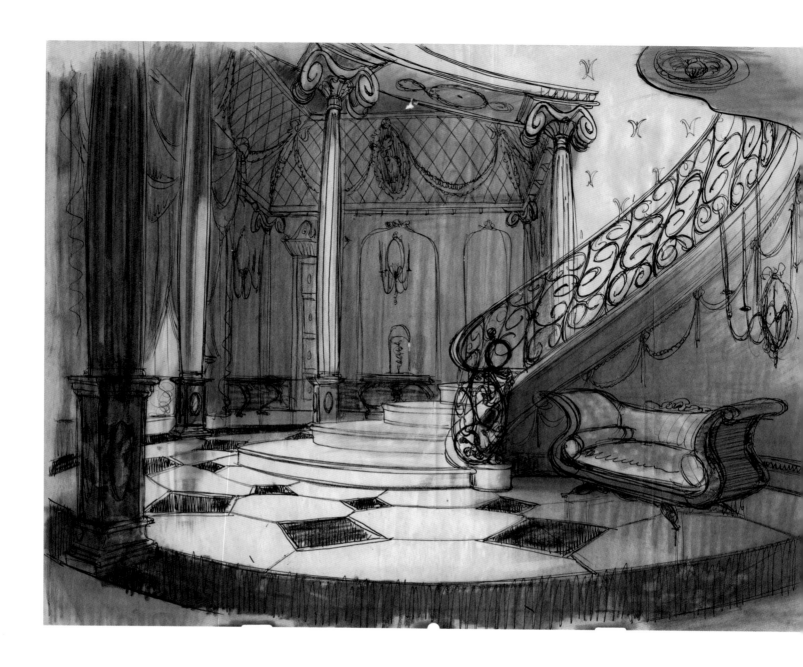

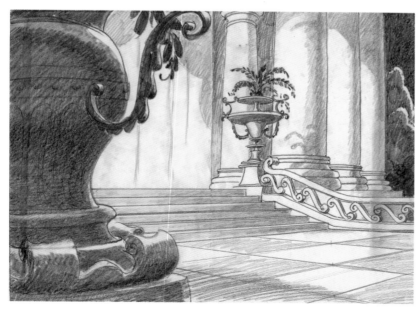

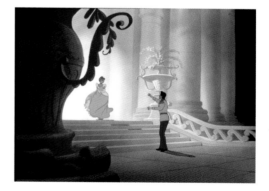

This page:
Two studies of interiors by Ken O'Connor for *Cinderella* caricature the forms that typify French design, and a final film execution of the palace. Disney veteran Maurice Noble would create similarly exaggerated ionic capitols in the Bugs Bunny short *What's Opera, Doc?* (1957).

Right:
The cavernous hall and grand staircase in the palace.

Below:
A preliminary drawing of the carriages arriving at the palace for the ball features overscaled architecture to emphasize grandeur of the location and the occasion. The same scene in the film retains the effect although the camera position is slightly different.

Pages 88–89:
The eligible young women of the kingdom make their bows before the Prince in the gargantuan ballroom.

86

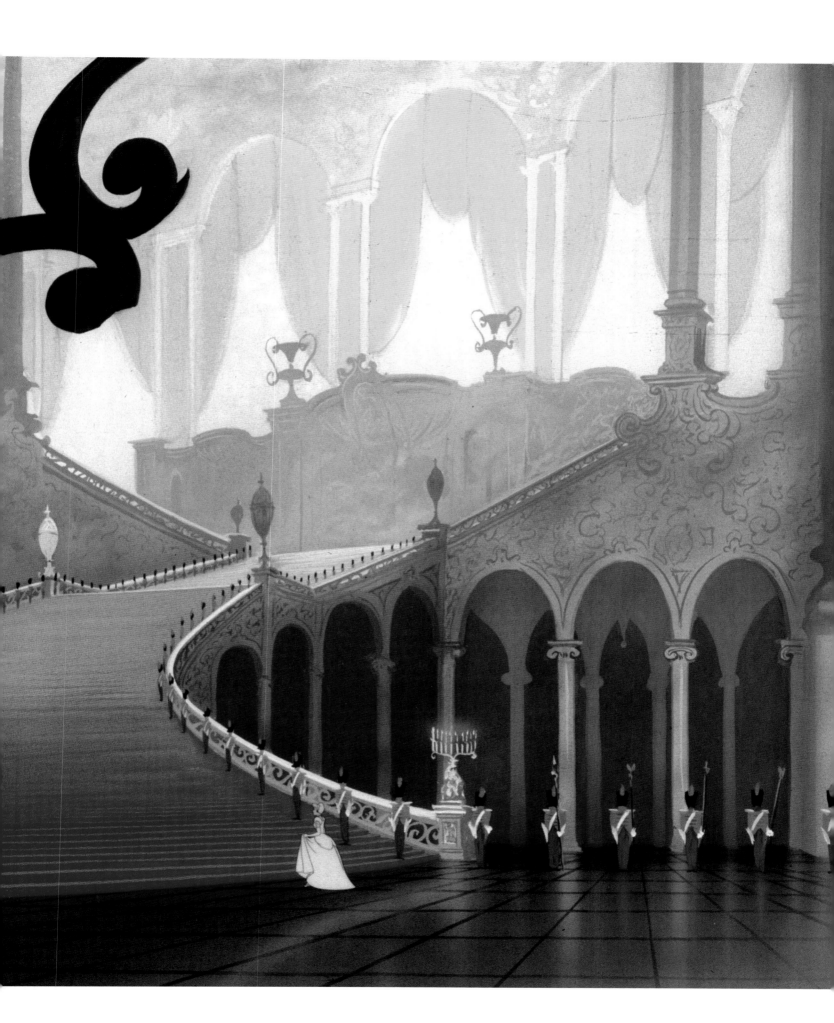

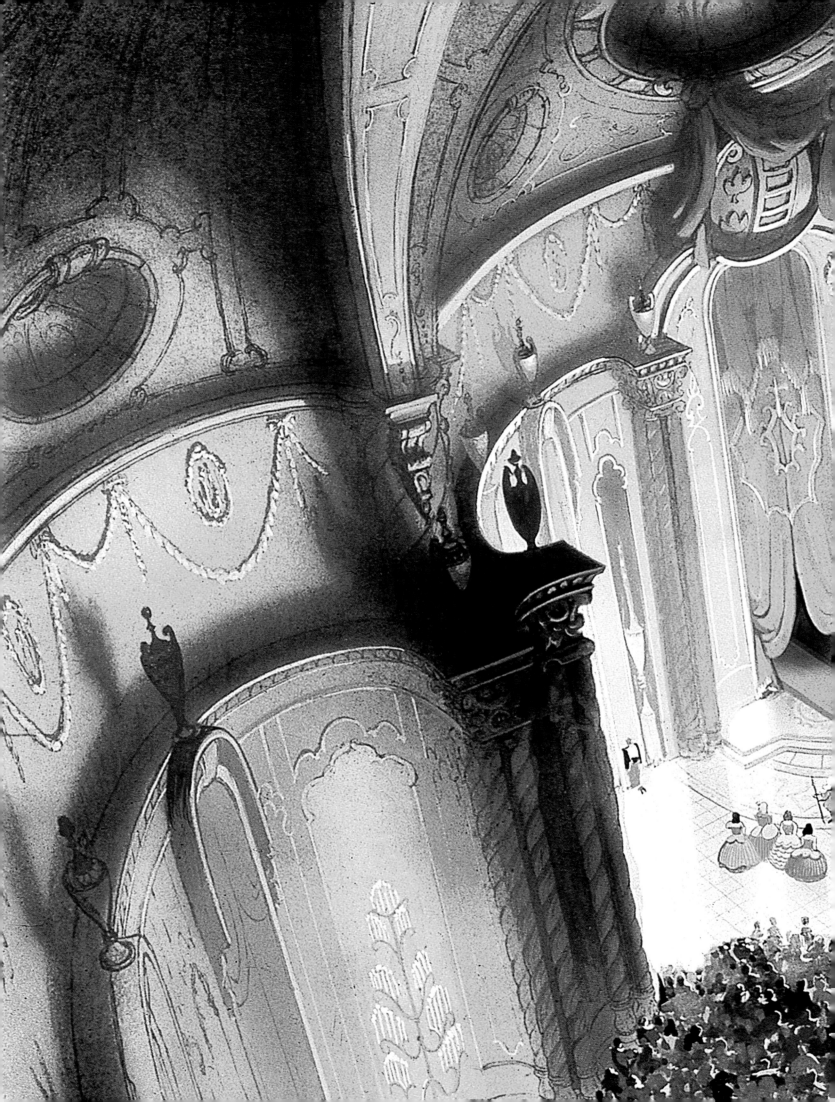

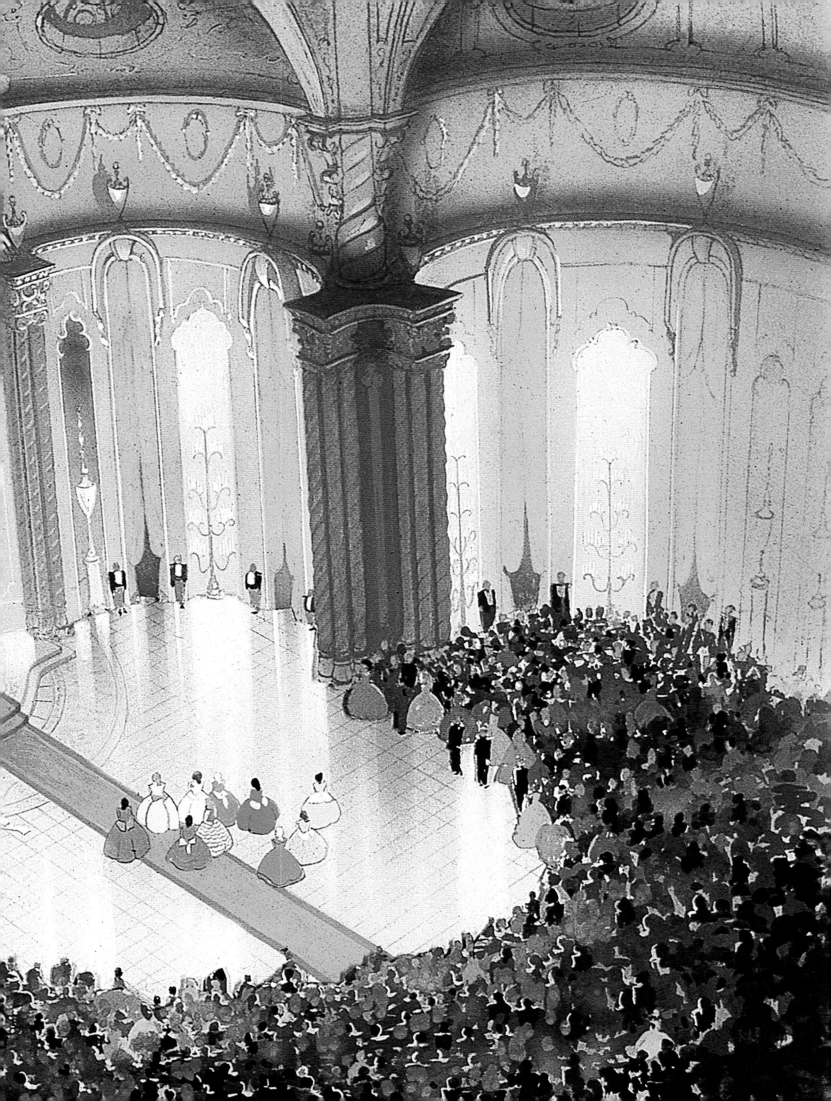

This page:
A final frame of the grand hall (top) and a layout drawing of the entry stair (bottom) are similarly overscaled to give the audience the same sense of the awe and intimidation that Cinderella feels as she makes her entrance. Medium: pencil, colored pencil.

comments, "In terms of the backgrounds, in the previous films, it was always, 'What's the next world we're going to?' Here, it feels like Cinderella was going up and down that same set of stairs five or six times. The artists had to lay everything out like a live-action set."

A decade earlier, a critic noted that *Dumbo* employed "as many camera angles as *Citizen Kane*." Sohn stresses that *Cinderella* similarly reflects contemporary live-action cinematography. "Throughout the film, every time we meet the stepmother, the layout artists, background painters, and directors are all working with the lighting and the shadows," he says. "My favorite part is the build to when the stepsisters tear her dress that the mice make for her. The lighting feels very of-the-time, as it does in the dance sequence with the Prince and Cinderella. You can tell the artists were inspired by the films they were watching like *The Red Shoes*."

When Cinderella makes her rather hesitant entry into the palace, she passes through overscaled pillars that could dwarf an Egyptian temple. The exaggerated architecture reflects Cinderella's awe, making it clear that's she's uncomfortably aware of being outside her familiar surroundings. But when she meets the Prince and begins dancing, the palace no longer feels alien and intimidating.

"In the palace, so much of the relationship between human beings and architecture is terribly uncomfortable and imbalanced," says MacLean. "The pillars look too big. The staircases look too wide. The curtains look too tall. Then we move into a series of designs where everything begins to be comfortably proportioned. The humans are no longer overpowered by the scale of the architecture. It takes on a more friendly quality, partly because of the way the proportion is handled relative to the characters."

Although much of the story unfolds in a dimensional space that fits the realistic characters, the artists stylized the backgrounds in the emotional moments, especially when Cinderella and the Prince waltz to "So This Is Love." Pixar designer Ralph Eggleston explains, "Everything is presented from an emotional point of view. The stylization of the backgrounds is grounded in the emotion. When an emotional moment hits, the backgrounds become how the characters perceive the world around them in that moment."

"A lot of the shapes in the environment during 'So This Is Love' take off from the Mary Blair artwork," Giaimo adds. "Some shapes are flattened out: staircases, bridges, huge urns, and the sort of flowery elements coming out of them are all stylized and flattened out. Yet you have a depth of space in the distance."

"When you watch the scenes of her dancing with the Prince, the backgrounds are very romantic," Eggleston notes. "But the moment the clock starts chiming, she tears away from the Prince and runs back into the castle, and the same series of shots which initially had lots of curves become higher contrast and much more angular. Even the style of painting is different: same layout, but painted differently. The Studio artists were using everything in their arsenal to tie it all together."

"You go into this wonderful palette of blues in the sequence with them falling in love by moonlight, and it softens everything like a dream world," adds MacLean. "You don't dream in vivid, focused Technicolor. You dream in a kind of expressionistic way where there are accents on particular shapes or colors."

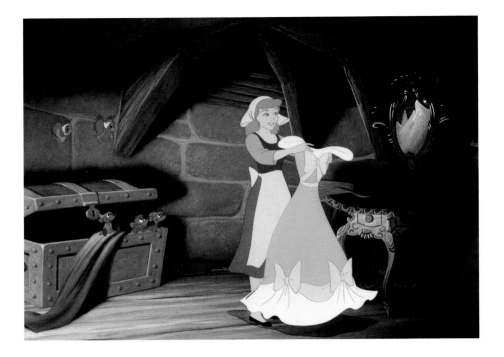

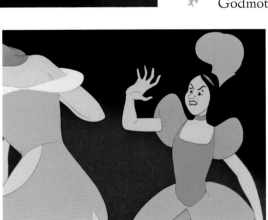

In contrast to the softened palette Eggleston and MacLean describe, the colors are harsh and more stylized in the heartbreaking moment when the stepsisters rip apart the dress the mice have so carefully altered for Cinderella to wear to the ball. "During a series of cuts as the stepsisters tear at her clothes, the background gets redder and redder," says Sohn. "It goes completely cool when the stepmother says, 'Girls, girls,' and we're back in the real time of the film. What an attack it was! They did a similar thing in *Bambi* when the young bucks duel, but somehow because we're in these interiors, it's very effective."

The intense colors, simpler backgrounds, rapid motions, and staccato cutting combine to make the scene emotionally devastating. Her hopes finally shattered, Cinderella runs through the house to the garden, where she collapses by a stone bench. She weeps brokenheartedly, while her animal friends watch helpless, unable to comfort her. One of the most emotionally wrenching scenes in any Disney feature, it slowly shifts in tone as the Fairy Godmother materializes.

Decades later, Frank Thomas confessed, "I still get a lump in my throat when her dress is torn off and she runs out into the garden. Marc [Davis] always thought that was throwing her to the hounds, so to speak; to have the stepsisters rip her to shreds was more than was needed. The fact that she's not going to get to go to the ball was enough. You didn't need to tear up her pretty dress, but the sequence is beautifully structured. It gets to you."

When asked about the sequence, Davis modestly recalled, "I worked on the girl. I didn't do any of the stepmother, but I did

the stepsisters when [Cinderella] appears with the dress the mice and birds have made, and then they rip it off."

Davis gave credit to others as well. "I worked in story with Ken Anderson on the staging of the Fairy Godmother's appearance. I had the girl leaning on the bench, then the godmother fades in and the girl's head is on her lap. I think that little sequence worked very, very well."

"*Cinderella* is one of Disney's darkest movies," adds Giaimo. "The sequence where the stepsisters rip the dress off her and she goes running out into the garden is one of the most exquisitely lit scenes that has ever been done in animation. Talk about dark-light contrast! The depths of her despair and the art direction completely support it with these strong, deep values. It's lifted with the Fairy Godmother's appearance. I often marvel at that whole sequence; they get the feeling of moonlight just by illuminating the characters. Stunning."

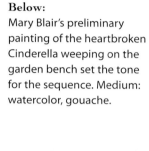

Below:
Mary Blair's preliminary painting of the heartbroken Cinderella weeping on the garden bench set the tone for the sequence. Medium: watercolor, gouache.

Sing, Sweet Nightingale

One of the cleverest things about the score for Cinderella *is how well the songs support the story and move it along. But with minimal lyric changes, they can be lifted out of the score and exploited as popular songs.*

— Composer/historian Alex Rannie

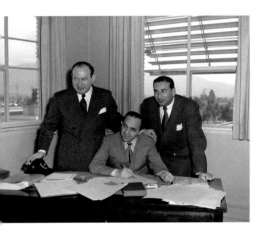

Above:
The songwriting team of Mack David, Al Hoffman, and Jerry Livingston, who scored a big hit with the nonsense number "Chi-Baba, Chi-Baba" before writing the songs for *Cinderella*.

Below:
Animator Marc Davis shows a drawing of Cinderella to Ilene Woods, the actress who provided her voice.

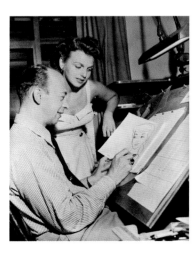

Following the pattern he had set more than a decade earlier with *Snow White and the Seven Dwarfs*, Walt decided to make *Cinderella* a musical. Oliver Wallace, who had won an Oscar for Best Original Score for *Dumbo*, and Paul J. Smith, who won the same award for *Pinocchio*, collaborated on the score.

Composer and historian Alex Rannie notes, "The in-house guys were still writing stuff for the shorts; Oliver Wallace had a hit with 'Der Fuehrer's Face.' But Walt was looking to exploit the songs as much as possible. Supposedly he heard [the song] 'Chi-Baba, Chi-Baba' on the radio driving to work one day and said, 'that's the kind of song we need for *Cinderella* for the Fairy Godmother.'"

Perry Como scored a big hit in 1947 with the half-nonsense *lullaby* "Chi-Baba, Chi-Baba," which was written by Mack David, Jerry Livingston, and Al Hoffman. The song stayed on the Billboard chart for twelve weeks, topping at number one. The songwriters were friends with the popular young singer Ilene Woods, who had her own show on ABC Radio and had traveled extensively with the USO during World War II. They asked her to record demos of the songs they were working on for a film.

"I didn't know it was for Walt Disney—they said [it was] for a movie," Woods recalled. "I went into a studio with a piano and did 'Oh Sing Sweet Nightingale,' 'So This is Love,' and 'Bibbidi-Bobbidi-Boo' and sort of forgot about it."

Disney was so impressed with the demos, he chose Woods to be the voice of Cinderella.

"They told me they had auditioned around 380 girls; I always wondered what he heard in my voice that was so different from any of the 380 he'd listened to," Woods later recalled. "He came in every day at the end of our recording, whether it had been music or dialogue, and checked everything out."

Early versions of the script for *Cinderella* included a fantasy number where she imagined having an army of servants to do the chores for her. The sequence was transformed into Cinderella's rendition of "Oh Sing Sweet Nightingale" as she scrubs the stairs and entry hall of the château.

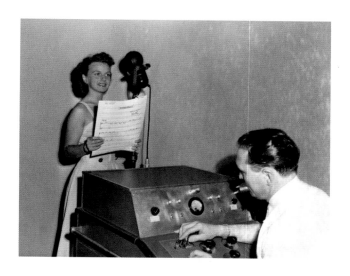

Above:
Ilene Woods poses while recording a song for *Cinderella* with an unidentified sound engineer.

Below:
Two storyboard drawings and a frame of film from the "Oh Sing Sweet Nightingale" sequence. Woods's performance of the multipart harmony represented a technical breakthrough.

Rannie notes, "Part of what that song does is show that Cinderella finds happiness in her own company. The music in her life comes from within her; she provides her own accompaniment within her little world. That's how she remains happy."

As the bubbles rise from her scrub bucket, the reflections of Cinderella join with her to sing in multipart harmony. The result is lovely and effective, both musically and dramatically. Having one singer perform multipart harmony was something of a technical breakthrough, as Woods recorded the song before Patti Page released the hit "(How Much Is) That Doggie in the Window?"

Woods said Walt came up with the idea spontaneously: "When we were recording 'Oh Sing Sweet Nightingale,' he looked up and said, 'Ilene, can you sing harmony with yourself?' I said, 'Gee Mr. Disney, I don't know; I can't even hum and whistle at the same time. What did you have in mind?' He said, 'I can see it.'

"He turned to the engineer and said, 'We'll put the earphones on her and she'll sing second-part harmony. I see her scrubbing the floor and another bubble comes up and she sings third-part harmony and so on and so on.' The engineer said, 'Well, if you say so Walt, we can do it.' And we did it.

"When we first heard it played back, it was really beautiful," she said. "Sisters' voices blend well together, but when the same person is doing all the parts, the blend is unbelievable. Walt said, 'You know, all these years I've been paying the Andrews Sisters three salaries and I could've had you for one.'"

Although Woods's story is entertaining, Rannie doubts the effect was conceived and executed on the spur of the moment. He points out Disney had

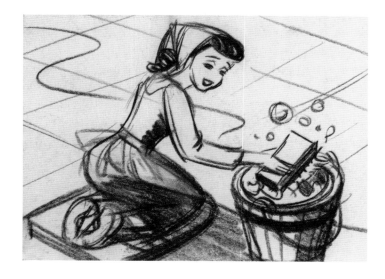

97

Below:
The cover for the original sheet music, which was released in conjunction with the film.

already featured Adriana Caselotti singing with herself in "I'm Wishing" in *Snow White*, and that Nelson Eddy had supplied three voices singing together in "The Whale Who Wanted to Sing at the Met" in *Make Mine Music*. But an arranger would have to write the parts for Woods to sing, and while it's easy to overdub with modern digital technology, setting up the less sophisticated equipment available in the late 1940s would have taken considerable time and effort.

"Her description doesn't make technological sense because it would have been a difficult setup to perform immediately," Rannie explains. "It's possible that the arrangement was originally for Cinderella and a group of backup singers who would record separately; and Ilene could have sung those parts herself. Overdubbing was in the air in terms of popular music, but it hadn't hit the big time yet. The musical zeitgeist of the 1930s and [19]40s, more than any specific person or technological breakthrough, points the way to 'Oh Sing Sweet Nightingale.'"

Regardless of the story, the music from *Cinderella* earned three Academy Award nominations: Best Scoring of a Musical Picture, Best Sound Recording, and Best Song for "Bibbidi-Bobbidi-Boo." The film was also nominated for a Golden Lion at the 1951 Venice Film Festival and received a Golden Bear for Best Musical at the 1951 Berlin International Film Festival.

A Princess's Premiere

Cinderella is one of Walt Disney's top achievements as an animated story-spinner. He catches the warm and simple charm of the Charles Perrault classic so effectively and with such easy presentation that the film truly is a delight, a cinch to please audiences of all ages.

— *Variety*, December 13, 1949

Opposite:
The original one-sheet poster for *Cinderella*.

Given the strained finances of the Studio, it's not surprising that Disney launched *Cinderella* with an extensive publicity and merchandising campaign. J. C. Penney offered a kit to "make your own Walt Disney's Cinderella apron." A home-improvement campaign used the slogan, "Make your home your palace, says Walt Disney's *Cinderella*: Clean Up, Paint Up, Fix Up."

Other tie-ins included bridal fashions, shoes for teenagers, and little girls' dresses. For "the sweetest story ever told," Libbey issued a line of jelly glasses with scenes from the film. Cottage cheese was sold in the same glasses, and a trade journal announced, "Walt Disney's *Cinderella* gives you

For All the World to LOVE!

WALT DISNEY'S

CINDERELLA

A LOVE STORY WITH MUSIC

Greatest since SNOW WHITE

Color by TECHNICOLOR

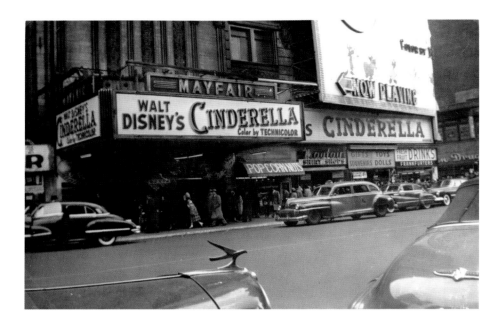

Right:
Crowds outside the Mayfair
movie theater in Times Square
in New York City shortly after
the film opened.

Above:
Walt Disney with a winner of
the Chicago Cinderella Girl
contest.

the greatest cottage cheese promotional theme the dairy industry has ever seen!"

One hundred Chicago high schools girls competed to be chosen as Cinderella in a contest held by a local department store. Ilene Woods appeared at a special screening of the film for the posh ($25-a-plate) New York Heart Ball. One of the highlights of the event was a society matron modeling specially decorated $3,000 designer shoes. *Life*, *Look*, *Newsweek*, and *Catholic Boy* ran feature articles about the film. In France, *Le Soir Illustré* included a fictionalized interview with a Cinderella, while a Disney Studio writer retold the story from Jaq's point of view in *Cinémonde*.

The reviews were generally favorable. In the *Los Angeles Times*, Edwin Schallert wrote, "Only Disney could create a picture so rich and imaginative in beauty . . . It is a wonderful fairy tale of the cinema for both children and adults. Its appeal should be universal." The *Hollywood Reporter* praised it as "just wonderful—the very best Disney since *Snow White*." Mildred Martin in the *Philadelphia Inquirer* gushed, "Disney and his staff are right back where they belong, at their best again in a world of sheer enchantment." Oscar Davis dismissed anyone who didn't like the film as "a Scrooge" in Washington, D.C., *News*. Although some critics complained that the Prince was wooden, there was unanimous praise for the mice and Lucifer.

In *Box Office*, Ivan Spear noted, "Inevitable it is that the picture will be compared on many counts with Disney's former masterpiece, *Snow White and the Seven Dwarfs*. And on virtually every one of those counts, the current offering must inevitably emerge with the laurels."

Martin wrote, "Whether, on every score, *Cinderella* quite equals *Snow White and the Seven Dwarfs* or not seems to us totally unimportant. Only a

churl would begrudge Walt Disney and his sprites a rousing, unreserved vote of gratitude." Schallert concluded, "Not, perhaps, since *Snow White and the Seven Dwarfs* has Disney done anything so delightful as *Cinderella* in the true familiar fairy-tale manner. In most ways it reveals progress far beyond that picture. In some respects (I am thinking of the dwarfs), it may not be quite as fully fledged. But for any time and any place it stands as rare and radiant filmmaking."

More importantly, the public embraced *Cinderella* with an enthusiasm that recalled the response to *Snow White*. One of the top films of 1950, the film grossed more than $4 million on its initial release. Buoyed by his first unqualified success since *Snow White*, Walt turned his attention to an ambitious slate of projects, one in which animation played a smaller part.

But *Cinderella* apparently held a special place in Walt's heart. Marc Davis said, "Somebody told me this second hand: they were having lunch with Walt and some rather important people, when one of the women said, 'Mr. Disney, of all the animation that's come out of your studio, what is your favorite?' He thought for a second, then said, 'Well, I guess it would have to be where Cinderella got her gown.' That doesn't mean that it's the best animation, but it means something about Walt's personality, that he picked this scene of a poor person overcoming the terrible degrading things that had happened to her."

Right:
Cinderella gracefully admires the reflection of her new gown.

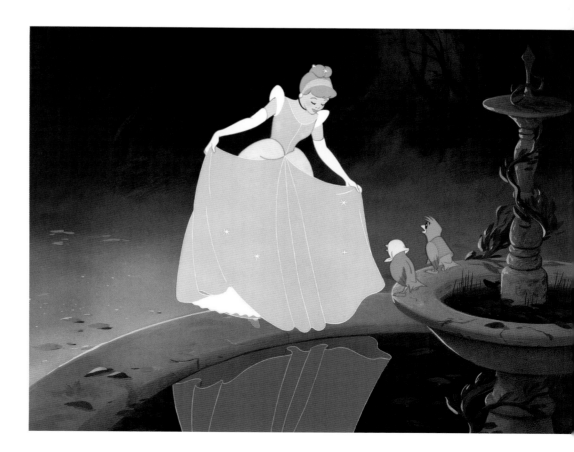

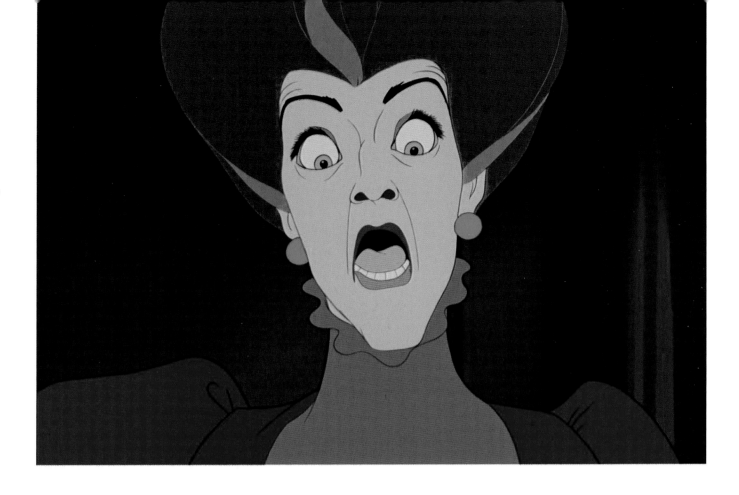

Above:
Lady Tremaine is aghast.

Unlike many films which enjoy brief periods of success and are then forgotten or dismissed as curiosities, *Cinderella* has retained its popularity. Its initial video release earned over $100 million, and *Toy Story* director John Lasseter notes, "In the tremendous success of Disney Consumer Products Division's Disney Princess line, Cinderella is to this day, the number-one princess. Some of the new ones we've created are becoming as popular. But she's the top because of how good this movie is."

In addition to the film's ongoing popularity with general audiences, it influenced many artists to choose animation as a profession—just as the Silly Symphonies had excited artists about the prospect of working at the Disney Studio decades earlier. Mark Henn, who animated many recent heroines, including Belle and Mulan, reflects, "*Cinderella* was pivotal in my career. I actually didn't have a career at six or eight when I went to see it. As a kid, I just loved to draw, and at that point I was old enough to understand that this was drawn. I didn't know how animation worked, but I knew that drawings made this happen."

Ratatouille director Brad Bird adds, "I saw *Cinderella* with an audience more than once, and I remember paying attention to how wrapped up and upset people got in the last fifteen minutes. I noticed that it had the same effect on different audiences. The same moments were excruciating whether it was the audience that I was with now or the audience that I was with the week before. I started to think there was a real art to the way stories could

be presented on-screen—and that certain people were doing it consistently better than others."

Lasseter sums up the enthusiasm of his generation's animation filmmakers when he says, "*Cinderella* is the pinnacle. [Walt's] true masterpiece. You feel that he had something to prove, too. *Snow White* was a massive hit and brought on a new form of entertainment: the feature-length animated film. *Pinocchio* was incredible, but the European market was going away. Then there were the war years. So coming out of that time, he really wanted to come back strong. I can feel that this was a very important film for him.

"Why I do what I do for a living is really because of those moments Walt did for me as a kid in the audience," Lasseter concludes. "What he did for audiences all over the world: blending story and art and animation and music and color and everything together to craft these incredible emotions. Happiness and hope and joy; good over evil."

Below:
The moment audiences feared would never arrive: the glass slipper fits!

Pages 106–107:
And, of course, they lived happily ever after.

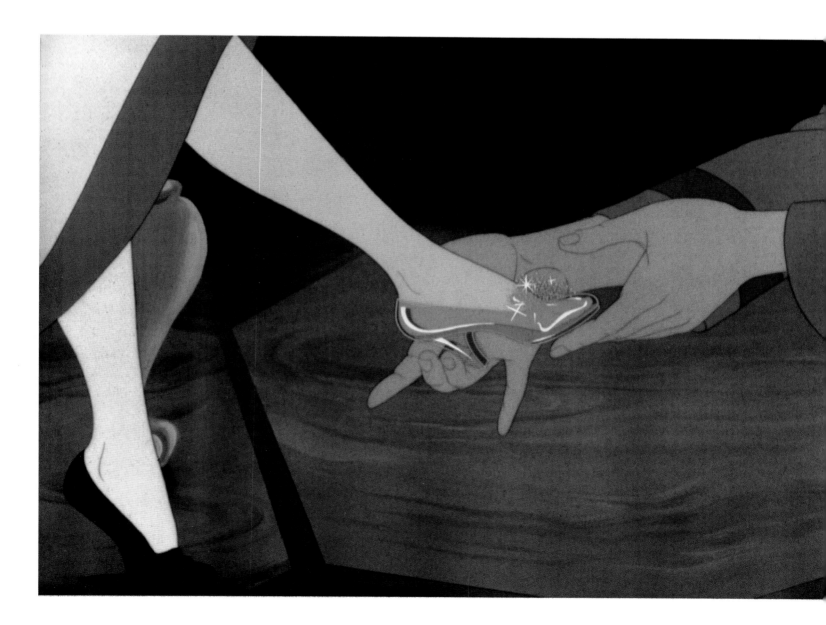

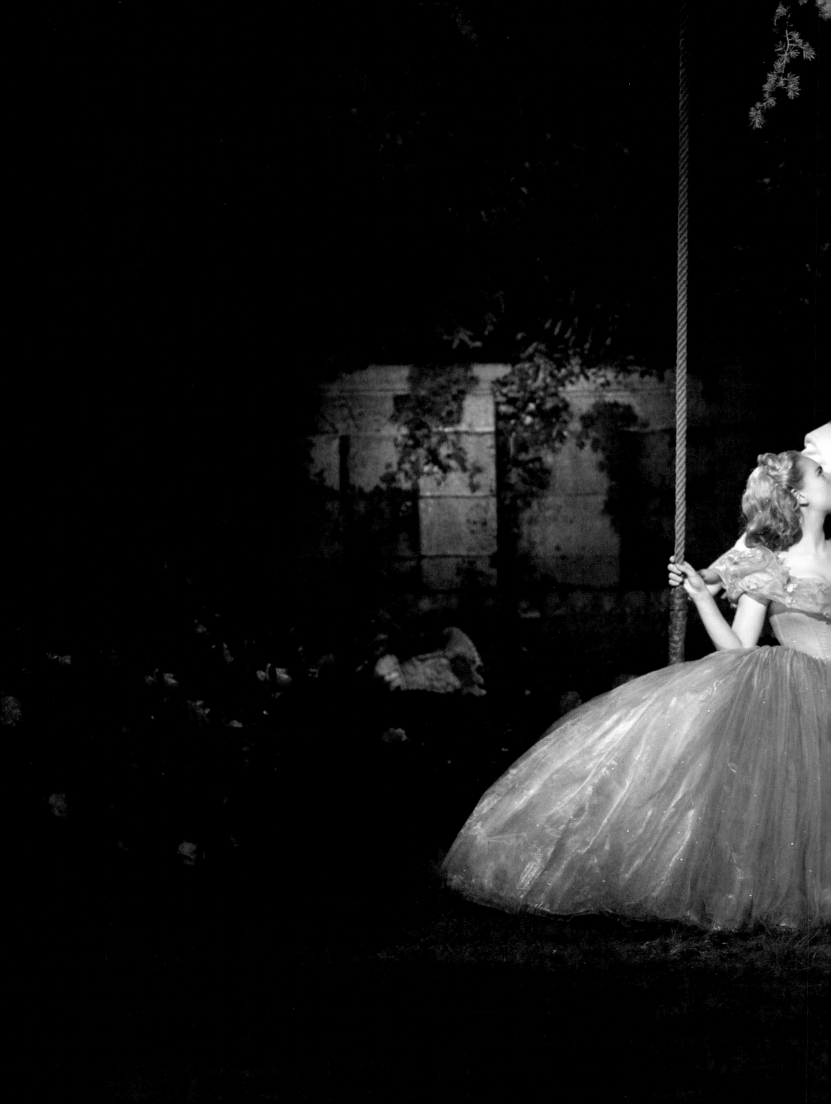

Part III
A Live-Action Fairy Tale

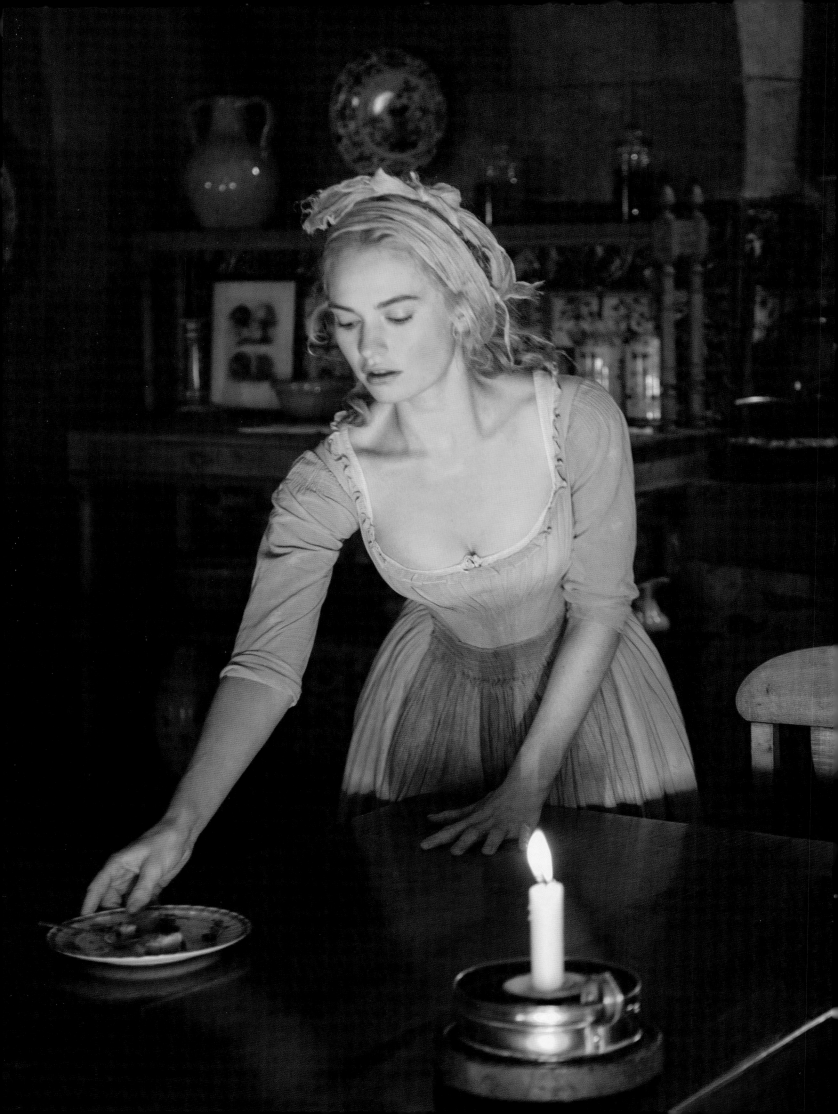

We all know the story of "Cinderella." We all know the story of Hamlet. *But we go and see* Hamlet *over and over because the best production makes us think maybe this time he* will *kill Claudius. Because it's truly funny and truly tragic, people are going to feel that they're being told the story of "Cinderella" for the first time.*

— Cate Blanchett (Lady Tremaine)

Pages 108–109:
Cinderella (Lily James) and the prince (Richard Madden) slip away from the ball to enjoy a quiet moment together.

Opposite:
James's attitude as she performs her morning chores suggests both Cinderella's gentle upbringing and her reduced status.

When the creative team at The Walt Disney Studios began thinking about making a live-action film of "Cinderella," their goals were both modest and grand. Everyone agreed that they wanted to re-tell the story in a way that preserved its classic elements and appeal. But they also wanted to make a beautiful movie that would endure for decades, just as Walt's animated version has.

"'Cinderella' is one of the greatest stories ever told, but no one has ever done the definitive live-action version," explains Sean Bailey, president of production, Disney Studios. "Walt Disney's would be considered the definitive animated film, certainly. Sometimes our competitors make these movies, and that's well and good, but we always think about how we can set the gold standard, the very best.

"That approach turned on a lightbulb: we've got to make the movie that people say, 'If you want to know the story of "Cinderella," this is the film to see,'" he continues. "We started developing the screenplay with a very talented writer named Chris Weitz. We got a wonderful director in Ken Branagh. The cast kind of came together from there."

Bailey's modest remark that some elements "kind of came together" covers months of work devoted to casting, development, and design. But everyone associated with *Cinderella* expresses the same enthusiasm and the same desire to make a film that balances the essence of the classic fairy tale with a contemporary sensibility to create a warm, human film that will appeal to viewers of every age.

111

Producer Alli Shearmur says, "Figuring out a way to build on the legacy of fairy tales at The Walt Disney Company was a high priority. They had a real desire to modernize the character of Cinderella without turning their back on the animated classic. Those were the basic priorities when I joined the project.

"I'd worked as an executive at Disney in 1993–96, but we weren't pursuing this kind of movie then," she continues. "*Cinderella*, in my opinion, is the most classic of all the princess classics. Having a daughter of my own who's now twelve, I've been through the princess chapter of her life. Cinderella has always been her favorite princess. They could never have anticipated what a giant honor the offer to work on *Cinderella* was for me."

As Shearmur's comments suggest, Walt Disney's *Cinderella* remains an important film not only in the history of animation, but in American popular culture. For decades, little girls have grown up wanting to look like Cinderella, dress like Cinderella, and share Cinderella's adventures.

Screenwriter Chris Weitz reflects, "I am a man. But I realized I had a chance to work on a film that would have a tremendous effect on generations of little girls who are going to see it. That's a public trust. My wife, my sister-in-law, and every other woman I know has seen and been deeply, deeply affected by the animated *Cinderella*. I took that fact very seriously and thought about it a lot."

Director Kenneth Branagh adds, "Disney wanted to readdress a story that was a central part of their DNA in the animated classic. They started by selecting the very talented Dante Ferretti and Sandy Powell as production designer and costume designer. I read the script, visited both Dante and Sandy, and tried to work out how the story spoke to me.

Below:
In this preliminary painting, Cinderella tends to the geese outside the Tremaine château. Artist: Adam Brockbank; medium: digital.

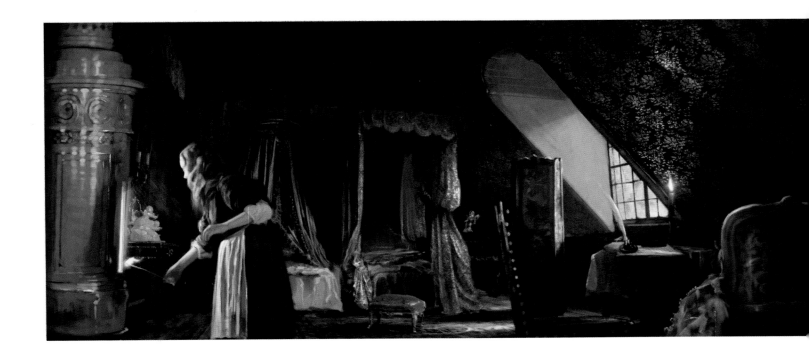

Above:
Visual-development art of
Cinderella cleaning Lady
Tremaine's bedroom. Artist:
Frederico Constani; medium:
digital.

"I had never considered directing a fairy tale," Branagh remembers, "but I was captivated by the power of the story and thought I was in sync with the visual artistry that was being developed. I felt it would be a wonderful thing to be part of."

"Our North Stars, if you will, were to try and make the definitive *Cinderella*, and to make one of the most beautiful films the Studio has ever produced," Bailey concludes. "We want it to be for families and children, but this story is so powerful, we believe it can play across all generations."

A Traditional Story for Modern Viewers

I love fairy tales in general—and "Cinderella" in particular—because they deal with complex issues that children face. So many stories that children get told now make them feel like they're heroes who can overcome anything, and the world is a perfect place. The timeless fairy tales, like "Cinderella," say the world can be a nasty place: you need a lot of courage and resilience. It's a story where kindness is a super power. That's something Ken [Branagh] talked about early on that I found really exciting.

— Cate Blanchett (Lady Tremaine)

113

Everyone involved in *Cinderella* was eager to retell the well-loved story. But inevitably questions arose about how to present the fairy tale in a way that would appeal to modern audiences while retaining the elements that made it a favorite of generations of readers and filmgoers.

"It's not only the quintessential underdog story, it's a story that says if you conduct yourself with kindness and dignity and courage in this world, you will be rewarded," says Bailey. "If you are brave and generous in the midst of cruelty, ultimately there is a good end for you. It's tremendously affirming. The story releases something very emotional inside most people.

"I think a lot of us go through a lot of change in the modern era; things are not as reliable as they once were," Bailey continues. "'Cinderella' explores how to conduct yourself in times of tremendous adversity, so the story has resonance. Revisiting the Disney movie and [Charles] Perrault, going back to the original sources, was very rewarding. But we looked to Perrault more than the animated picture. We paid pretty good attention to the Disney picture, but we said if we're going to go do the definitive version we need to go back to Walt's source."

Although the story retains a relevance for contemporary audiences, society has undergone enormous changes since Perrault gave the tale its definitive form in 1697. A young woman who was perceived as dutiful and obedient in the late seventeenth century might strike twenty-first-century viewers as a subservient doormat. But if the heroine abandoned her chores to take up the sword and fight injustice, no one would accept (or recognize) her as Cinderella.

"The version of 'Cinderella' we're doing is not revisionist," states Weitz. "She doesn't learn kung fu. She doesn't start her own business. She does what the character did in the fairy tale. If you're not careful, that character can seem submissive to a modern audience that's used to a different kind of heroine. The question was how to embody what we thought was great and beautiful about the story and the heroine. For us it was a tremendous sense of purpose and honor and fortitude that you don't see much in heroes these days.

"For a modern audience, it's very hard to figure out why Cinderella doesn't run away and go to social services or something like that," he adds. "She stays in what we would think of as an abusive parental relationship. But she has a tremendous sense of duty and honor and keeping her promise to her parents that prevails."

"The reason this story is told again and again is because the character is defined by her kindness and goodness and generosity towards others; she doesn't have to change those values to have her life work out in ways far better than she ever imagined," agrees Shearmur. "She can still be who she is, even though she's tested by cruelty and unkindness. I think we all like to

Above:
Young Ella (Eloise Webb) with her mother (Hayley Atwell): a scene the filmmakers added to the traditional story.

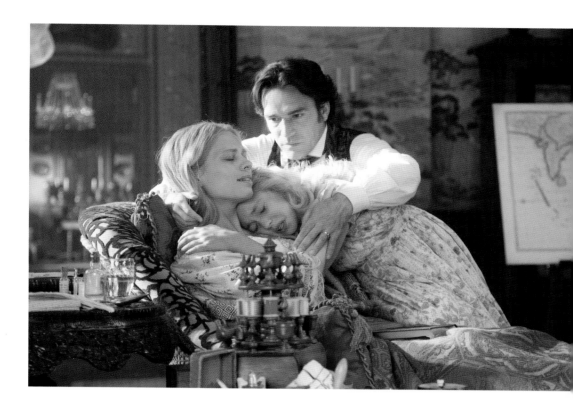

Right:
Ella (Webb) with her dying mother (Atwell) and her father (Ben Chaplin): the live-action film explores Cinderella's early relationship with her real parents.

believe that goodness and kindness will win out at the end of the day. This story allows our protagonist to be tested and emerge the same pure, kind soul she was from the beginning."

As Bill Peet noted sixty-odd years earlier, when he was at work on the story for the animated feature, the audience knows how *Cinderella* will end before they walk into the theater. The trick is to tell the story in a way that's so engaging, the viewers forget they know the outcome and worry about the heroine's fate.

The filmmakers added a prologue depicting Cinderella's happy childhood with her father and mother. Her mother dies when the girl is seven. On her deathbed, she asks Ella to promise she will have courage and be kind. Cinderella keeps that promise, even when her life darkens, first with the arrival of her stepmother and stepsisters, and then after the death of her father.

"On her deathbed, her mother says to Ella, promise me that you'll have courage and you'll be kind, and you'll be able to survive life without me. Ella lives by that promise," says Lily James, who plays Cinderella. "The father brings in a wife who's not wicked, but who's been battered by life. She needs to be supported. Ella's goodness versus her bitterness means that she begins to treat her like a servant. When Ella's father goes off on his travels, the stepmother can't cope with her goodness, so she abuses her."

Below:
Ella (Webb) examines a butterfly and its cocoon with her father (Chaplin). The love of nature that she learns from her parents influences her character throughout the film.

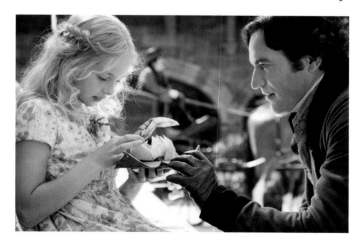

115

Above:
Pre-visualization art of Cinderella and her father leaving her mother's funeral at sunset. Artist: Gary Freeman; medium: digital.

Opposite:
A preliminary painting of the prince riding through the verdant woods, where he'll meet Cinderella. Artist: unknown; medium: digital.

Pages 118–119:
Cinderella (Lily James) and the prince (Richard Madden) meet by chance in the forest.

Cinderella's virtue and strength give her an independence and an autonomy that became central to the story. As Shearmur explains, "Something that Ken always talked about that was very important to us is Cinderella would be fine if the prince never found her. A major consideration was, 'How do we *not* make this a story where a girl gets rescued by a guy?'"

To fulfill this vision of "Cinderella," the artists had to expand the role of Prince Charming, who has traditionally been little more than a cipher. In the animated film, he represented an ideal and the realization of a dream, but he wasn't imbued with much personality. This prince had to have more depth and complexity or this Cinderella wouldn't be interested in him.

"'Cinderella' is an incredible love story. We know from the original that the prince becomes so enamored of her, he's determined to find her," says Bailey. "We had a lot of fun sitting around saying, 'So what were the obstacles in his way?' In any great love story, both sides have tremendous obstacles to

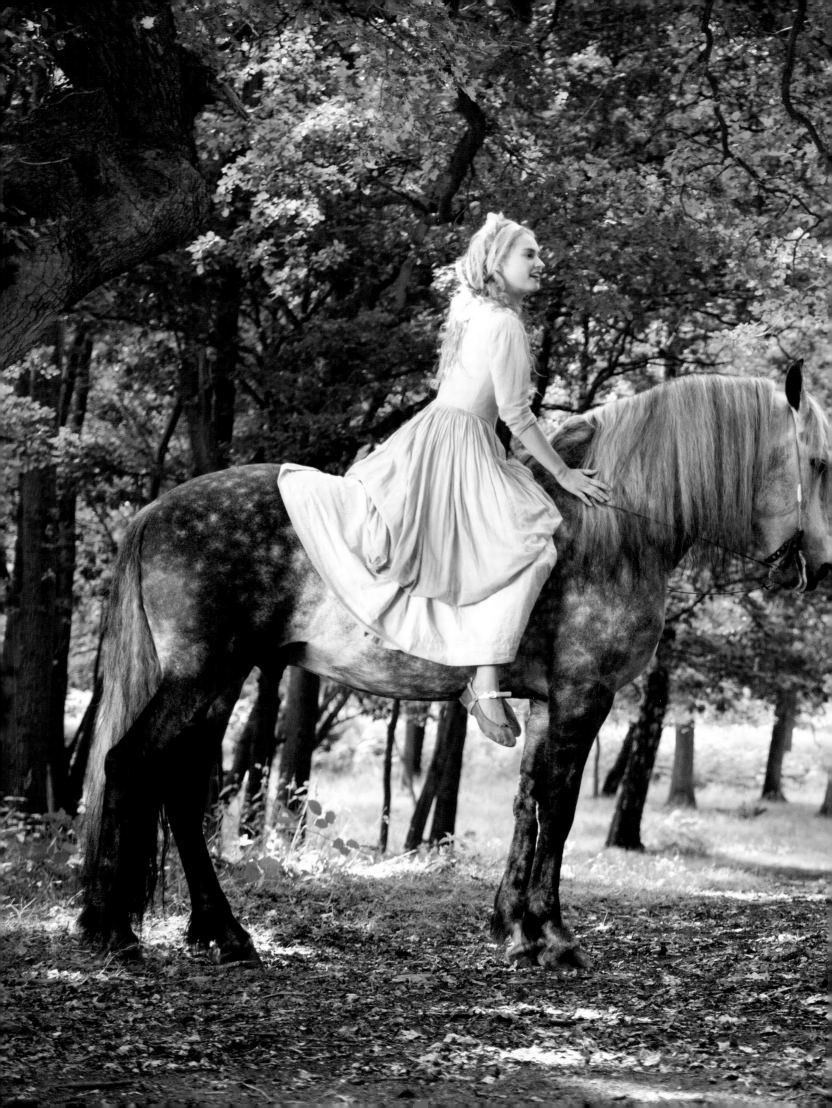

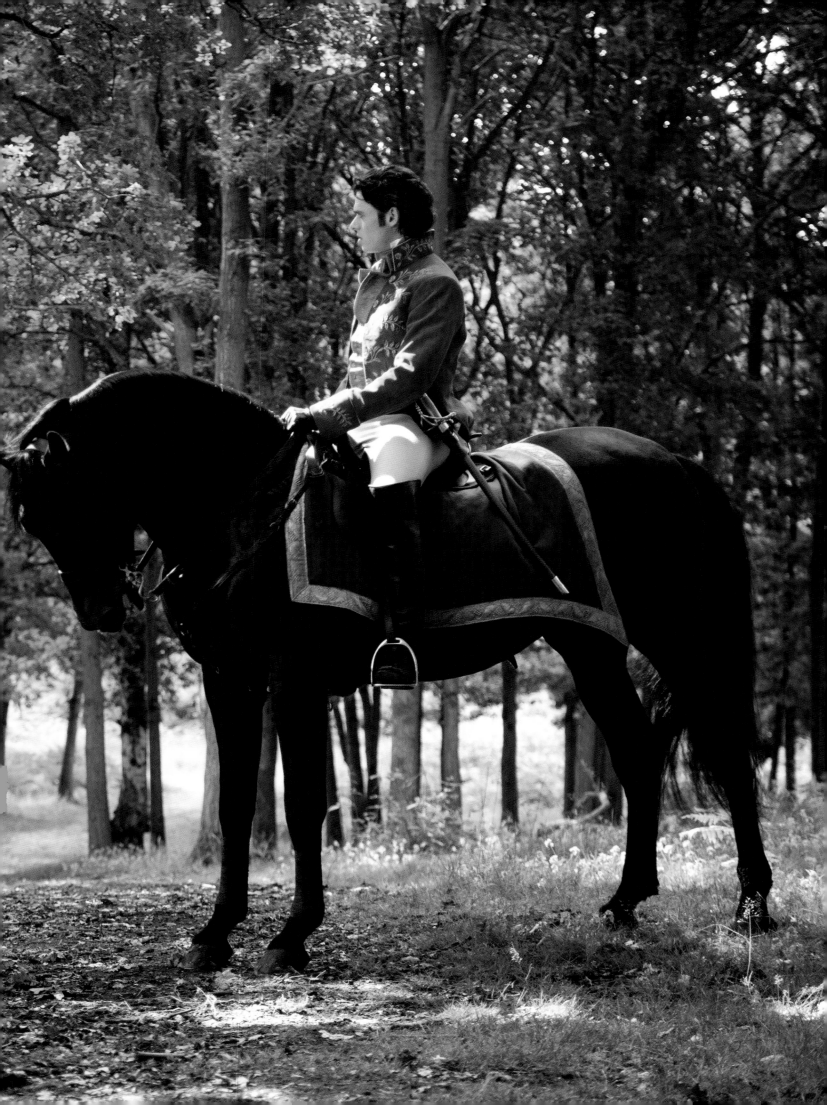

overcome in order to be together. It was really interesting to bring dimension to the prince who had traditionally been a one-dimensional character."

Richard Madden, who plays the prince, found the image of the character from the fairy tale and the animated film rather daunting. "Everyone has a strong idea of what Prince Charming is, but I worked very closely with Ken on who this young man was," he explains. "In the cartoon, you don't really know much about the prince until you actually see him. In this version, we learn that he's been at war for five years. He's a much more interesting character."

"We give our prince the sense of a man who has been in the wars, who knows in a very personal and meaningful way the cost of war," says Branagh. "He's less shinily innocent than princes have been in the past. We give him philosophical and political positions about how a country is ruled. He's surrounded by people who suggest that countries are ruled effectively by having wars, claiming other countries, and uniting kingdoms. He finds in Cinderella a kindred spirit who believes that the important thing is not to go to war with your fellow man, but to have courage, to be kind and generous, and, where possible, to turn the other cheek: to see that as strength, not weakness."

Below:
The prince (Richard Madden) and his troops riding through the forest after his encounter with Cinderella.

120

Characters

In the script, we tried to make absolutely clear that we were presenting a girl whose life would not be dependent on or defined by a man arriving. Her life would not be dependent on or defined by glamorous or expensive things arriving. Also, this girl would not be defined by having some easily available magical or supernatural force, like a fairy godmother as an omnipotent, omniscient agent who would take care of everything. The fairy godmother helps, of course, but as in life, things are mostly up to the individual. Cinderella rises to the challenge.

— Kenneth Branagh, Director

As Weitz continued working on the script, the filmmakers turned to the challenges of casting. Branagh presented a clear vision of the qualities the actress playing Cinderella would have to express and embody.

"Cinderella has a strong sense of humor and maturity. She assumes people don't necessarily mean to be cruel and aren't necessarily evil," the director explains. "She can turn the other cheek. She can find things funny. She can be happy with her surroundings. She knows how to enjoy a sunny day without seeming like a simpering or precious individual. She is at ease with herself, and has a full sense of her own identity. She's interested in other people and is naturally generous and unselfish.

"These things are presented as expressions of strength, not weakness," continues Branagh. "We do indeed have her stand up to the stepmother: as in modern life, one might reasonably expect someone to eventually stand up to those who have done them wrong. We see her use her intelligence. We see her forgive. We present Cinderella as a distinctly strong individual whose spirit and maturity is her easy power. She is not a helpless or self-pitying victim. She is a very present, very positive, spiritual individual."

Clearly, the role would be a complex, challenging one for any actress, let alone one young enough to be a credible Cinderella. Shearmur says, "There were so many different boxes that needed to be checked: a purity, a goodness, an innocence. Someone you believe hasn't yet fallen in love. Someone capable of tremendous compassion. A beauty, but a real beauty. In our process of finding Cinderella, we met with many different sorts of women, not just ones defined by the classic image of Cinderella in the animated classic. We were very interested in somebody who looked and felt like a real person."

After discussing the performances and potential of numerous ingénues, the filmmakers chose Lily James, a British actress known for her role as the rebellious and scandalously modern Lady Rose MacClare on the popular miniseries *Downton Abbey*. James, who found the prospect of playing Cinder-

Below:
Cinderella (Lily James) goes about her duties, wary of what her stepmother and stepsisters may demand next.

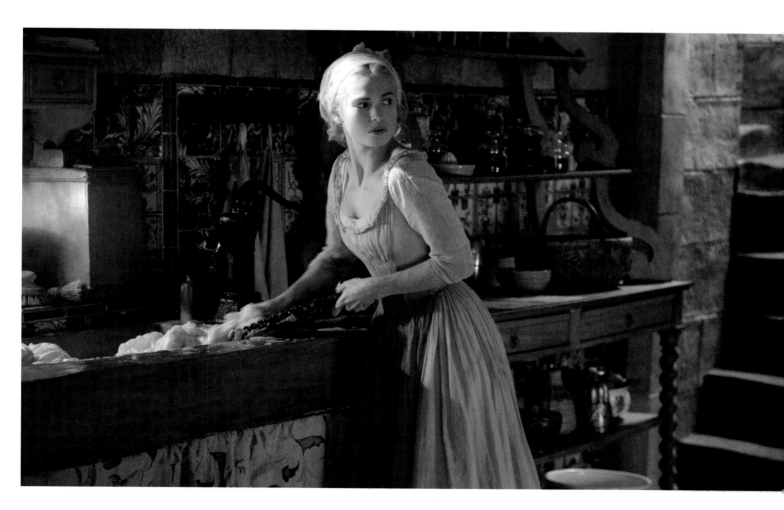

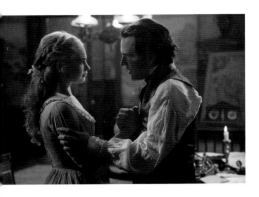

Above:
Cinderella (Lily James) bids her father (Ben Chaplin) farewell, not knowing it will be for the last time.

Below:
Cinderella (James) in the village with her stepsisters Anastasia (Holliday Grainger) in yellow and Drisella (Sophie McShera) in pink. The gaudy colors of the stepsisters' dresses suggest cotton candy.

Opposite:
Asleep by the hearth, Cinderella (James) dreams a wish her heart makes.

ella both frightening and exciting, reflects, "Everyone has a vision of Cinderella, whether it's from the animated or live-action films or storybooks. You've got a big act to follow. It's very scary. I did yoga to try to get the posture and the grace, the elegance that Cinderella has. I watched every Disney movie involving a princess, and *Cinderella* loads of times. But at a certain point, you have to let go of the animation and embody it your own way."

Turning to the complicated relationship her character shares with the stepsisters, James continues, "I don't think that Cinderella actually dislikes the sisters: she doesn't understand them, and I think she pities them. She sees they're unhappy, selfish human beings. She also finds them funny. But there's certainly pain involved. She hates them at times, but she struggles with her feelings. She's got that strength."

Halfway through filming, James still hadn't fully absorbed her fairy-tale reality: "Obviously every girl wants to be a princess, but to be a Disney Princess and Cinderella feels like it's too much to believe," she commented. "It's a dream role, because she's so special, and kind, and unique."

Shearmur adds, "As a woman and the mother of a daughter, I think it's fantastic that she's a strong female character. Just because she's kind and good doesn't make her weak. It makes her stronger. She believes in herself and in the goodness of the world around her, and that allows her to succeed. We

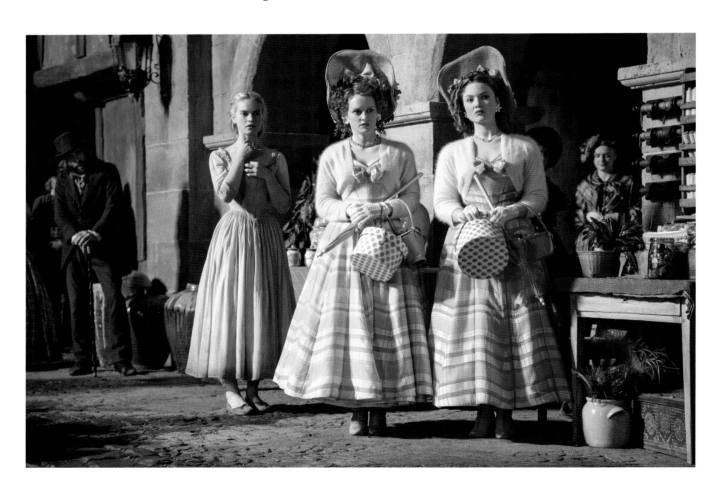

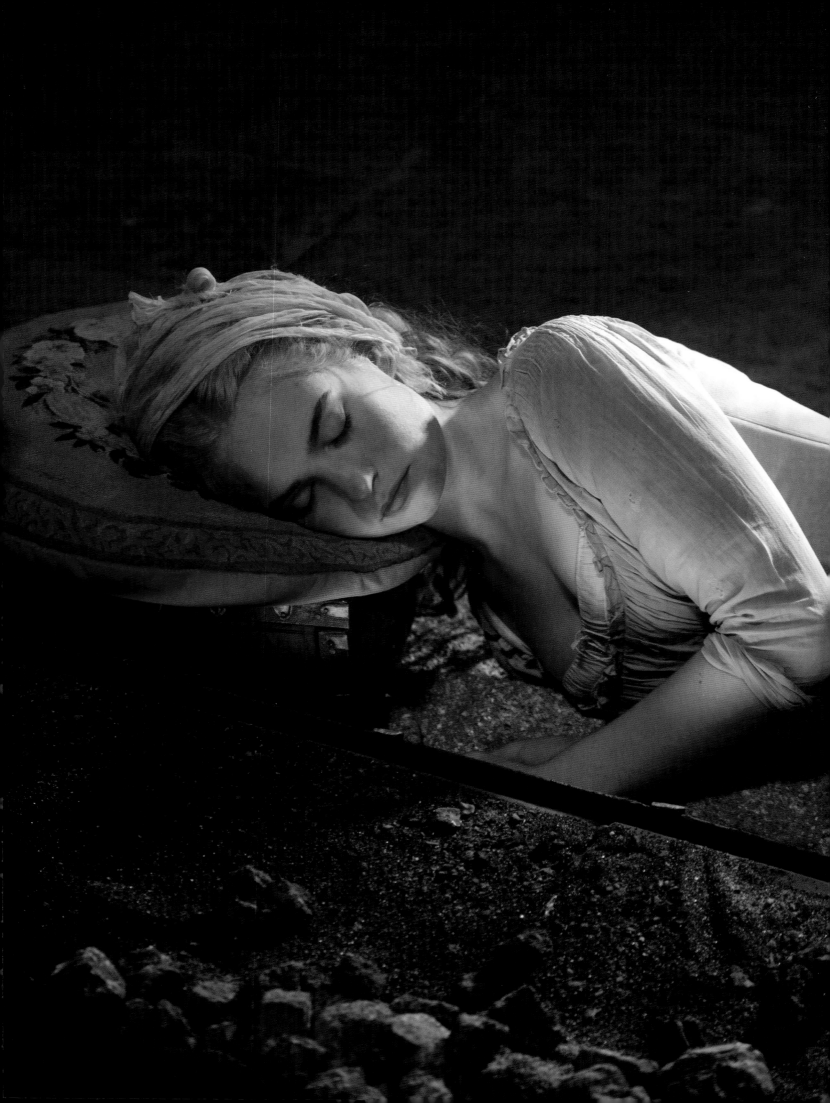

124

remember the legacy of the animated film, which people love. But more of the consideration was how do we *not* make this a story where a girl gets rescued by a guy who thinks she's pretty, so she gets married and has a big house and all these great things. The strength of the character is why I believe the story keeps being told."

Holliday Grainger, who plays the stepsister Anastasia, recalls that on the set, James truly embodied the character of Cinderella, "I felt really starstruck when I first saw Lily in the ball dress, because she looks just like Cinderella, but come to life and even more beautiful!"

Unlike Cinderella, the fairy godmother was not nearly so well defined as a character. Perrault created her but didn't really describe her personality or appearance. Over the years, illustrators have portrayed her in very different ways, and the Disney artists turned her into a somewhat befuddled maiden aunt.

Helena Bonham Carter has played the romantic Lucy Honeychurch in *A Room with a View*, the murderous Bellatrix Lestrange in the Harry Potter films, and the sensible Queen Elizabeth in *The King's Speech*, for which she received an Oscar nomination for Best Supporting Actress. As she and Branagh have been friends for years, the casting process was simple: "Ken texted me and said, 'Would you like to play the fairy godmother?' It sounded like a good idea, and it was as simple as that.

"Playing the fairy godmother was fun, but it's a bit like reinventing the wheel: You think, 'Why did she make a carriage, and where does she get the mice and why should it be a pumpkin?'" she reflects. "I came up with the idea that she might not be a totally efficient fairy godmother. They're late for the ball and she's incredibly old, so she's not quite with it mentally.

"I start off as an old beggar woman; it took them four hours to make me look about a thousand years old," she continues. "It took about five hours

Below:
Cinderella (Lily James) first meets her fairy godmother (Helena Bonham Carter) in the guise of an old beggar (left). But the character soon reveals her true appearance in a glowing gown (right). Carter described herself as looking like "a night lamp on a little girl's bedside."

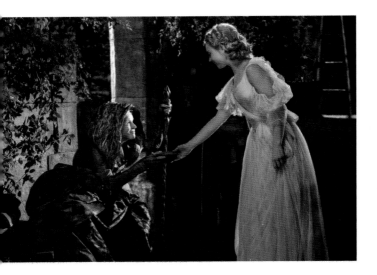

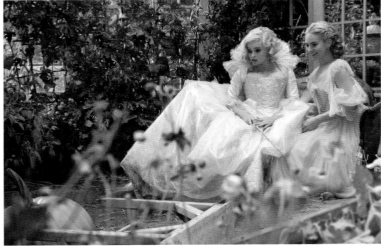

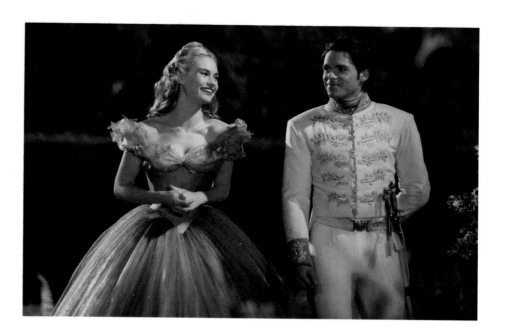

Right:
Cinderella (James) and the prince (Richard Madden) leave the ballroom to stroll through the palace garden.

to make me look like a fairy godmother. She's basically what a five-year-old would think is a perfect fairy godmother—which might not be what everybody else thinks is perfect."

When it came time to cast the prince, Branagh, who has played dashing heroes from Benedick and Hamlet to Sir Ernest Shackleton, had definite ideas about how to flesh-out the character. "We make him a pragmatic realist in a messily political world. We give the prince a problem, but we make him a thinking man and a feeling man, not just a handsome sap. He has to prove himself the spiritual and moral equal of Cinderella, with her depth of feeling and understanding."

The challenging assignment was given to Scottish actor Richard Madden, who won the attention of viewers as Robb Stark in the hit cable TV series *Game of Thrones*. As it turned out, Madden was already well versed in the Disney animation legacy: "There are so many amazing Disney moments I love: when Aladdin takes Jasmine on a magic carpet ride; when Simba's raised up above all the other animals. From *Cinderella*, I remember clearly from my childhood the moment when you see the stepmother in bed. You just see her eyes coming out of the darkness in the morning. I also remember moments that break my heart, especially when you see Cinderella crying. It's really moving how they capture these moments through animation."

Madden understood Branagh's desire to make the prince a more complex character. To prepare for the role, Madden explains, "I read a lot of books about being a young ruler and being unprepared for it. I tried to read the books I imagined that the prince would have read at the time, including Machiavelli's *The Prince*. That was one intellectual way I was trying to understand this young man."

125

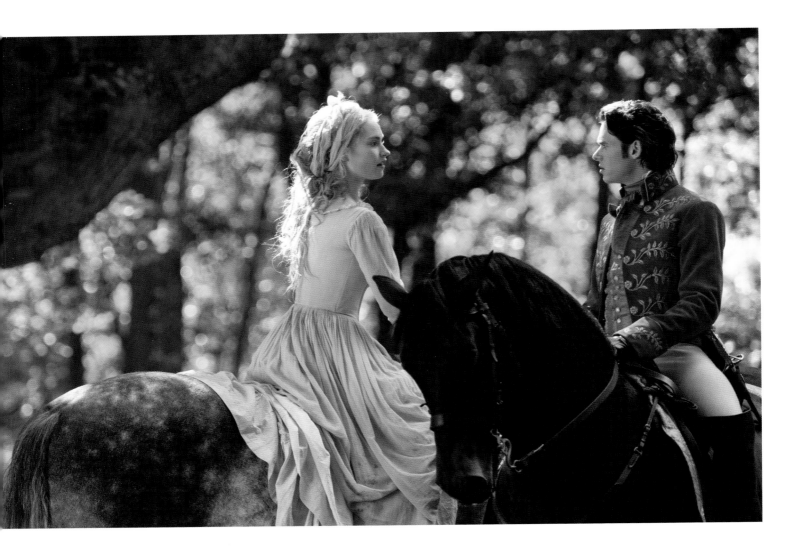

Above:
When Cinderella (Lily James) and the prince (Richard Madden) meet for the first time, he discovers she is an intelligent young woman with ideas of her own.

After seeing the two leads interact on camera, Branagh was deeply satisfied with the layers that their acting lent to the characters: "The performances of both Lily James and Richard Madden have intelligence, depth, and complexity in the way they react to things, in the way they carry themselves, in the way they present a weight of thought. These are people you sense feel deeply, but [they] also have enormous capacity for fun and kindness."

Of their on-screen chemistry, Madden comments, "I love the relationship between the prince and Cinderella; there's so much humor in it. It feels modern in terms of how they connect with each other. The scenes where the prince and Ella speak to each other properly for the first time have a very teenage feel to them. You don't know how to talk to each other; you really like someone, but you don't quite know if they like you back. The story lends itself to that element of insecurity that comes with a new relationship. It gets very confusing but very real."

The filmmakers wanted to deepen the personalities and explore the backstories of all the characters in the story, not just the hero and heroine. A stepmother who could abuse Cinderella without becoming totally

unsympathetic to the audience demanded an actress who was capable of presenting a multifaceted performance on the screen.

"There was always one person in everybody's mind for the stepmother: Cate Blanchett," says Shearmur. "We were interested in her for many of the same reasons Ken was interested in doing the movie: developing a complex psychology and a more fleshed-out understanding of who these characters were. Both Ken and Chris wanted to know these characters in a deeper way, so they were real human beings and not simply archetypes."

Blanchett, who dazzled audiences as the emotionally damaged title character in Woody Allen's *Blue Jasmine*—and won an Academy Award for Best Actress for her performance in it—reflects, "No one is purely evil: everyone's got a motivation. The stepmother is what happens when good is perverted: it often turns wicked. I was interested in exploring what makes someone wicked. Through little vignettes, you get a glimpse that this is a woman who has tried to start her life again, and becomes intensely jealous of the deep affection that her new husband has for his daughter, Cinderella. When he dies, the financial pressures, the panic, and the jealousy grow: that is what makes her wicked. She's not as beautiful and not as kind and as good as Cinderella."

Below:
Cinderella (James) serves breakfast to Anastasia (Holliday Grainger), Lady Tremaine (Cate Blanchett), and Drisella (Sophie McShera).

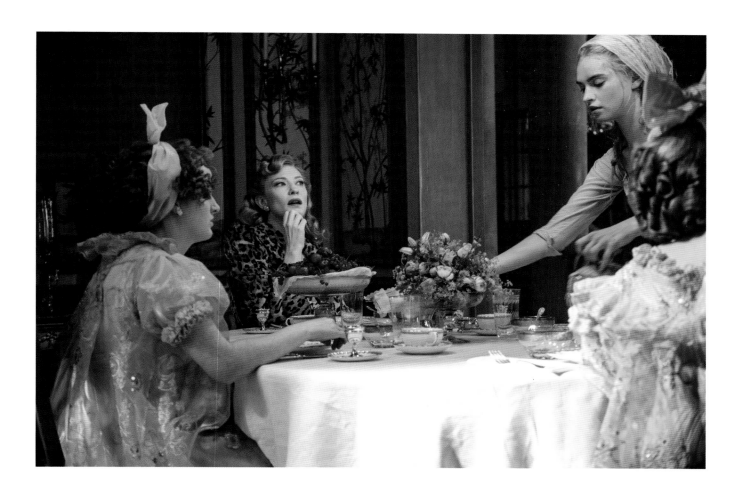

James adds, "There's a great scene where Ella asks the stepmother, 'Why do you treat me like this?' She says, 'Because you are good and young and beautiful—and I am not.' This woman has had a hard life, and doesn't deserve what's happened to her. She's not just a villain, and she's not just cruel: it's much deeper."

Weitz continues the line of thought, explaining, "We don't necessarily view the stepmother as a villainous figure. Cate Blanchett is a tremendously compelling actress. She makes you see the point of view of the stepmother much more than you do in other versions of the story."

For the stepmother's two spoiled daughters, the filmmakers decided to keep the names the Disney artists had invented: Anastasia and Drisella (spelled with an 's' as opposed to a 'z' as it had been for the 1950 film). But they insisted that the girls, like the stepmother, had to have more depth than traditional versions of the story provided.

Below:
Lady Tremaine (Cate Blanchett) examines Cinderella (Lily James) as she descends the stairs in her mother's remade gown.

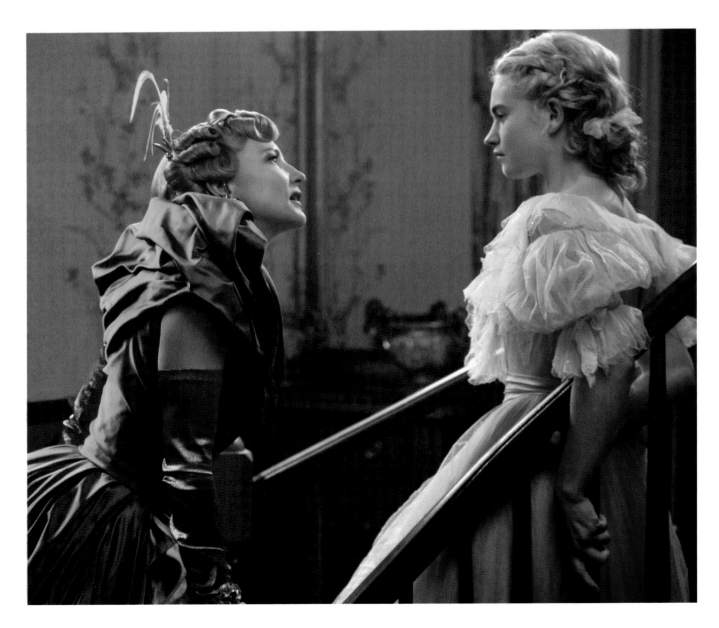

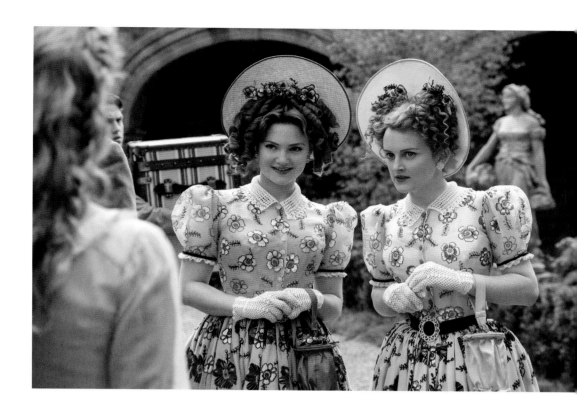

Right:
Cinderella (James) stands by while Drisella (Sophie McShera) and Anastasia (Holliday Grainger) exchange unpleasantries.

Pages 130–131:
Lady Tremaine (Cate Blanchett) and Drisella (Sophie McShera) try to look assured and composed, while Anastasia (Grainger) wrestles with the Captain of the prince's guards (Nonso Anozie) and struggles to cram her foot into the glass slipper.

Holliday Grainger, who appeared as Estella in Mike Newell's adaptation of Charles Dickens's *Great Expectations*, was chosen as one stepsister. "The Disney fairy stories are such an important part of most kids' growing up—*Beauty and the Beast* was always my favorite," the actress says. "In *Cinderella*, I play Anastasia, whom I've decided is the younger, pretty one to Drisella's not-that-clever one. They both have such a lack of self-confidence that comes out in jealousy and selfishness. It's not their fault they're not that attractive or talented, and that no one wants to marry them.

"Finding backstories is all about finding motivations for your character, what makes them do the things they do," Grainger continues. "The stepmother and the stepsisters have the feeling of a wolf pack. The stepmother is the head honcho; Anastasia and Drisella look to her for approval. They do the things they do to get approval from the master of the pack."

Sophie McShera, whom viewers know as Daisy, the ambitious kitchen maid in *Downton Abbey*, plays Drisella. "The name 'Cinderella' is a stroke of genius of mine," she says. "[The stepsisters] brainstorm over breakfast for mean names they could call her, and Drisella comes up with Cinderella. I hope we provide a bit of comic relief and aren't just vile. We are pretty vile, but we look ridiculous, so you can't help but feel a bit sorry for us sometimes."

The two actresses clearly enjoyed playing off each other, and became close friends. Each woman is quick to praise the other's talent, and speaks fondly of the bond they've developed. "Sophie's got such comic timing; she's funny in everyday life," says Grainger. "On set, we spend hours together get-

129

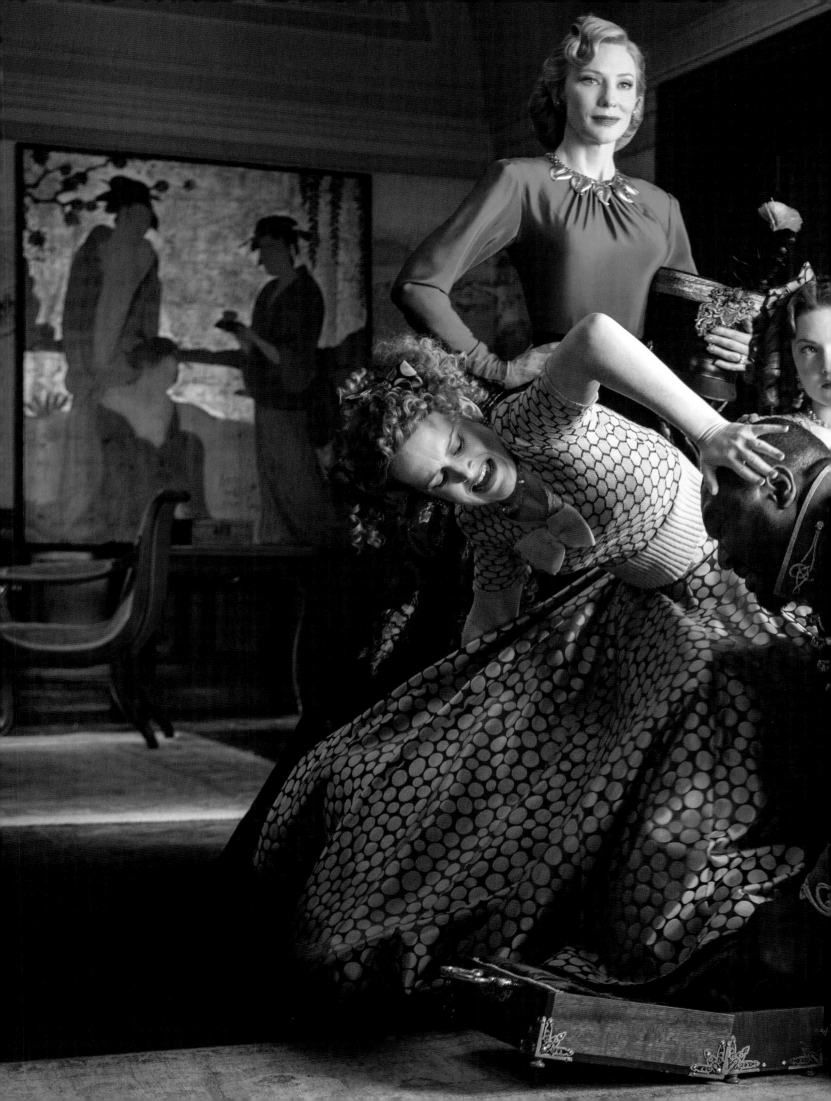

ting ready: Ken likes us to do improvisation. As a result, Sophie and I have developed a rapport: we have to overlap our words, finish each other's sentences, and drag each other around, be silly on set."

"I've had so much fun working with Holliday," McShera replies. "It's been so nice to bounce off somebody, and she's really funny and clever. It would have been weird if I had met my sister and we hadn't got on, because we've spent every hour together. I'm getting separation anxiety, because we're about to finish, and she'll go back to Manchester."

An Actor's Director

We wanted to tell this epic love story and character journey. We wanted to see this opulent world and incredible performances from an incredible cast. So Ken just seemed like a natural choice. In our early conversations with him, he talked like a sculptor chipping away at a block. He wanted to reveal it more than just fabricate it. That felt very true to what we were trying to do.

— Sean Bailey, President of Production, Disney Studio

Above:
The young Ella (Eloise Webb) watches as the royal guards ride past.

As a director, Branagh has made an array of notable films, from the pastoral version of *Much Ado About Nothing* to the blockbuster action hit *Thor*, before coming on to *Cinderella*. All the filmmakers share an enthusiasm for Branagh's intensity, flexibility, and vision. Supervising art director Gary Freeman says, "When Ken came on board, the art department presented him a context for the film. Fortunately he fell in love with it and went with it. He's a very precise man, very practical. His attitude wasn't, 'I'm the king of the castle, and this is what I want.' He worked with us."

Grainger is even more enthusiastic in her recollections: "For the audition, we spent about an hour with Ken just playing: trying it really theatrical and melodramatic, trying it subtler, trying the comedy. It felt like an acting workshop with Kenneth Branagh. Actors would pay a fortune for that hour! When it came to rehearsals, Ken, Sophie, and I sat down and talked about potential backstories of the characters and tried to find psychological realism for the roles. He'll often let you bring what you want to a scene, but then his notes are really specific. He's always interested in adding the psychological realism to the characters, and knowing our reasons for doing things."

"It's a behemoth, the legacy of a Disney classic and a classic fairy tale: there are such expectations," says Blanchett thoughtfully. "Ken was able to find the tone of the film, at once sweet and delightful, but also sinister. He was

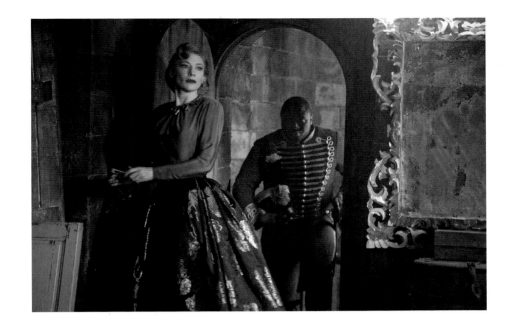

able to harness the domestic moments between the characters, and the grand moments. He's got a wonderful sense of rhythm as a director. You knew you were in safe hands. Being such a great actor, he's very good at using the rehearsal time in the morning. He's able to incorporate everyone's process, and make it feel like a collective effort."

Branagh's experience on both stage and screen enabled him to help Madden flesh-out the personality of the prince. "I realized that we were going to have to create a character from scratch that had never been understood properly before," Madden adds. "Ken challenges me as an actor every day, and challenges the way I'll play a scene. We have these great days on set where we play around with the scene and do it in many different ways, which really frees you up."

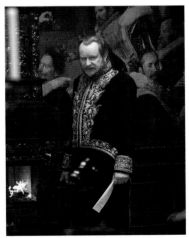

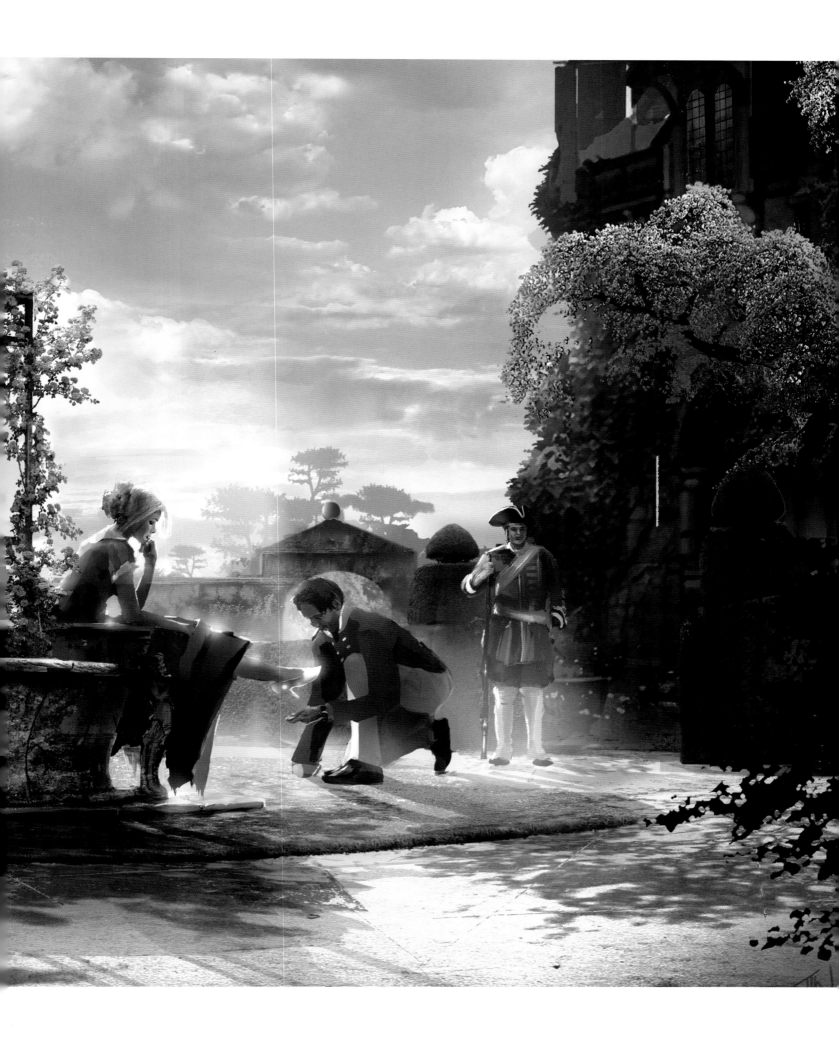

A Vision of the Screen

It was a challenge to find a new vision of the story, but I am certain that the audiences of this Cinderella *will truly see something they have never, never seen before.*

— Dante Ferretti, Production designer

Pages 134–135:
The prince fits the slipper on Cinderella's foot by a marble planter in this preliminary painting. Artist: Tom Wingrove; medium: digital.

Above:
An inspirational painting of Cinderella's early life with her parents and pet at the château. Artist: Adam Brockbank; medium: digital.

One of the major decisions the filmmakers faced was where and when to set *Cinderella*. The backgrounds in the Disney film evoke provincial France; the women's dresses suggest the nineteenth century, but no specific year or even decade. For the live-action film, the artists agreed that the mid-nineteenth century was the best choice, but that neither the time nor the setting should be too specific.

Branagh felt the lack of specificity was liberating. "I found it releasing to have some license and flexibility. It's an impression of the nineteenth century. The palace suggests the Austro-Hungarian Empire: great polish and hurrah and splendor. A country living in a potentially idyllic interconnectedness and harmonious relationship to others," he says.

"But we also wanted to deliver a place that had the possibility of magic and the intervention of a fairy godmother," the director continues. "So the

opportunity to make something just a little more heightened was a useful by-product of borrowing from architecture and costumes and designs across the whole of the nineteenth century, rather than a specific, documentary-led date. It allowed us to have the audience feel comfortable about the distance at which they were seeing this; the way people speak and dress and react sits comfortably in the world of a fairy tale. It allows for the drama of magic."

"The story of 'Cinderella' is absolutely timeless in the best possible sense," agrees Blanchett. "To locate it in one particular period would have been to say, 'that was then, this is now.' These visuals are much more opulent and available to our modern eye."

Production designer and three-time Oscar winner (*Hugo, Sweeney Todd: The Demon Barber of Fleet Street,* and *The Aviator*) Dante Ferretti notes that placing the story in the mid-nineteenth century allowed him to incorporate earlier styles of architecture into the settings. The kingdom that the prince will inherit has stood for a long time; the buildings reflect its history. "The characters

Below:
Preliminary artwork of the prosperous, vaguely central European kingdom where the story takes place. Sailing ships in the river below the town suggests a bustling community (top). Artist: Unknown; medium: digital. The keep of an old castle still guards the bridge leading into the town (bottom). Artist: Gary Freeman; medium: digital.

live amid locations that were built centuries before the year in which the story is set. So I took elements from many older periods and different countries and places," Ferretti explains.

Freeman, whose work encompasses films as varied as *Saving Private Ryan* and *Pirates of the Caribbean: On Stranger Tides,* adds, "Ken wanted the look to be sort of mid-nineteenth century. Setting it then allows you to use a broader spectrum of architecture.

There are buildings that could have been there in the fifteenth or sixteenth century. Dante referenced the Baroque quite a lot, because it has a magical, luxurious quality to it. That style originated in the seventeenth century, but was revived in the rococo and later years, so it gives you a broader architectural historical background."

As is often the case in modern filmmaking, the ideas for the sets were worked out using a combination of traditional materials and cutting-edge computer techniques. "Dante makes pastel sketches, but they tend to be design development—something you'd sketch on your pad to think out composition and details," Freeman continues. "Because these films cost a lot of money, people really want a clear idea of what they're getting for that money. We use computer visuals because we can take a photograph, dress the location and change the lights to reflect the mood of the scene. People want to see what they're buying into. The sketch pad still is in the background, but the computer screen tends to take front row these days."

Everyone involved agreed that the ballroom, where Cinderella officially meets the prince and they share their romantic dance, had to be an

eclipsing vision of beauty that would add to the significance and emotional weight of the encounter. Ferretti notes, "The ballroom had to be magical, so I looked at a lot of French architecture, like the Louvre and the Opéra Garnier with its great staircase. Then we added our own touches, like the frescoes and set decoration. The set decoration is very important in this film, for example the curtains in the ballroom took two thousand meters [nearly three-quarters of a mile] of material, so it was really a huge job."

Crews built most of the enormous ballroom on the 007 Stage at Pinewood Studios, near London. "We built the set to a height of thirty feet. The remaining sixty or seventy feet is a digital composite," explains Freeman. "It's huge, it's spectacular, all marble finishes. But it isn't overly pumped up on steroids. It was beautifully lit. The one thing they did make a lot bigger were the chandeliers. Francesca, the set decorator, really wanted to do over-the-top chandeliers; they're works of art in themselves. But it's really about the moment, the dancing."

The chandeliers were custom-made in Venice, and it took more than an hour to lower them all, light them, and restore them to their proper positions. Blanchett recalls her initial impression of the ballroom: "The first time I walked onto the set, even before it was lit, I was gob-smacked. I had to pick my jaw up off the floor. Then to see what Sandy did with the costumes, it was like an old MGM Technicolor moment: I felt transported back in terms of cinema.

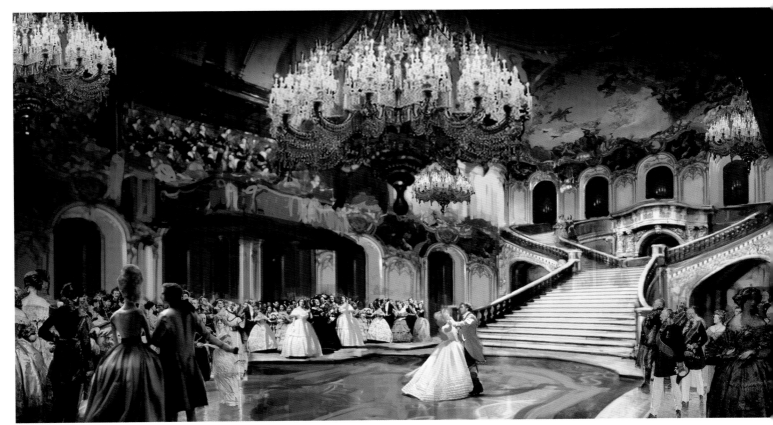

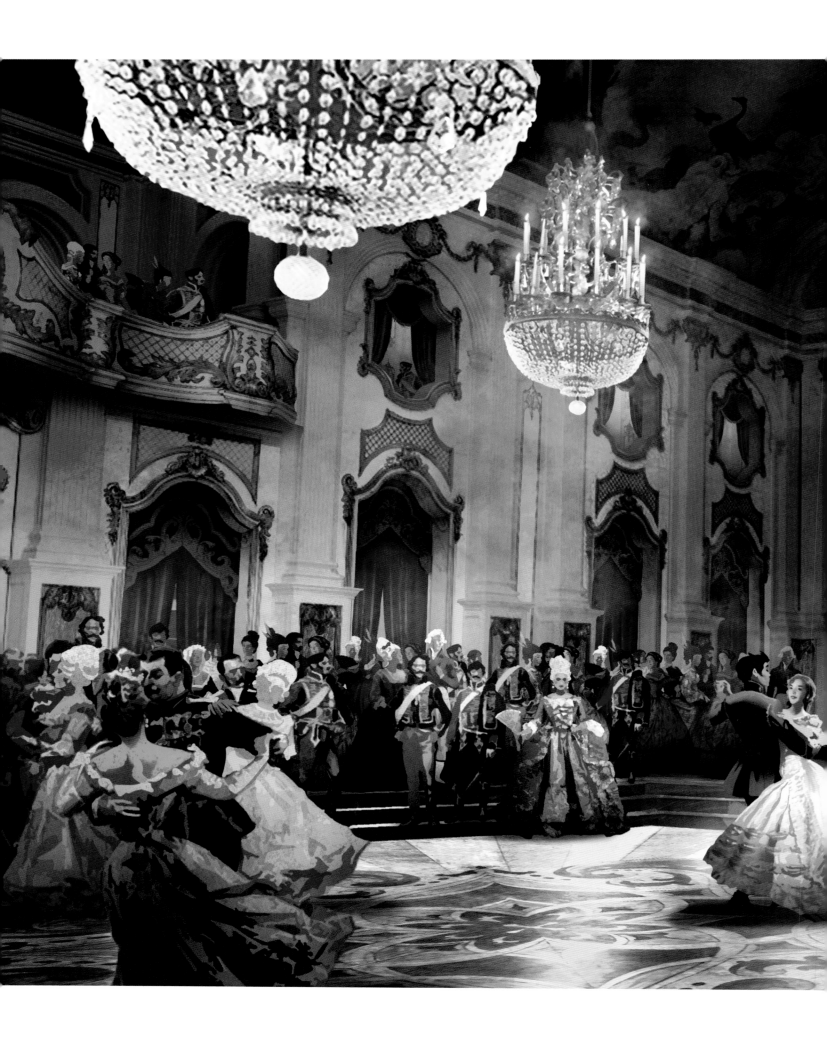

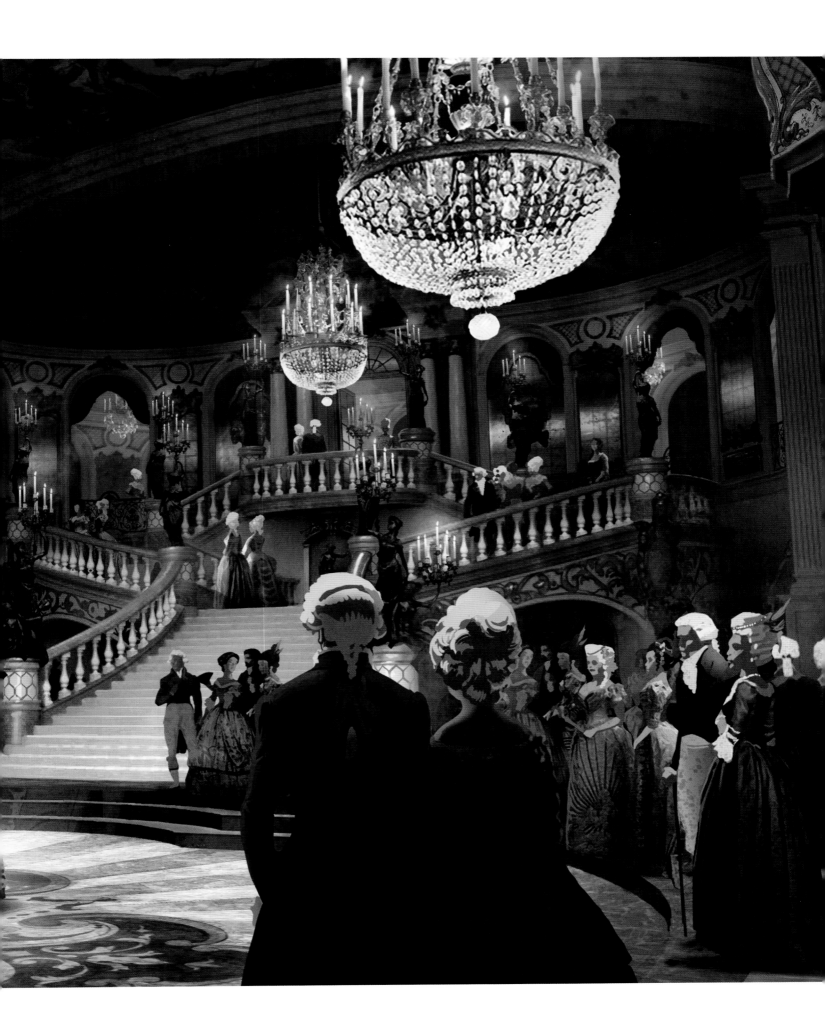

"It was a wonderful, storybook world to enter," she continues. "But when Richard and Lily took the floor, it was really hard because my character has to be suspicious and judgmental and jealous. Here were these two young people who had worked so hard on this dance. They were so graceful and so true, and kept the focus on one another. I don't think there was a dry eye in the room."

But to reach that glittering ballroom, Cinderella needs the gown, coach, horses, and attendants her fairy godmother creates from humble materials and creatures. The effects had to look truly special, a daunting challenge in an era of over-the-top, effects-laden films. And it was essential that the metamorphosis of the pumpkin into the coach, the mice into horses, and the lizards into footmen support the emotional tenor of the moment.

"The problem is that audiences have seen practically everything on-screen," says Weitz. "The question becomes not one of making the most magnificent thing—although things do need to be magnificent—but of the

Below:
The coach that the fairy godmother creates from a pumpkin sparkles in the moonlight in this inspirational study. Artist: Tom Wingrove; medium: digital.

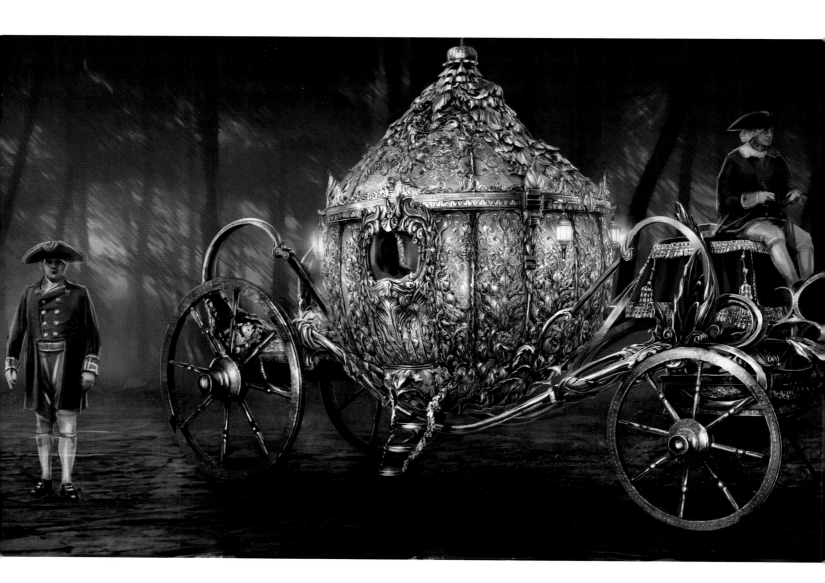

Right:
Working from designs by
Dante Ferretti (production
designer), Stuart Rose
(senior art director), and Tom
Wingrove (concept artist),
Coyaltix Carriages of Dolsk,
Poland built the chassis, with
decorative elements and
leather work from BGI Supplies
Ltd. at Longcross Studios in the
United Kingdom.

aesthetic of what's being presented, which comes down to extraordinary work in the production design, VFX, and costume departments. Trying to encompass the dire situation this young girl is in and how astounding it is to have this magic laid at her feet. It really has to work on the level of emotion, because without that, no amount of CGI would make up for it."

"In the case of the pumpkin, I wanted to do something quite different from what had been done before," explains Ferretti. "So instead of working on a fruit or vegetable, I worked on a piece of jewelry. I wanted the pumpkin-carriage to be a beautiful jewel which enfolds Cinderella, who is the real jewel in the story."

To create the moving jewel Ferretti envisioned, the artists incorporated elements of the greenhouse where Cinderella had grown the original pumpkin. The addition of the architectural touches kept the pumpkin from looking like an overinflated balloon. Freeman comments, "Using CG, they can blow the pumpkin up to one hundred times its size, but we needed something to morph the size and scale without it looking ridiculous. The transition through the glasshouse gave it that middle ground, so it didn't have to grow enormously."

143

Ella's House

Opposite:
These two inspirational studies depict the Tremaines' home as an English country estate, rather than a château. Artist: Adam Brockbank; medium: digital.

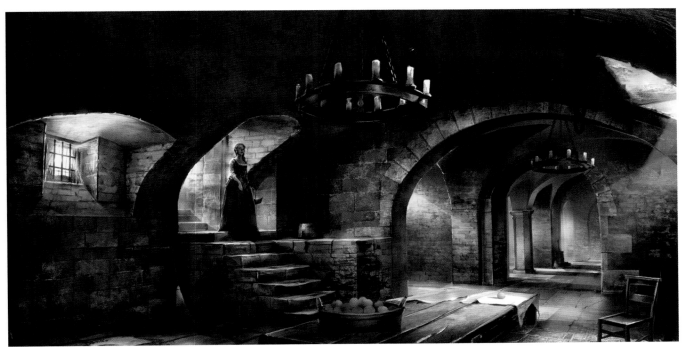

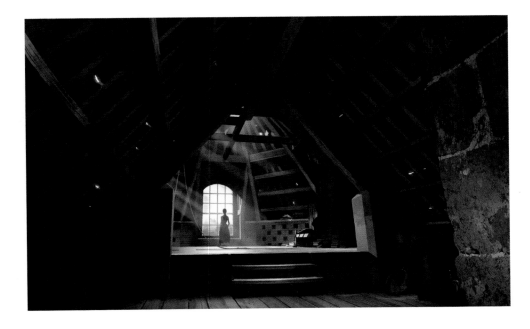

This page:
Three inspirational studies of the Tremaine château suggest décor, mood, and status. Cinderella's father has a study that is spacious, sunny, and agreeably cluttered (top). Artist: Adam Brockbank; medium: digital. The subterranean kitchen looks shadowy and bare (above). Artist: Tom Wingrove; medium: digital. Cinderella's garret room feels bleak and lonely, despite the large window (left). Artist: Brockbank; medium: digital.

145

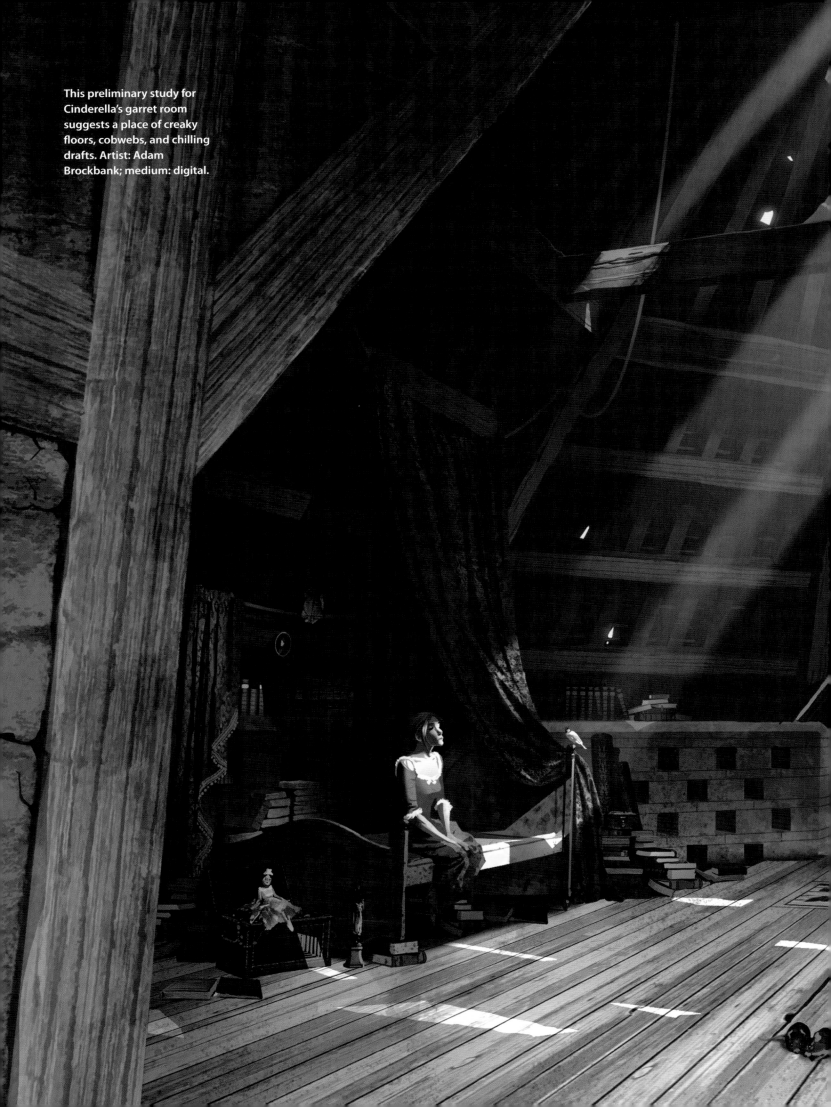

This preliminary study for Cinderella's garret room suggests a place of creaky floors, cobwebs, and chilling drafts. Artist: Adam Brockbank; medium: digital.

The Palace

These pages:
Three preliminary visions of the prince's palace. The silhouette of the palace at sunset echoes the towers of Neuschwanstein in Bavaria (right). Artist: Tom Wingrove; medium: digital. A grand triumphal arch rises behind the courtyard where carriages arrive (below). Artist: Wingrove; medium: digital. When she arrives at the palace, Cinderella will cross a courtyard with an outsized fountain that suggests a nineteenth-century reworking of a baroque fountain by Bernini (opposite). Artists: Adam Brockbank and Wingrove; medium: digital.

Pages 150–151:
In this pre-visualization of the palace, a nineteenth-century carriage drawn by four horses crosses a paved courtyard framed by iron gates and a grand staircase. Artist: Gary Freeman; medium: digital.

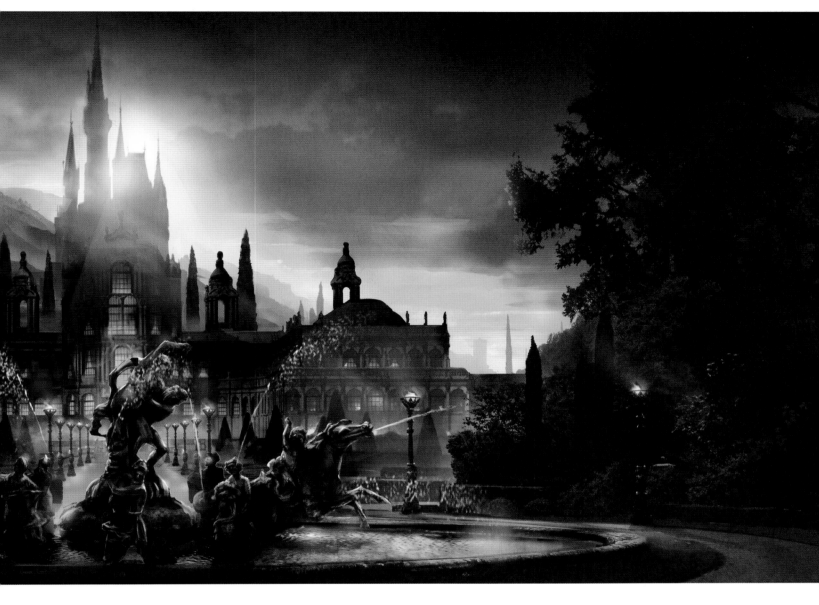

149

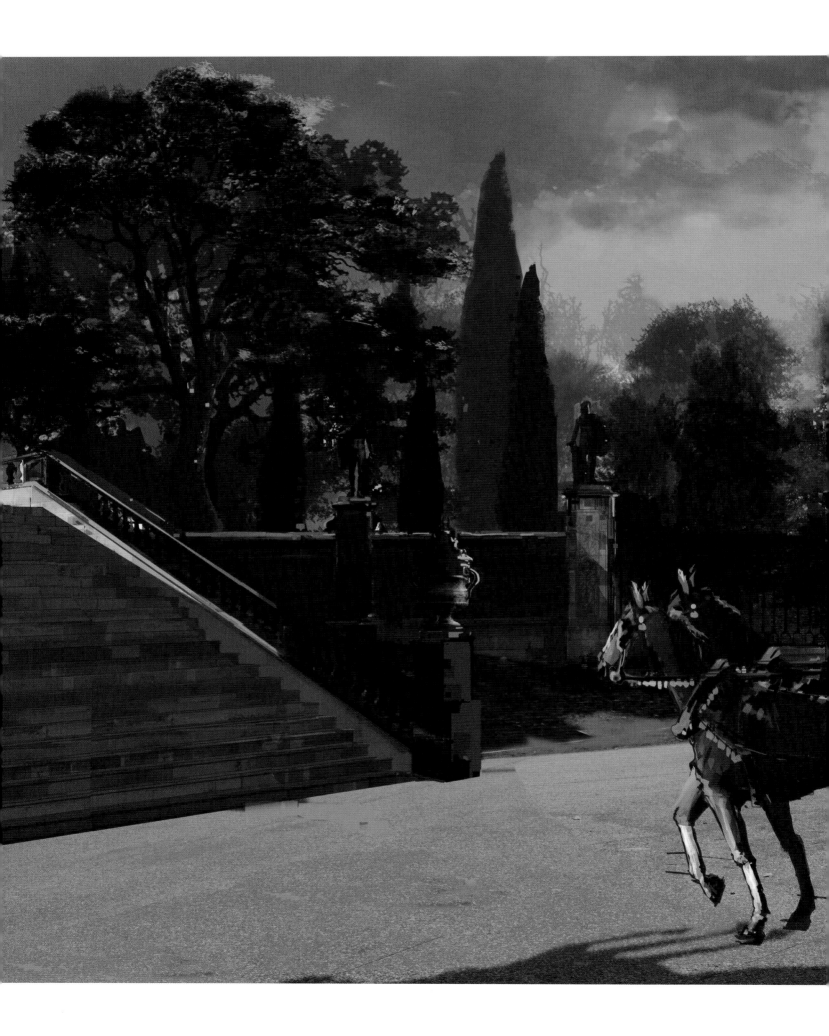

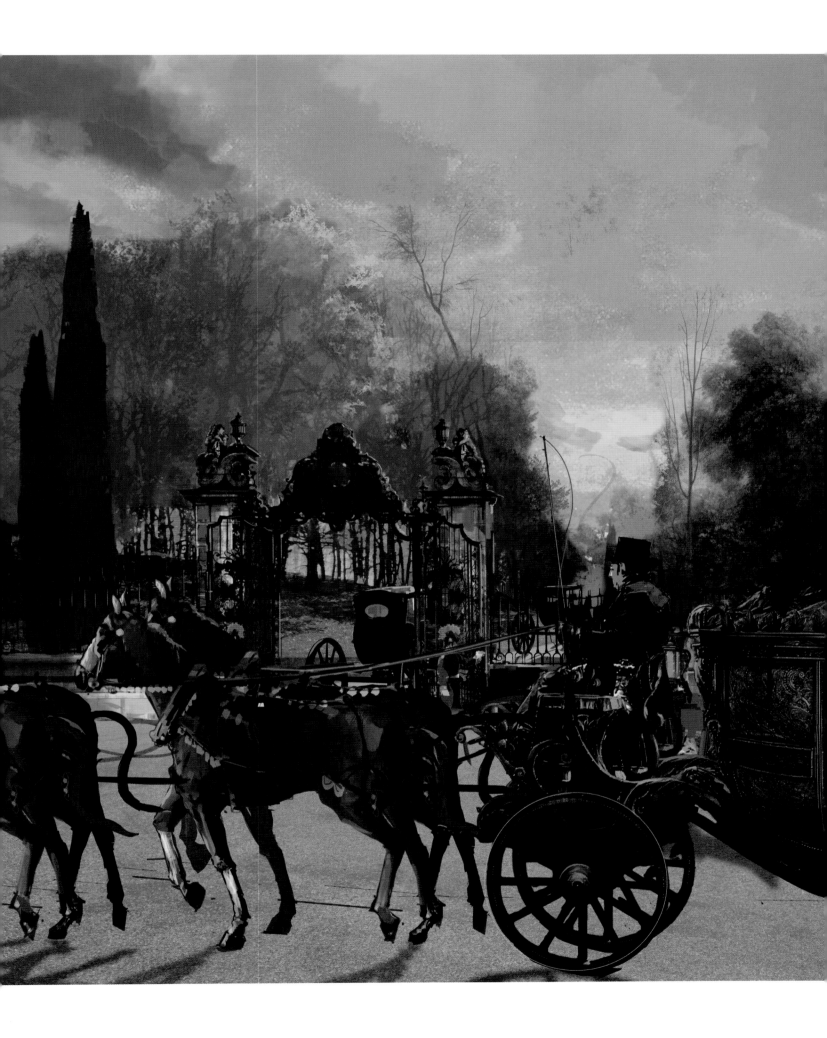

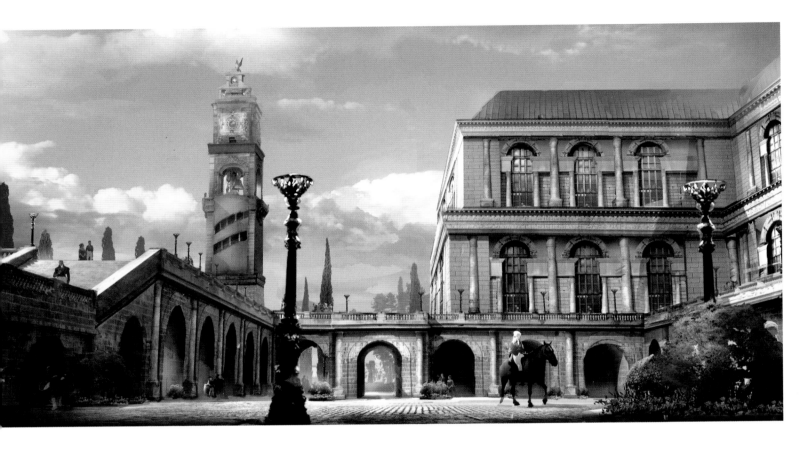

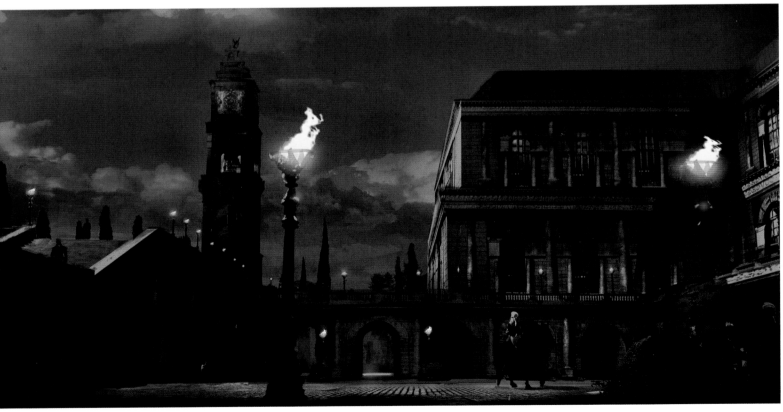

Above: Two inspirational studies of the palace by day and night feature Italianate galleries, copper roofing, raised promenades, a central European bell tower, and Empire Style streetlights transformed into torchères. Artist: Tom Wingrove; medium: digital.

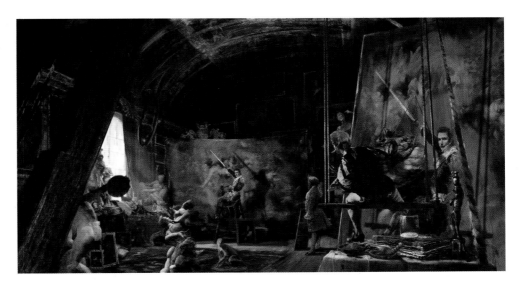

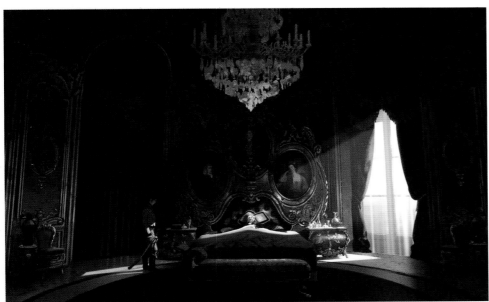

This page:
Three interior studies. The prince having his portrait painted in a studio that suggests the influence of Velasquez (top); compare it with the scene in the finished film (page 133). Artist: Frederico Constani; medium: digital. The prince pays his respects to his father, lying in his bed chamber, shrouded in dark velvet and lit by an outsize chandelier (left). Artist: Adam Brockbank; medium: digital. The prince and Cinderella visit a picture gallery that suggests the royal family has been collecting art for centuries (below). Artist: Frederico Constani; medium: digital.

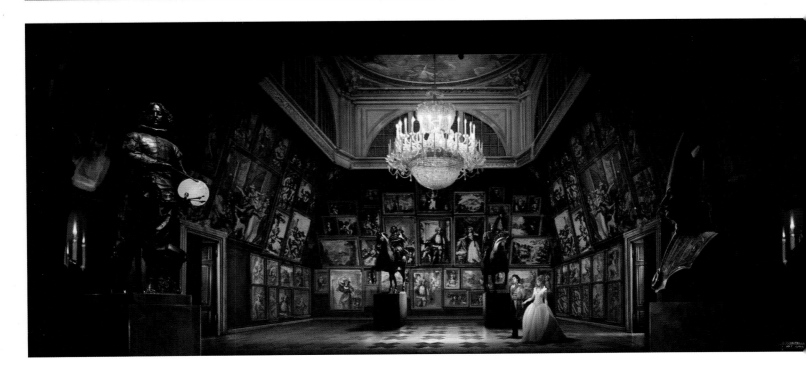

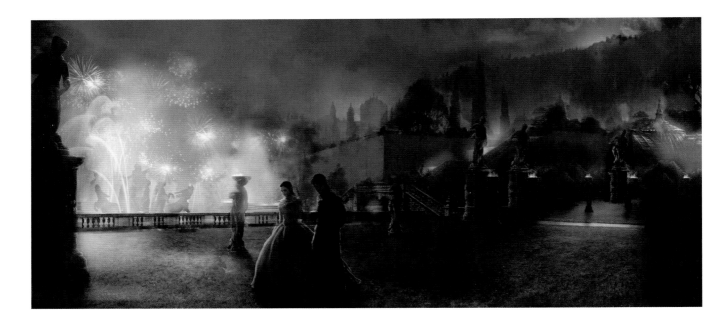

Above:
A fireworks display creates patterns of light and smoke in the palace garden in this preliminary painting. Artist: Marc Homes; medium: digital.

Opposite:
Tom Wingrove envisioned Cinderella making her way to the ballroom down a grand marble hallway with tessellated floors. Artist: Unknown; medium: digital.

Right:
At the stroke of midnight, Cinderella dashes down the grand staircase to the courtyard where her pumpkin-carriage awaits in this pre-visualization painting. Artist: Unknown; medium: digital.

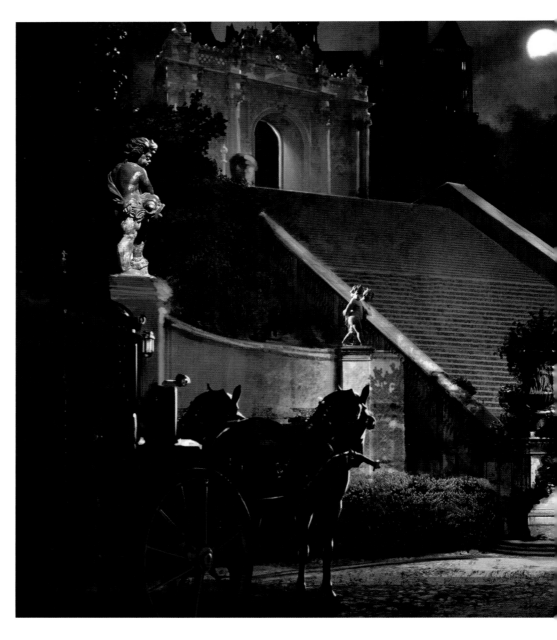

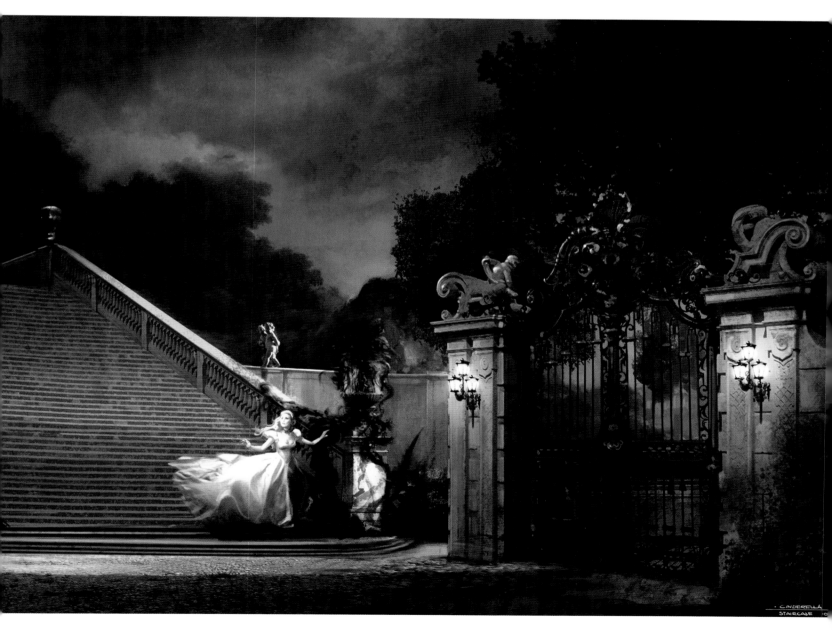

Branagh enjoyed revisiting the classic scenes and adding new touches: "My background is in the theater, where you often meet famous set pieces, whether it's Henry the Fifth coming on for the 'Once more unto the breach' speech or Hamlet asking whether 'to be or not to be.' For me, one of the most exciting invitations was to come up with a memorable, magical series of images for the transformation of mice into horses and lizards into footmen. These were opportunities to strike images that (if successful) could live in the hearts of audiences across the world."

Computer animation enabled the artists to create believable, three-dimensional versions of the mice Cinderella befriends. But the role of the diminutive characters had to be rethought to fit the new script. "You have to assess how they fit into the story: are they actual actors who are going to influence events? What are they there for?" Weitz says thoughtfully. "In the animated *Cinderella*, they provide a lot of entertainment while a very straightforward story is retold. Here, where we were expanding the story that our humans were enacting, it was natural to make them more of a Greek mouse chorus."

"In CGI, anything can be done," Freeman adds. "But for me and for Dante, it was very much 'you pick your moments of magic.' We knew the mice were a story point, and they needed to be controllable. Twenty years ago, they would've been stop-motion mice, which always looked a bit funky. The effects have to be much more accurate because everybody's comparing it to the last film they saw."

"The hardest thing to do with CG characters is to act opposite them because you have nothing to interact with," adds Weitz. "Writing for CG characters is easy, because you can have them do anything. But you want them to have a grounded feeling, you want them to feel as though they are actual creatures. The more realistic they look, the less able you are to put dialogue into their mouth. The speaking mice you have in the animated version wouldn't work for ours."

"A combination of approaches was something to embrace in the transformed animals," Branagh explains. "Partly makeup: what you see of the lizard's teeth when the lizard becomes a man. Tom Edden, a wonderful, physical actor, gave the lizard tremendous humanity and a kind of humor and warmth. But working back from that to the lizard in lizard form, we bring in some of Tom's work and borrow from what the prosthetic makeup artists did. It was a fusion of techniques."

Branagh's enthusiasm is palpable when he describes fusing multiple techniques to create showstopping imagery. But he grows more serious when he returns to the need for those images to support the emotions underlying the magic. "The different ways to do that—live action, real props, computer-

Opposite:
Cinderella (Lily James) emerges from her carriage at the palace.

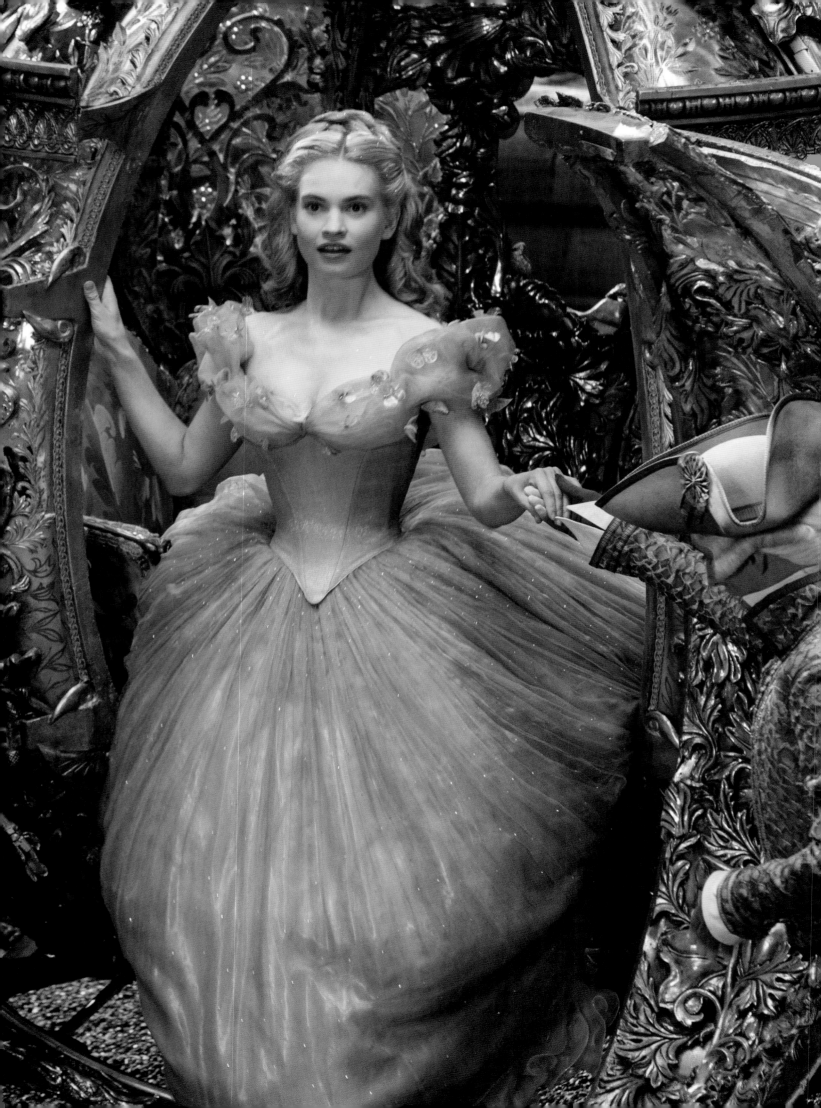

generated images—were fun to coordinate, to get the best ideas from the different directions," he says. "But my approach was to stress the human dimension. When presenting animals, I worked with the actors who were being those animals in human form. When it comes to lizard footmen, mice, and horses, we try and take essential characteristics from real examples and use them to inform what our visual effects team does. We use every technique to make it feel organic to the way we're treating the rest of the story. Which goes back to this idea of Cinderella's basic humanity informing the whole piece. We tried to do that with the creation of the magic. It has the fun. But it also has heart."

She Shall Have Music

I'm often asked about the difference between music for an animation film and music for a live-action film: as a rule, there isn't any. I treat both genres with the same degree of respect. The first film I ever went to see as a young adult on my own was Walt Disney's Fantasia *at a cinema in Glasgow. This remains one of my favorite films.*

— Patrick Doyle, Composer

To compose the score for *Cinderella*, Branagh chose Patrick Doyle, whose distinguished career encompasses the music for *Sense and Sensibility*, *Harry Potter and the Goblet of Fire*, and *Brave*. Doyle also scored three of Branagh's previous films: *Henry V*, *Much Ado About Nothing*, and *Thor*. He began working on *Cinderella* during the early stages of its creation.

"I received the script for *Cinderella* very early on during preproduction" he recalls. "I looked at the designs and talked with Ken in great detail about what the tone and size of orchestra he envisaged was. I was there for a great deal of

Right:
The prince (Richard Madden) leads Cinderella (Lily James) onto the ballroom floor for their waltz. Composer Patrick Doyle describes their waltz as the "pivotal moment" in the story.

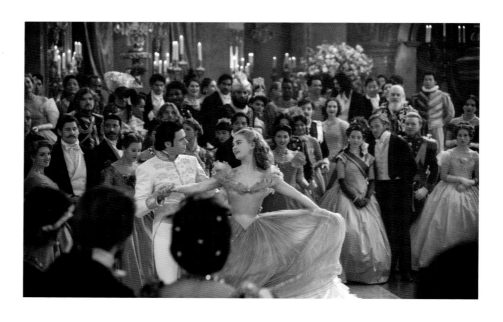

the filming, particularly the ballroom scene, and was on set every single day supervising the playback music of the electronic demo of two waltzes and a polka, which I fully orchestrated. I visited the set on other occasions, as it's so beneficial to see the actors performances close up. I like to experience that whenever I can, and I always visit the set for this reason when I work with Ken."

Doyle was also attracted to the story's enduring appeal. He explains, "There are many reasons why it's so perennially popular. It features the underdog: despite the cruelty imposed upon her by her stepsisters and stepmother this lonely but quietly determined heroine rises above it. This family dynamic creates a riveting conflict. It has magic with animals changing into humans, a beautiful dress, a golden coach, and a glittering ball. It has, as we all know, a wonderful classic happy ending with a wedding thrown in. There's a ballroom and dreaming the dream. All these aspects make it a story of extraordinary resonance and power.

"These elements and the outstanding performances as you can imagine were an inspiration to me. Those are my beacons," the composer adds. "There're wonderful injections of dark and light comedy, which relieves the tension for the audience. That's always a hugely effective element."

Doyle's score incorporates the traditional song "Lavender's Blue," which Cinderella learns from her mother. The lyrics were first printed in England in the late seventeenth century, shortly before Perrault published his version of "Cinderella." And in another link to Walt Disney, Burl Ives sang it in *So Dear to My Heart* (1949), earning an Oscar nomination for Best Original Song. Ives's recording of "Lavender's Blue" renewed the song's popularity in the twentieth century.

Like the artists who created the physical production of *Cinderella*, Doyle enjoyed the freedom the nonspecific, nineteenth-century setting provided: "I've worked with Ken on films that give you a sense of a period but you are not necessarily restricted by it. Here, there is a sense of the late eighteenth and early nineteenth in mindset; I don't have to pin down a specific harmonic period. I like the flexibility this allows."

Although Doyle speaks with great enthusiasm, he takes a serious tone when he turns to the demands the story places on the score. "I've written a waltz, which Ken and the studio are thrilled with. I am delighted they are, of course, as it was a real musical challenge: it being the famous first dance between the prince and Cinderella, which everyone is waiting for," he says. "Everything leads to the ball: the pivotal moment is this waltz. The ballroom set is just staggering, and the waltz between Lily and Richard is one of the most beautiful, romantic, and moving things I've ever seen."

"My job is to make the music as fresh, appealing, hypnotic, and attractive as possible: a strong score that sweeps you along," Doyle concludes. "Hopefully, I will create a timeless score."

Pages 160–161:
Cinderella (James) descends the grand staircase as she prepares to take her rightful place in the ballroom—and in the prince's heart.

159

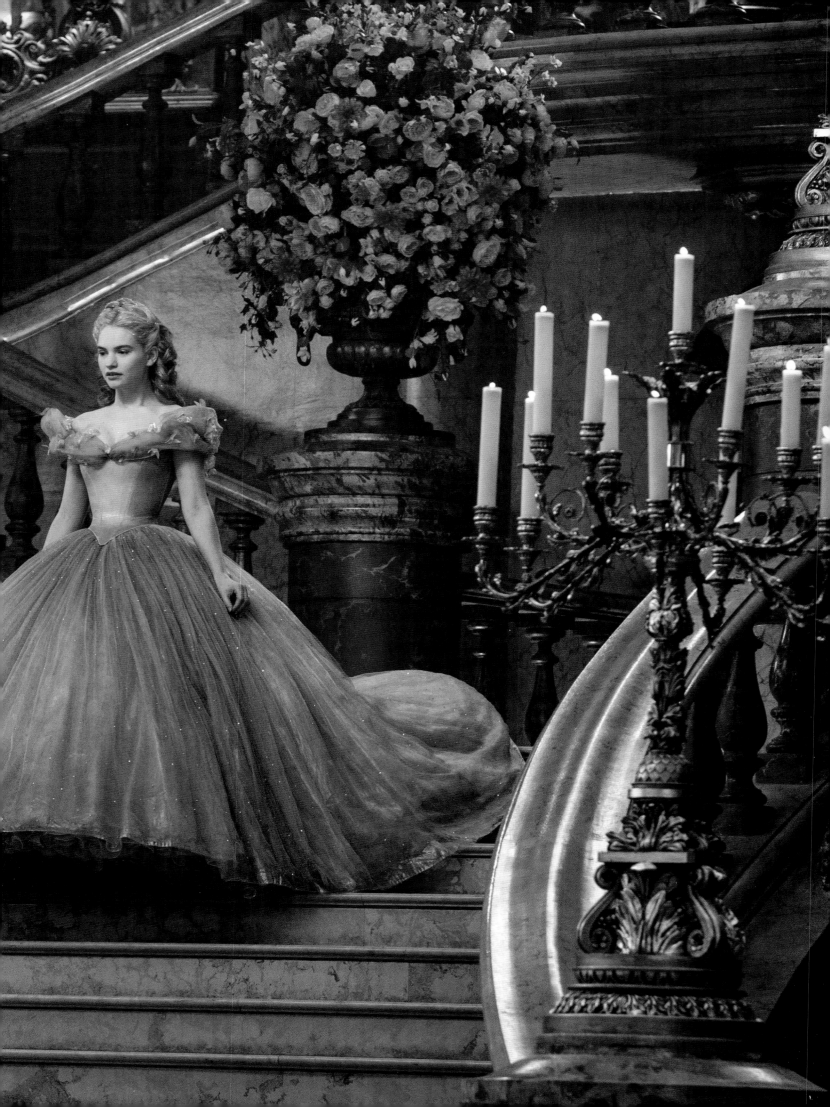

Dressed for a Ball

If I were invited to a ball, I would steal my costume and wear it proudly. I think that it's the most beautiful ball dress in the world.

— Lily James (Cinderella)

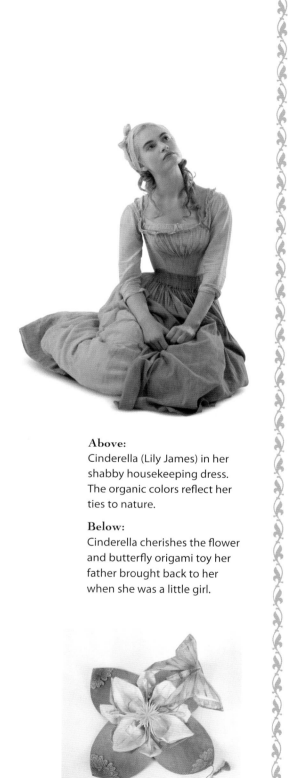

Above:
Cinderella (Lily James) in her shabby housekeeping dress. The organic colors reflect her ties to nature.

Below:
Cinderella cherishes the flower and butterfly origami toy her father brought back to her when she was a little girl.

Sandy Powell, who won Oscars for her costumes for *The Young Victoria*, *Mrs. Henderson Presents*, and *The Aviator*, recalls, "One of the very first things I did in my research [for *Cinderella*] was investigate setting it in different periods. The eighteenth century is really beautiful, but I was not interested in it because that's usually the pantomime version of 'Cinderella.' I wanted to avoid any similarity to pantomime. I thought rather than be completely specific in a period, let's do my take on it as far as costumes were concerned. I was kind of doing a 1940s, 1950s version of the nineteenth century."

Like the other artists and designers, Powell enjoyed the freedom Branagh gave her to exercise her imagination. "I did a lot of research," she continues. "I presented Ken with all of that and we talked in great depth about each character. As we developed costumes, I would show him the fitting pictures so he could see what was happening as we went along."

For Cinderella's daily chores, Powell dressed the heroine in a pale green dress with a light brown apron—shabby, but becoming. The muted colors reflect the subdued mood of those dreary days of toil and abuse. But for the ball, Powell created a sweeping gown of shimmering blue, glittering with thousands of crystals. On the bodice are tiny fabric butterflies, recalling a special memento from Cinderella's father—a treasured butterfly toy contained in a lotus flower–shaped box—and the lesson about beauty lying within that it embodied.

"To become Ella in her normal rags is a much simpler journey, although I'm still in a corset every day, which is torture," says James. "To become Princess Ella takes a long time. I have hundreds of Swarovski crystals hand-stuck into my hair. The dress has six layers to the skirt, and it takes a really long time to get in and out of. I've had to learn a lot about posture: You can't slouch in a corset."

"The gown is very cleverly engineered, so that even though it's voluminous, it's actually very well balanced; it's not even heavy," explains Powell. "Where it sits on the body, and how the boning supports it makes it incredibly easy to move in. She does an amazing dance routine in it and never had any problems. It's fun to do things on a large scale, but [the gown] had to be delicate because this is Cinderella."

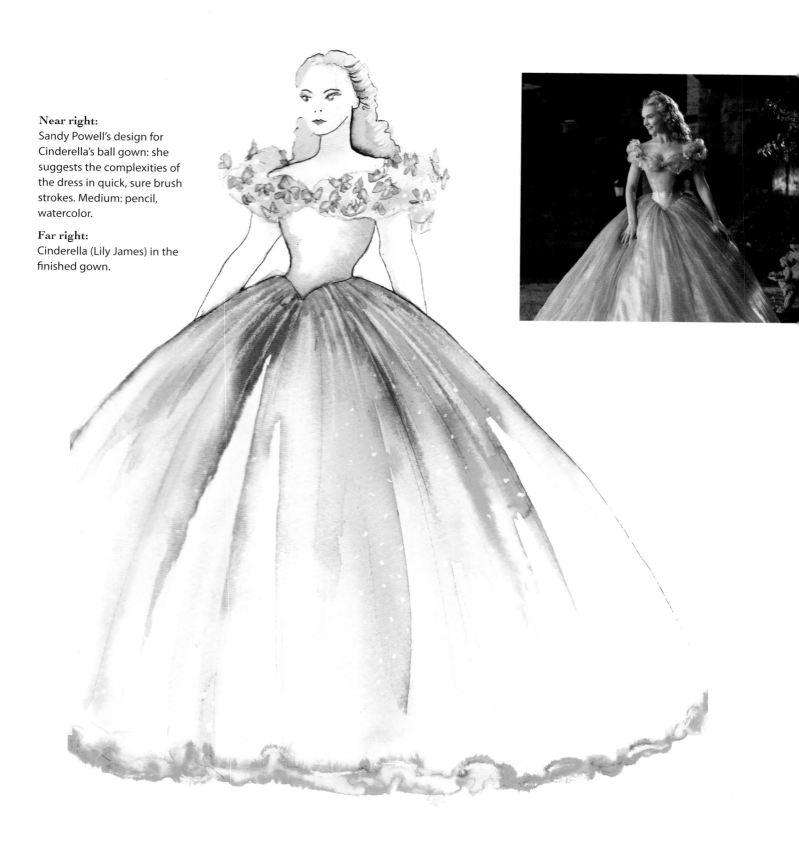

Near right:
Sandy Powell's design for Cinderella's ball gown: she suggests the complexities of the dress in quick, sure brush strokes. Medium: pencil, watercolor.

Far right:
Cinderella (Lily James) in the finished gown.

Pages 164–165:
Gracefully marshaling her voluminous skirt, Cinderella (James) enters between serried ranks of guards.

"It really is every little girl's dream to put on a dress like that," James adds enthusiastically. "Around the top of the corset there are butterflies, which have a sentimental value. When the fairy godmother appears, Ella says of her torn frock, 'Don't change it: it was my mother's,' so the shape is very similar to the dress her mother wore. When she has the dress on, it feels like her mother and father are with her: Ella wants the strength of her parents by her side. The dress looks beautiful, and there's a lot of story in it."

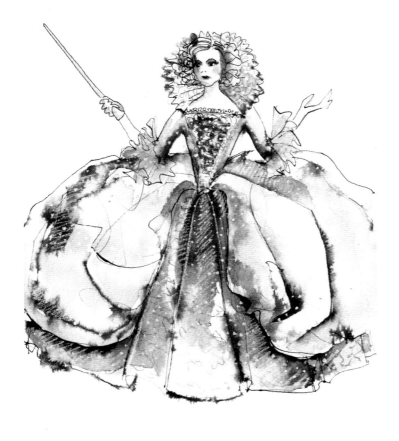

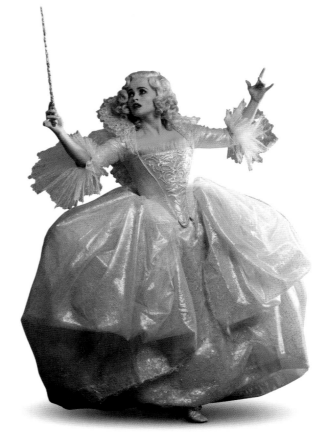

Above left:
Sandy Powell's design for the fairy godmother's dress echoes the lines of an eighteenth-century gown with panniers. Medium: pencil, watercolor.

Above right:
The fairy godmother (Helena Bonham Carter) in the finished gown, which features scores of tiny LED lights, powered by a battery pack hidden in the bustle.

Creating a look for the fairy godmother who effects Cinderella's transformation proved more challenging. "The fairy godmother was actually quite hard because it could be absolutely anything," says Powell. "I really came to how the fairy godmother should look once we knew it was Helena. Casting is often the key. I wanted her to be every little girl's idea of a fairy godmother, literally sparkling with light, so we worked with a lighting company (Phillips) that created small lights throughout the dress designed to twinkle on and off."

"My costume is possibly the biggest one I've ever had to wear," replies Carter with a laugh. "It's white, silvery, and about four feet wide. And I light up! There's about twenty batteries up my bum. This lovely man from Philips basically turns me on with a switch on my bum and then he goes off and he operates me remotely from his computer. Every time I do a spell, I change color. I'm like a thing that you could put on a Christmas tree."

In contrast to the white costume of the fairy godmother, Powell gave Cate Blanchett's stepmother a great, black picture hat with a veil that focuses

Right:
Sandy Powell's pencil sketch for Lady Tremaine's day gown. Medium: pencil, watercolor.

Far right:
Lady Tremaine (Cate Blanchett) wearing the outfit. The accompanying picture hat and veil keep the audience focused on her penetrating eyes.

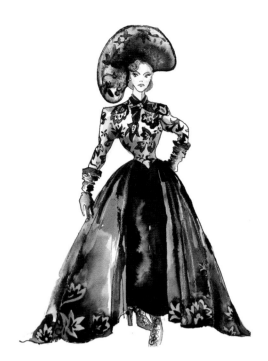

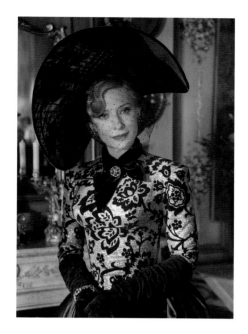

Below:
Lady Tremaine (Blanchett)

Below right:
Powell's pencil drawing of Lady Tremaine's green and gold evening gown for the ball, to be worn by Blanchett. Powell described Blachett as one of "a handful of actors that you can throw anything on and they look fabulous." Medium: pencil, watercolor.

the audience's attention on the actress's piercing gaze. For the ball, the step-mother wears a sweeping gown of green and gold satin with an aigrette. The hats and coiffures hold her hair away from her face, creating an effect similar to the animated character. "It's a designer's dream because Cate Blanchett is one of the greatest people there is to dress," Powell comments. "There's only a handful of actors that you can throw anything on and they look fabulous. Evil's easy. The baddies are easier to dress than the goodies: it's quite difficult to make a good person not dull."

When Ollie Johnston animated the stepsisters, Walt Disney insisted they were grotesque and comic, but not aggressively ugly. The live-action

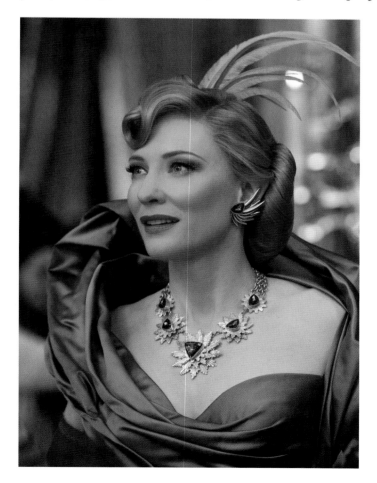

Above:
As this sketch indicates, Sandy Powell drew a single design for the stepsisters's outfits, but distinguished them by using contrasting colors. Medium: pencil, watercolor.

Above right:
Anastasia (Holliday Grainger) and Drisella (Sophie McShera) pose in their dresses.

filmmakers took a similar approach: Anastasia and Drisella are not gargoyles, but spoiled, arrogant, thoughtless young women.

"We never thought about the ugliness without, but the ugliness within," says Shearmur. "Both actresses are very pretty. But there's a lack of self-awareness about just how far they're pushing their hairstyle, their makeup, the garishness of their dresses. Their appearance reflects the singular attention on their own needs without any consideration for anyone else: that defines their ugliness within."

"The whole idea behind the stepsisters is that they weren't physically ugly: they are beautiful but ugly on the inside and vain," agrees Powell. "That was fun to play with. Basically, I overdressed them. They went one step too far with what they were wearing—without it becoming a visual mess. I dressed them identically, like twins, except for the colors: if one was in pink with green trim, the other was in green with pink trim. Exactly the same outfit, the same print, but in different colors.

"I thought I had an original idea; then I looked back at the animated film, and that's what the Disney artists did," Powell sighs. "I thought I'd forgotten all about the Disney cartoon, until after I had designed this *Cinderella* and saw there were quite a few similarities. I think they were unintentional, but maybe they were subliminal. But in the animation, no one changes their clothes much. In our film, the stepsisters and stepmother change every five minutes."

The actresses who portray Anastasia and Drisella were delighted with their over-the-top outfits. "The sisters' costumes are amazing: they're really beautiful, but they're a little bit too garish, or the lengths of the skirts are not quite right, or the way the toes of the shoes turn up," says Grainger. "Something's not quite right with their taste."

"I've never had a job where I've had so many costumes. I know that a lot of them are supposed to be in bad taste, but I love all my costumes," agrees McShera. "Being with Holliday and having our matching outfits in different colors has been so funny; we love everything Sandy puts us in."

Below:
Anastasia (Grainger) and Drisella (McShera) in their ball gowns. As Grainger notes, "Something's not quite right with their taste."

169

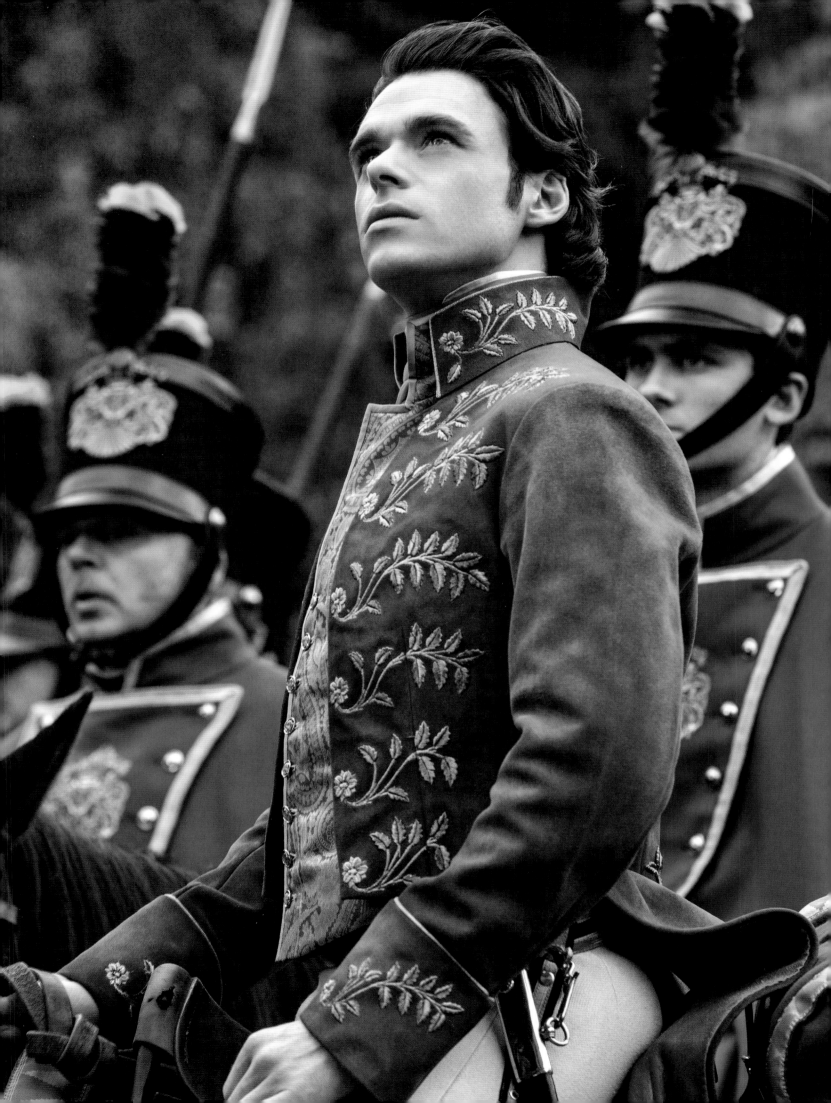

Right:
Sandy Powell's sketches
for uniforms for the prince
(Richard Madden). Medium:
pencil, watercolor.

Opposite:
As Powell intended, Madden
looks appropriately dashing in
his embroidered green jacket.

Below:
The prince (Madden)
approaches Cinderella (Lily
James) with the slipper, hoping
it will fit her.

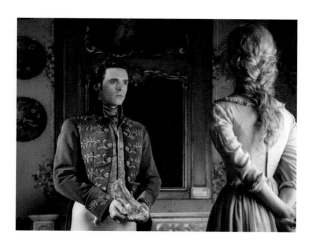

For the prince, Powell says, the brief was simple: "Make him handsome." "Of course, I had a handsome actor to begin with," she adds. "But I added sparkles. The prince is military looking: There's nothing more attractive on a man than a really beautifully fitting uniform. He looks very dashing. I wanted him in light blues and greens and whites, as opposed to more somber, masculine colors."

Madden found the uniforms affected his performance as the prince. "The costumes are so intricate and detailed. I've had so many fittings, trying colors and textures; then the tailor goes away and makes them with Sandy," he explains. "They have a romantic feel that's also masculine. They affect the way I move, the way I stand, the way I sit on my horse. These things become very useful for me as an actor to work at how the character holds himself."

The iconic glass slipper proved more problematic in real life than it had in illustrations or animation. "We made shoes of real crystal, which in reality, no one can wear, not even Cinderella. Crystal has no flexibility, so you can't actually fit your foot into it," says Powell. "The shoe we created out of crystal is the shoe that's held and passed around. It's the shoe that people try to get their foot into. When we see the shoe on Cinderella's foot, it's the visual effects version. We made leather shoes she could actually wear that were the same shape; then visual effects magically transformed them into the glass slippers."

"The glass slipper is where I got the idea I might not be the best fairy godmother," says Carter with a laugh. "If you think about it, it's completely impractical, uncomfortable, and un-walkable-in.

But I'm good at shoes. The shoes are the only thing that last beyond midnight. Everything else turns back."

Madden found the glittering slipper useful—and disconcerting. "I'm terrified of the glass slipper because it's worth about $10,000. People hand it to me to use in the scene; they're wearing white gloves and I have my bare hands," he confesses. "I'm walking about the set terrified that I'm going to drop it. As an actor, it helps me there's actually a glass slipper I can pick up and be in awe of—then look at Cinderella and be not surprised that she'd wear this amazing slipper because she is who she is."

Ever After

What I remembered from Cinderella *and the other Disney classics is their grandeur: they were films that transported you into another world that was big, with castles and ballrooms and vast staircases. I hadn't remembered quite how full of music* Cinderella *is. The running time is seventy-eight minutes, yet it's full of songs and comedy business with the mice and birds. A very enjoyable movie to watch, as well as being a very romantic story.*

— Kenneth Branagh, Director

Above:
The Grand Duke watches Cinderella and the Prince dance together through his monocle in the animated feature.

Opposite:
And, of course, they lived happily ever after, too.

Although everyone involved in *Cinderella* wanted to make a film that would stand on its own merits, they had all seen Walt Disney's animated classic, and found it crept into their consciousness. Ferretti recalls, "I grew up in Macerata [Italy], where my parents used to take me to the cinema, and I remember going to see Walt Disney's *Cinderella*. I watched the film again on DVD while I was preparing our version, not as an inspiration, but simply to recall the characters of *Cinderella* that were buried deep in my memory."

Shearmur's voice cracks slightly when she remembers seeing *Cinderella* and other Disney features as a little girl: "Every single summer when I grew up, there was a local theater that brought back Disney classic films. One of the deepest, fondest memories I have is my dad taking myself and my siblings every summer to that theater."

"In this film, we're in the fairy-tale space and with a character and a story that I consider to be one of the pillars of this studio," concludes Bailey. "The exploration of how to approach this title was very interesting to me. It was very encouraging that it attracted the highest-end talents in our business. I think as soon as people see the first frames of this film, they're going to say, 'I understand exactly why they did it this way, but it's also not what I expected.' Which I'm really excited about. I can't wait for people to see Cate as the stepmother!"

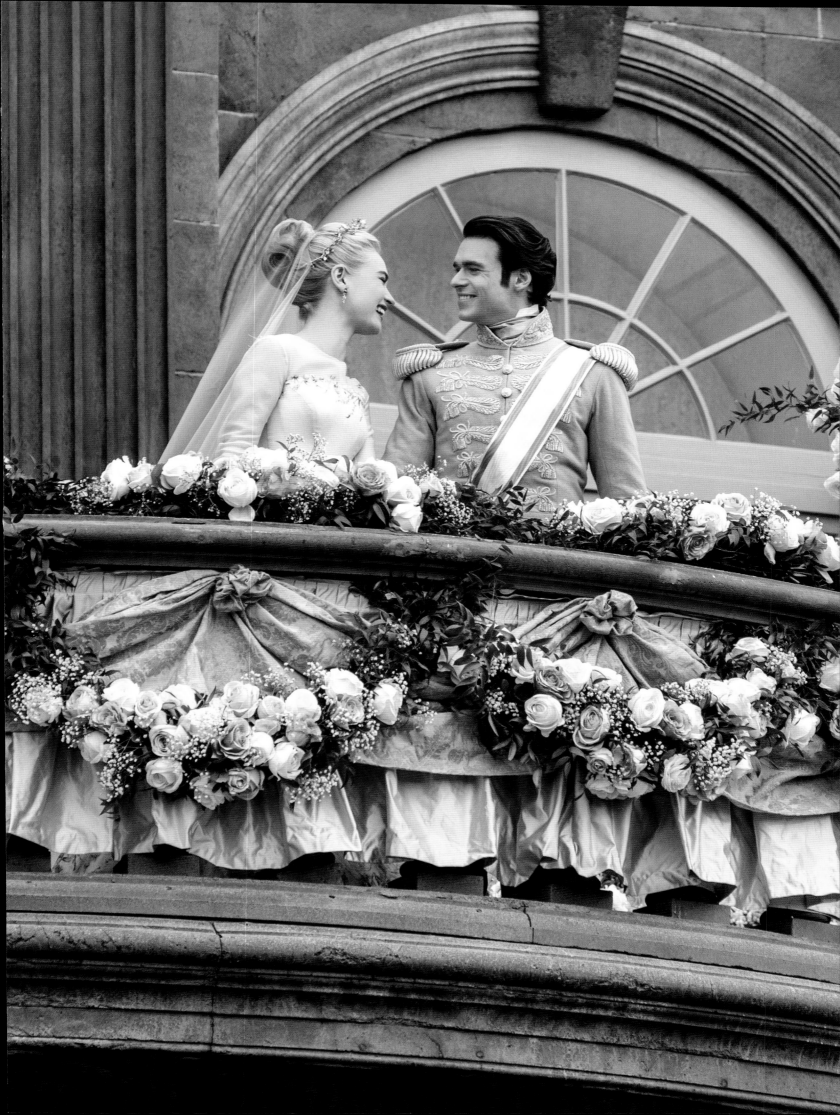

Dedication

To the memory of
Diane Disney Miller
A link to animation's storied past,
a generous patron of the arts,
and a kind friend.

Above:
Diane Disney Miller at The
Walt Disney Family Museum in
San Francisco. Photograph by
David Butow.

Right:
Walt Disney once said that
Cinderella getting her ball
gown was his favorite piece of
animation done at his studio.
Animation cleanup drawings.
Animators: Marc Davis, George
Rowley; medium: pencil,
colored pencil.

Acknowledgments

Cinderella remains one of the most beloved Disney animated films, and the heroine occupies a special place in the hearts of millions of fans, especially little girls. But many of those admirers are unaware of the film's significance in the history of Walt Disney's studio. So when editor extraordinaire Jessica Ward suggested a book about the film, it presented interesting challenges.

I was fortunate enough to have interviewed some of the artists who worked on *Cinderella*, and I remain grateful for those conversations. *Ave atque vale*: Eleanor Audley, Marc Davis, Joe Grant, Ollie Johnston, Milt Kahl, Eric Larson, Bill Peet, and Frank Thomas.

My sincere thanks to the younger artists who love *Cinderella*, learned from it, and wanted to talk about it: Ruben Aquino, Brad Bird, Brenda Chapman, Andreas Deja, Pete Docter, Ralph Eggelston, Paul Felix, Mike Gabriel, Mike Giaimo, Eric Goldberg, Randy Haycock, Mark Henn, John Lasseter, Fraser MacLean, Burny Mattinson, Dave Pruiksma, Alex Rannie, and Peter Sohn. From the live-action *Cinderella*: Kenneth Branagh, Sean Bailey, Patrick Doyle, Dante Ferretti, Gary Freeman, Sandy Powell, Alli Shearmur, and Chris Weitz.

Susan Goldberg once again shared her library of illustrated children's books. John Canemaker and Katherine and Richard Greene graciously shared their research. Greg Pincus transcribed the many interviews at a breakneck pace.

Typically, assistants, coordinators, franchise managers, and PR people did vast amounts of heavy lifting. Many thanks to Heather Feng, Molly Jones and Jeanette Marker at Pixar; Dominique Flynn, Jenna Frederick, Dale Kennedy, Stephanie Kluft, Renato Lattanzi, Christopher O'Connell, Karen Olin, Angela Shaw, and Julie Wicks at Disney; as well as Rae Murillo and Ardees Rabang. Further assistance came from Rebecca Cline and Steven Vagnini at the Walt Disney Archives; Michael Buckhoff put the Disney Photo Library at my disposal, assisted by Shelly Graham. As she always has, Mary Walsh made the Animation Research Library a welcoming place to do research; Fox Carney aided my efforts there with his accustomed diligence and puns. Flack-meister Howard Green remains an inexhaustible source of contact information, encouragement, and lunches.

At Disney Editions, Wendy Lefkon oversaw the project with her accustomed aplomb. Jessica Ward once again tended to the editing and production with her trademark patience and good cheer (even while changing coasts in midstream), assisted by managing editor Jennifer Eastwood and copy editor Warren Meislin. Faced with a plethora of striking illustrations and a tight deadline, designer Gregory Wakabayashi transformed the material into a handsome book.

My excellent agent Richard Curtis oversaw the contract. I remain grateful for my friends' enduring affection and forbearance when I fuss about writing: Julian Bermudez, Kevin Caffey, Pete Docter, Paul Felix, Eric and Susan Goldberg, Dennis Johnson, Ursula LeGuin, Jef Mallett, John Rabe, and Stuart Sumida. Additional thanks to Eric Goldberg for his hilarious caricature of me as Chaz-Chaz, a mouse who unfortunately doesn't appear in the final film. On the home front, special thanks are due to Scott, Nova, Matter—and "assistant writer" Typo. **—Charles Solomon**

CHAZ-CHAZ

ADDITIONAL SOURCES

Jacket and pages 14 and 18 illustrations by Frédéric Théodore Lix originally published in *Les Contes de Perrault*, Librarie Garnier Freres, Paris; page 7 photo of Kenneth Branagh by Jonathan Olley; pages 8–9 and 19 illustrations by Edmund Dulac originally published in *The Sleeping Beauty and Other Tales from the Old French*, Hodder & Stoughton, Ltd., London; pages 10, 15, and 17 etchings by Gustave Doré originally published in *Les Contes de Perrault*, J. Hetzel, Libraire-Editeur, Paris; page 13 illustration by Alexander Zick originally published in a nineteenth century German edition of *Grimm's Fairy Tales*; page 13 Portrait of brothers Jacob and Wilhelm Grimm, 1855 (oil on canvas), Baumann, Elisabeth Maria Anna Jerichau-(1819-1881)/Alte Nationalgalerie, Berlin, Germany/De Agostini Picture Library/Bridgeman Images; page 16 illustration by Arthur Rackham originally published in *Cinderella*, C. S. Evans, Lippincott, Philadelphia; Heinemann, London, 1919; page 18 illustration by Walter Crane originally published in *Cinderella*. George Routledge and Sons, London; page 20 illustration by Harry Clarke originally published in *Fairy Tales of Charles Perrault*, George, G. Harrap & Co., London; page 20 illustration by Charles Folkard originally published in *Grimm's Fairy Tales*, Adam and Charles Black, London; page 20 illustration by Arthur Rackham originally published in *Snowdrop and Other Tales by the Brothers Grimm*, Constable & Co., London; E.P. Dutton & Co., New York; page 21 *Cinderella, or Enchantment*, 1913 (oil on panel), Parrish, Maxfield Frederick (1870-1966)/© American Illustrators Gallery, NYC/www.asapworldwide.com/Bridgeman Images; and page 25 still from *The Tender Tale of Cinderella Penguin* © 1981 National Film Board of Canada. All rights reserved.

Above:
The closing image from the animated feature.

Pages 2–3:
Cinderella and the Prince walk by a fountain during the "So This Is Love" final sequence.

Pages 4–5:
A preliminary painting of Cinderella and the prince walking through a topiary allée during 2015's live-action *Cinderella*. Artist: Marc Homes; medium: digital.

and they lived happily ever after.

For information address Disney Editions,
1101 Flower Street, Glendale, California 91201
Editorial Director: Wendy Lefkon
Editor: Jessica Ward

Produced by Welcome Enterprises, Inc.
6 West 18th Street, New York, New York 10011
Project Director: H. Clark Wakabayashi
Art Director: Gregory Wakabayashi

This book's producers would like to thank Ashleigh Bateman, Jennifer Black, David A. Bossert, Monique Diman, Jennifer Eastwood, Dennis Ely, Winnie Ho, Alan Kaplan, Warren Meislin, Betsy Mercer, Scott Piehl, Steve Plotkin, Cameron Ramsay, Michael Serrian, Betsy Singer, Muriel Tebid, Marybeth Tregarthen, and Dushawn Ward.

ISBN 978-1-4847-1326-6

G615-7693-2-14360
PRINTED IN CHINA / FIRST EDITION
10 9 8 7 6 5 4 3 2 1

Visit www.disneybooks.com

The Official Disney Fan Club

Disney.com/D23